WATERCOLOR
without boundaries

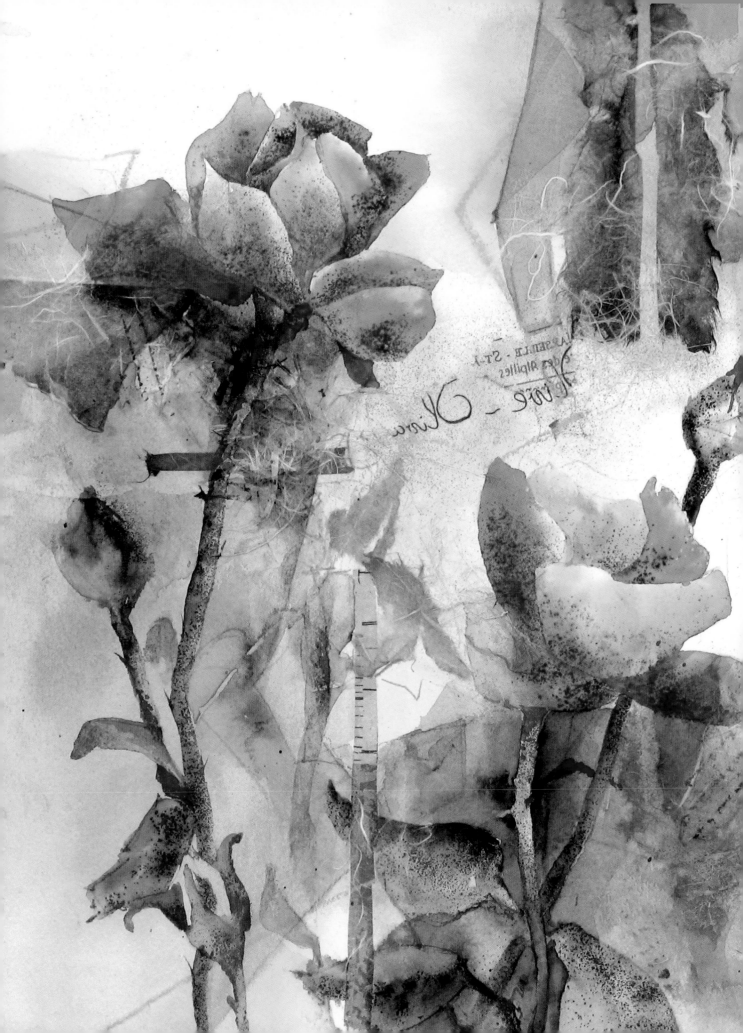

WATERCOLOR
without boundaries

**Exploring new ways
to have fun with watercolor**

Karlyn Holman

Karlyn's Gallery Publishing
Washburn, Wisconsin
www.karlynsgallerypublishing.com

About the author:

Karlyn is an internationally recognized artist, author and art instructor. She has owned and operated an art gallery since 1968. She is a prolific artist with a busy teaching schedule. Nature is the driving force in her paintings, whether abstract or realistic. Karlyn has a loose, spontaneous painting style and an energetic, encouraging teaching style.

John McFarland

Acknowledgements:

Becky Wygonik; a computer expert extrodainaire, and a photographer and editor ace in one.
Lydia Ricard for helping with photography, editing and taking charge of managing Karlyn's Gallery.
Terri Wagner for her skill and professionalism in editing my book.
Bradley Lemire for helping with editing.
Nancy Murphy who told me about the gutta bottle.
Lynda Chambers for her help with ideas and editing.
Jill Jacobson; Lois Doty; Margaret Brunn, who shared their photos.
Bonnie Broitzman who helped with organizing the book.
Karen Knutson, Lynda Chambers, Conne Cuthbertson, Paul Dermanis, Lee Fidler, Kathie George, Pauline Hailwood, Nikki Johnson, Rita MacDonald, Barbara McFarland, Tara Moorman, Cindy Markowski, Sue Primeau, Kristin Smith Procter, Mary Rice, Cida Smith, Jennifer Stone, Amy Kalmon and Deb Vandenbloomer for sharing their art in my book.

Dedicated:

To my nerdy, fun-loving staff who helped with this book: Becky Wygonik, Bradley Lemire, Kristen Christensen, Lydia Ricard and Sandy Isely.

Karlyn's Gallery Publishing
P.O. Box 933
318 West Bayfield Street
Washburn, WI 54891
715-373-2922
www.karlynsgallerypublishing.com

10 9 8 7 6 5 4 3 2
Edited by Teresa Wagner
Interior design and page layout by Becky Wygonik
Photography by Karlyn Holman, Becky Wygonik and Lydia Ricard
Front cover design by Wendy Dunning

Printed in the United States of America by
Service Printers of Duluth, Minnesota

Library of Congress Control Number: 2010920147
ISBN 978-0-9792218-7-3 (perfect bound hardcover, alk. paper)
ISBN 978-0-9792218-3-5 (hardcover with wire-o, alk. paper)
ISBN 978-0-9792218-4-2 (perfect bound paperback, alk. paper)
ISBN 978-0-9792218-5-9 (DVD companion)

Metric Conversion Chart

To convert	to	multiply by
Inches	Centimeters	2.54
Centimeters	Inches	0.4
Feet	Centimeters	30.5
Centimeters	Feet	0.03
Yards	Meters	0.9
Meters	Yards	1.1
Sq. Inches	Sq. Centimeters	6.45
Sq. Centimeters	Sq. Inches	0.16

Notes from the author

Watercolor has always intrigued me. I enjoy the challenge of trying to control this elusive medium and I love the luminosity that transparent paint can produce. Watercolor is a balancing act between control and spontaneity. Please join me as we approach watercolor with a bit of abandon. The only "rule" in this book is to trust whatever works visually. Add water to color, open your heart to mixed media, and do not be afraid to venture into the unknown.

Watercolor Without Boundaries offers ideas that I hope will inspire and motivate you and allow you to play without boundaries, as well as step-by-step instructional techniques to try. Consider this book a starting point.

It is not all inclusive, but rather a series of suggestions—discoveries that other artists and I share while fearlessly playing without boundaries.

My most successful workshops are those in which I offer guided instructions as a basis for creating a look of spontaneity. Once armed with knowledge and mastery of basic techniques, you will be able to venture into the fascinating world of watercolor and mixed media. If you study and understand color theory, learn what each brush is capable of doing, and most importantly, develop an attitude of taking risks, you will be able to freely explore "without boundaries."

Directory of Demonstrations

This directory of fifty-four demonstrations is designed to be "user friendly" so you can easily access the ideas that interest you. While these demonstrations are quite formulated, I really urge you to use them as a springboard to discover your own expression. I have organized the book like a cookbook to allow you freedom to jump right in and try any idea, knowing that the cross-referencing provided will direct you to the technical details you may need to finish your paintings. Similar to using a cookbook, you can follow the basic recipe, but add or substitute different ingredients to come up with a new creation. Challenge yourself to move beyond these demonstrations and create your own interpretation and style. Painting Without Boundaries

is a lot like making up a recipe; instead of adding the same old ingredients, throw in something different and maybe instead of the usual, you will come up with the extraordinary. Bon Appetit!

Companion line drawings on watercolor paper called "Just Lines" are available for many of these demonstrations. Sixteen of these demonstrations are also featured on the companion DVD. Both are indicated on the side of the image in this directory. Several of the lessons presented in this book are also available as "Lessons in a Bag." Each lesson is individually packaged and priced. See page 175 for specific details.

Getting started in landscape • Pages 16-67

Using foliage—a fantastc way to frame your subject • Page 24

Harmonic colors • Page 31

Starting with a range of values • Page 32

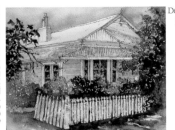

Layering color—a roadmap for success
Pages 34-35

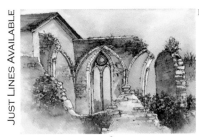

Wet into wet—an exciting way to start a painting • Pages 36-37

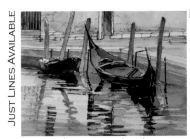

Combining traditional with non-tradtional • Page 38

Inventing a "path of light" on wet paper • Page 39

Inventing a "path of light" on dry paper • Page 40

Revealing a "path of light" on a wet surface is easy and fun
Pages 42-43

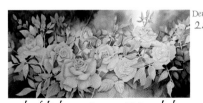
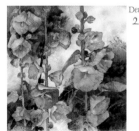

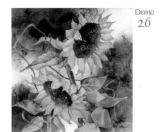

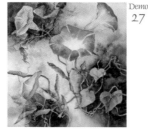

Opening the door to explore in mixed media · Pages 106-173

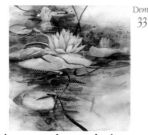

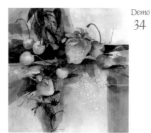

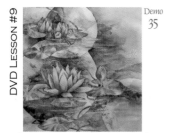

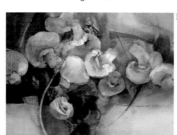

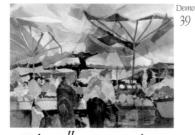

Demo 41

Starting with white acrylic shapes and lines • Page 139

DVD LESSON #11
JUST LINES AVAILABLE

Demo 42

Westie—the "alla prima" dog
Pages 140-141

DVD LESSON #12
JUST LINES AVAILABLE

Demo 43

Applying acrylic with a gutta bottle • Pages 144-145

JUST LINES AVAILABLE

Demo 44

Using the gutta bottle to create lost and found edges • Pages 147-149

Demo 45

An easy approach to an iconic portrait • Page 152

DVD LESSON #13
JUST LINES AVAILABLE

Demo 46

An iconic giraffe using a combination of drizzled lines and the gutta bottle Page 154

JUST LINES AVAILABLE

Demo 47

An iconic lion using only the gutta bottle • Page 155

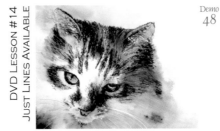

DVD LESSON #14
JUST LINES AVAILABLE

Demo 48

Painting an iconic cat
Pages 156-157

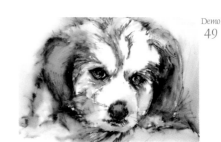

Demo 49

Creating distinctve linear drawings • Page 161

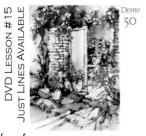

DVD LESSON #15
JUST LINES AVAILABLE

Demo 50

The Elegant Writer® pen creates spontaneous on location paintings Page 162

JUST LINES AVAILABLE

Demo 51

The Elegant Writer® pen creates spontaneous on location paintings Page 163

DVD LESSON #16
JUST LINES AVAILABLE

Demo 52

Combining the Elegant Writer® pen with tissue paper collage and Caran d'Ache® crayons is a perfect match • Pages 164-165

Demo 53

Watercolor batik on rice paper
Pages 168-169

Demo 54

Painting with food coloring instead of pigment • Pages 170-171

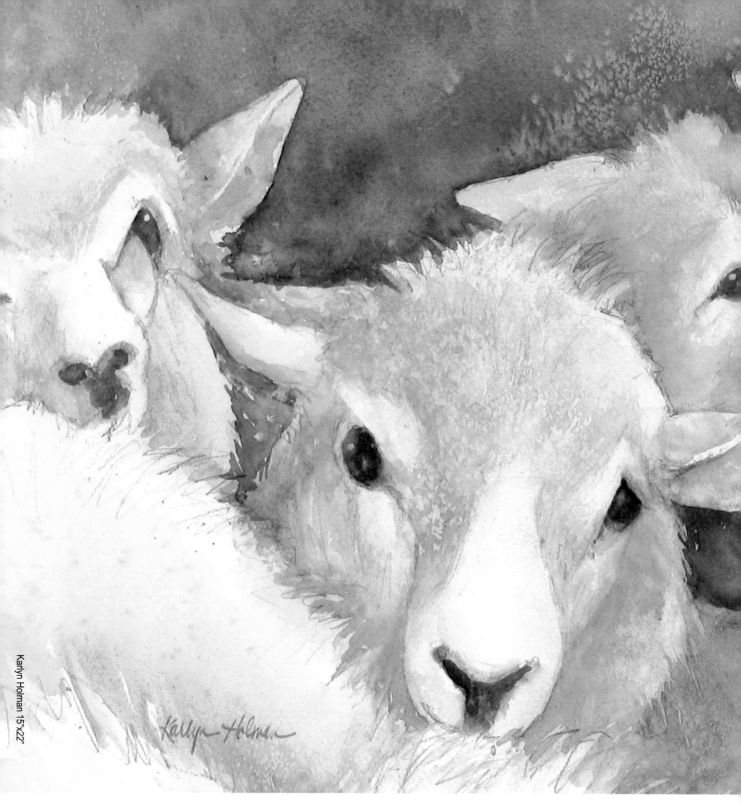

Karlyn Holman 15"x22"

Introduction

Watercolor has traditionally been thought of as a delicate medium and the broad, flexible range of expression that it can offer is often overlooked. This book is designed to help you think of watercolor as an intriguing and accessible medium that combines naturally with mixed media. Watercolor is artist friendly and has gained acceptance as a serious medium, allowing contemporary painters to express themselves in realism as well as in more expressive styles. The lessons in this book focus on these compatible qualities, allowing you to experiment and go way beyond traditional approaches and venture into a whole new world of possibilities.

Watercolor can be a difficult medium, but provides a true

challenge for those who are willing to take risks. If you are new to watercolor, you will soon discover it can be a challenge to control. Believe it or not, that is the exciting part. Unlike many other media, watercolor offers you a sense of immediacy, yet retains a sense of mystery. Be willing to give up some control, let the painting take on a life of its own and paint without boundaries.

Some practical suggestions

Brushes: Good brushes are indispensible and many are not that expensive. I have my own line of signature brushes available for purchase (page 175). My brushes are synthetic. I like the stiffness and the way you can control an edge with a synthetic brush. Natural fibers like sable are great for direct painting, but are unsuitable for losing edges. So much of my painting style depends on putting the color down and then losing an edge while actually lifting the color, so that is why synthetic brushes are the best choice for me.

Paper: One of the most critical decisions you will make is your choice of paper. The kind and quality of paper, as well as the softness, brightness, sizing and texture are all really important choices. Paint does not sit on top of the paper; it literally soaks into the surface. My preference is Arches® bright white, 140# cold press paper. This high quality, acid free paper allows the paint to soak in and become one with the paper. As you apply successive layers of color, the color soaked into the paper remains stable. You can still lift the color with a stiff damp brush but, in general, you can continue to layer color over color and the preceding colors will not reactivate. Watercolor paper comes in three surfaces, I use both hot press and cold press but I am not a fan of the rough surface. Always try to paint on the front of your paper. Look for the watermark and if you can read it, you are on the proper side of the paper.

I use only a few Oriental papers, mainly 10-gram Thai white unryu, Ogura and Ginwashi. Unryu is a beautiful, lightweight archival paper that is highly fibered and has many uses. I use it mostly for collage because it absorbs the watercolor when I place it into a wet wash. The white paper showcases elegant colors. I prefer to color white paper with high quality watercolors rather than purchasing paper pre-dyed. You never know the archival quality of these colors.

You can also glue Oriental papers over a finished painting. I use this technique when I am not entirely happy with a painting in the hope that it will magically transform the painting into a masterpiece. I also use lightweight tissue paper that I stain with my watercolors. I never use toned tissue paper; it is not archival and the color can bleed when wet.

How to cut your paper: Cutting your paper to fit standard sizes is a practical idea. Framing your successful paintings in standard sizes will save you a lot of overhead cost. A full sheet of imperial-sized paper is 22" by 30". The most obvious ways to cut your paper are listed below.

Half sheet. This size is 15" by 22". When framing a painting, artists usually use a 22" by 28" mat size which means you lose a full inch of your painting, resulting in a final painting size of 15" by 21".

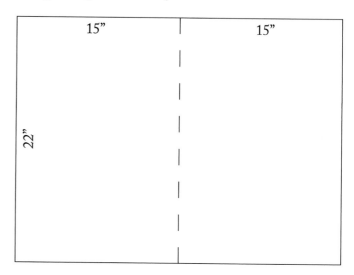

Quarter sheet. This is 11" by 15". This size is usually framed into a 16" by 20" standard mat. This is a great size for painting on location because you have plenty of time to finish on site and usually do not need to finish your painting in the studio.

Thirds: This long horizontal or tall vertically shaped paper is a lot of fun to paint. By cutting the paper into three equal 10" sized shapes, there is no waste. This 10" by 22" size frames into an 18" by 30" mat.

Squares: Squares are a popular shape and these equally sized shapes are a challenge to work with. When you cut an imperial-sized paper in half, you can create two 15" squares. The small piece left over is also a long vertical shape of 7" by 15".

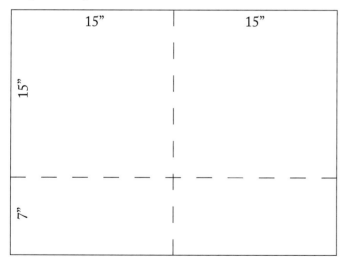

You may also cut a third of the paper and then make the remaining size into a 20" square.

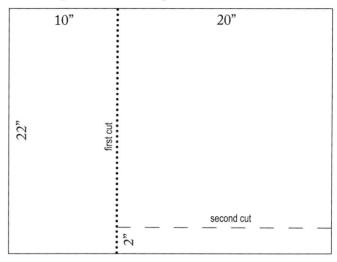

A practical way to get six 10" squares is to cut the paper like this.

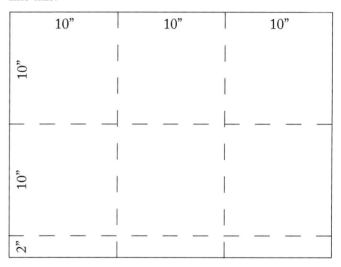

Another choice would be to cut three 10" squares and two 12" squares as shown below.

To stretch or not to stretch the paper: That is the big question. I usually do not stretch the paper because the process of soaking the paper removes so much of the surface sizing. I love to start my paintings with a wet into wet start, so having the sizing intact is very important. When you wet the paper, you activate this sizing which allows your paint to float around longer on the surface. As the paper dries, the colors soak into the surface and cannot be moved around or lifted. This playtime is critical for a successful under painting.

Palette: I believe in simplifying your choices of colors. A limited palette gives me confidence that there will be consistency in my paintings. Portability is important to me because I teach on location and at workshops all over the world. The palette of colors I use in my studio is the same one I use *en plein air*.

Colors: I like my color wells filled to the top with dry paint and arranged like a color wheel. This means I do the research about which colors I want and then place them in their perfect spot on the color wheel. I tend to choose transparent, artist quality and basically primary colors in a variety of values. Transparent paint reflects the light differently than opaque paint. When you use successive layers of transparent paint, the light passes through the color all the way to the white paper beneath. This reflecting light bouncing off the paper seems to create an inner glow that opaque paint cannot achieve. You can accomplish more depth and clarity when you layer transparent paint. Although opaque paint covers what is under it, I still love opacity and often choose to add this unique look to many of my paintings.

Painting grounds: The controversy over painting grounds and the definition of "watercolor" are hot issues. Various exhibitions are trying to clarify exactly what is eligible for entry. Always read the fine print before entering an exhibition because some are all-inclusive and others are very limited in scope. When entering shows, always read the prospectus carefully. My definition is all-inclusive; when you add water to color, you have watercolor. I debated calling this book "Water-media, Without Boundaries" and decided I like watercolor better. So enjoy whatever works and paint for your own enjoyment and expression. Actually, finding your unique style should be your first objective and entering shows will follow.

This mixed media painting was finished by veiling a blend of water and gesso to soften some areas. The veil of slightly transparent white paint added over color simplified the busy areas and created more interest in the focal area.

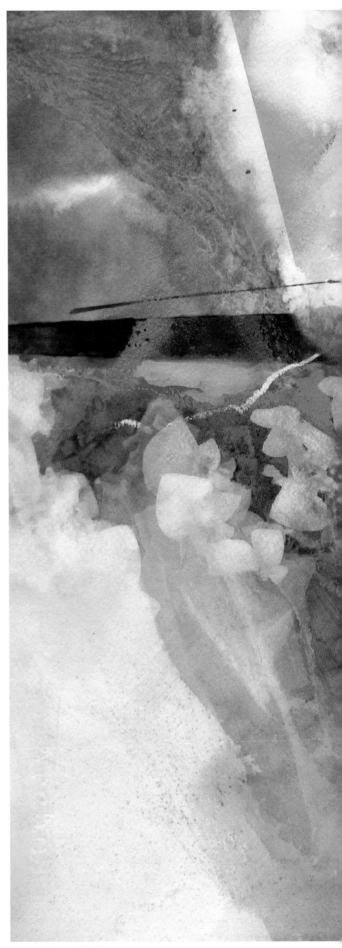

Karlyn Holman 15"x22"

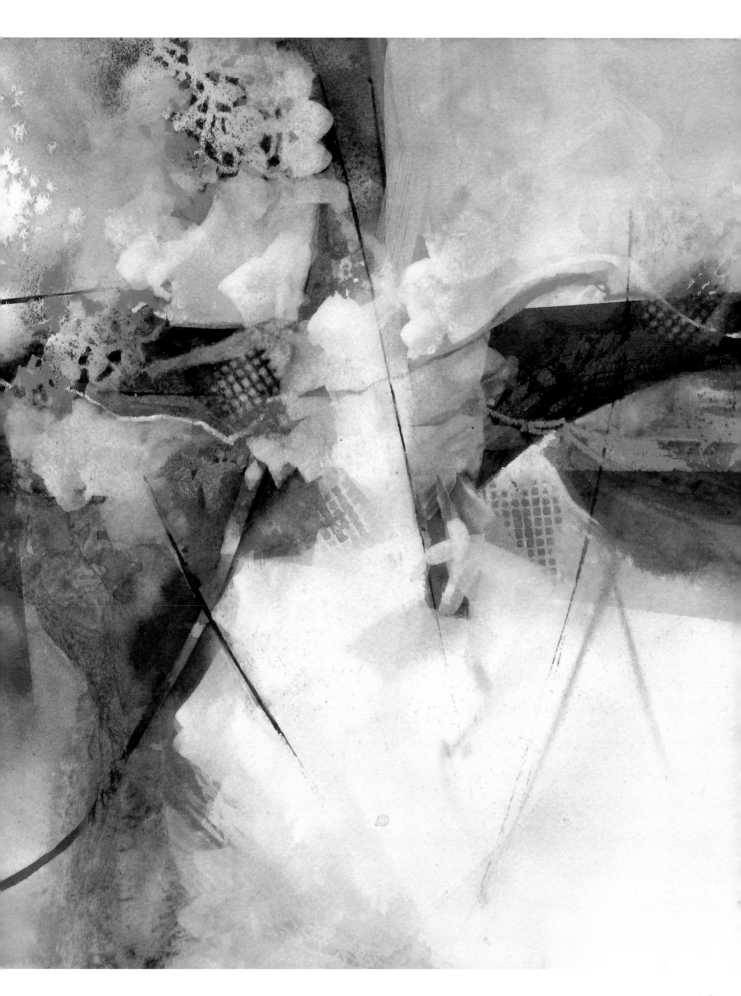

Getting started in landscape

Always remember that your creative process should be fun. Give yourself time to paint and play and explore. Somewhere there is an ideal place where the joy of painting and the creative process merge into an exciting venture. These lessons are designed to help you get started and enable you to come up with your own original variations. The lessons start with traditional styles of painting and then move on in more experimental directions and begin to explore non-traditional approaches.

This chapter offers compositional guidelines and suggestions you may consider when you begin your landscape. I have used ink drawings in combination with watercolor to make the lessons easier to follow.

Painting landscapes has always intrigued me. First, because landscapes are challenging and second, because I enjoy being able to capture luminosity using transparent paint. The surfaces of rocks, buildings and ground textures are varied and rough; by moving away from traditional techniques, allowing the paint to flow and run, and using unique materials to create textures, you can learn an exciting new way to capture the essence of a landscape. In other words, take advantage of this opportunity to start with freedom and end with control.

Painting landscapes usually involves trying to capture what you see, or in other words, trying to capture the way the light touches your subject. Unfortunately, the weather does not always cooperate and provide us with a sunny day. When you are faced with an extremely flat day or are simply bored with always painting "what you see," try some of the other suggestions in this chapter. Simply paint interesting color directly on the paper and create a "path of light" that focuses on the most interesting part of your painting.

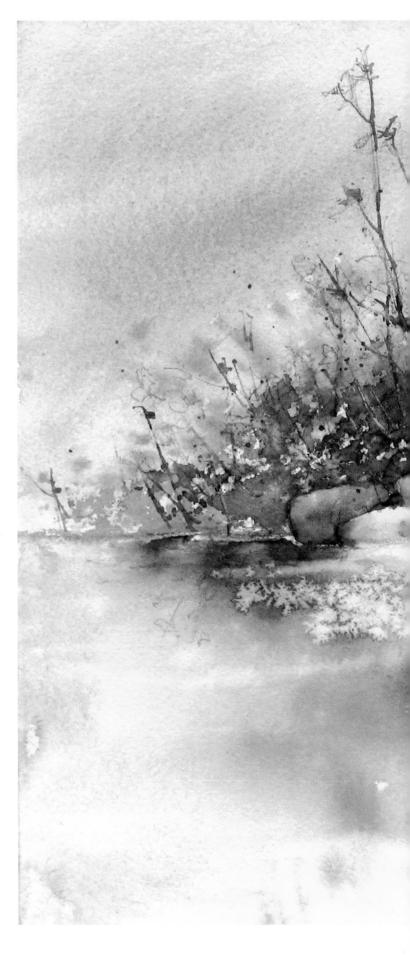

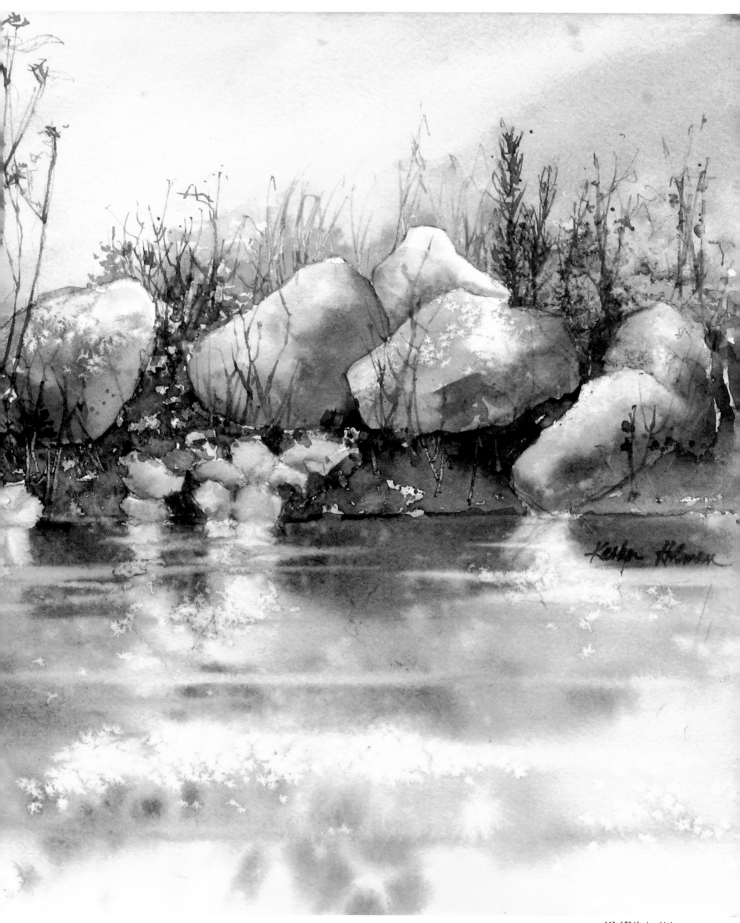

11"x15" Karlyn Holman

Starting and stopping a line for design

I feel it is important to go out and reconnect with nature or actually travel to other cultures to inject added depth into your work. When I am travelling and there is not enough time to sketch or paint, my camera is my best friend. I feel the research and time I spend composing through the camera lens is just as valuable as putting color on paper. A quick click of the shutter can result in an entirely new idea or direction. The following suggestions may be helpful when designing your compositions:

Begin to see yourself as an illusionist using line to create engaging interpretations.

Doors and windows are wonderful subjects for a focal area. When drawing the bricks and stones around a door, think of the stones as positive shapes and the mortar as negative shapes and carefully use line to create a sense of movement. Creating this sense of movement is a key factor in the success of your interpretation. Stay away from static lines and learn to use diagonal and broken lines. Try to connect these lines of movement throughout your composition. Do not draw all the shapes and details, only enough to suggest the story. This very selective use of line will create more interest and say more with less.

Karlyn Holman

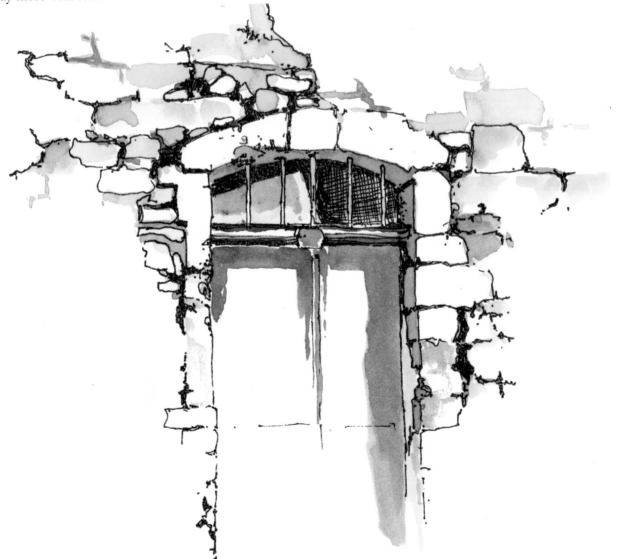

Straight lines point and may lead the viewer too quickly to the focal area, while non-linear objects can be used as stepping stones of color and shape that zig zag and gradually lead the viewer into the focal area.

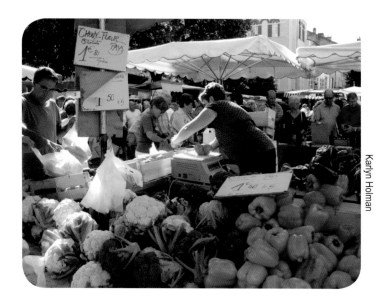

In this market scene in Southern France, by placing the cauliflower and peppers in the foreground, I was able to keep the viewer from moving too quickly to the focal area. You should always consider the need to entertain your viewer on the way to the center of interest.

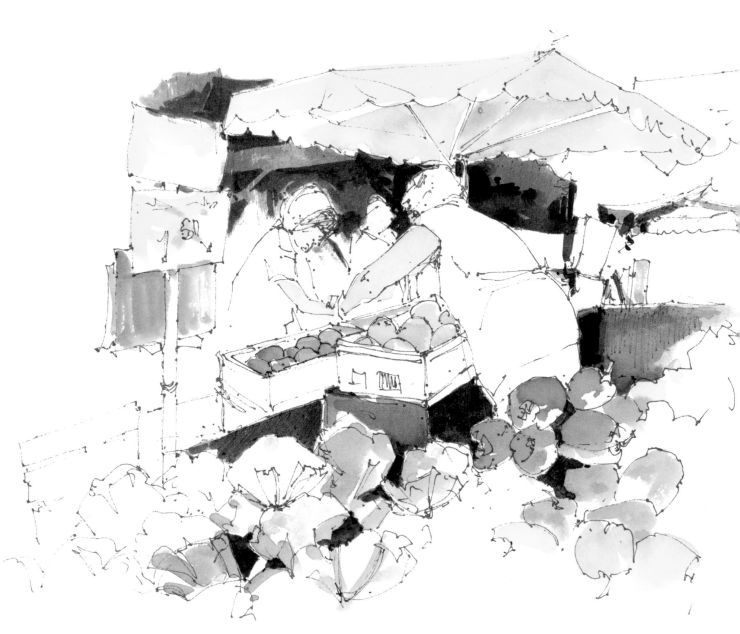

Using stairs to lead the viewer into your composition

As you use line to capture the movement in the stairs, always stop and start the line. Break it up with mortar lines or foliage and avoid making any perfectly straight lines. The mortar shapes connect to enhance the feeling of movement from one stair to another.

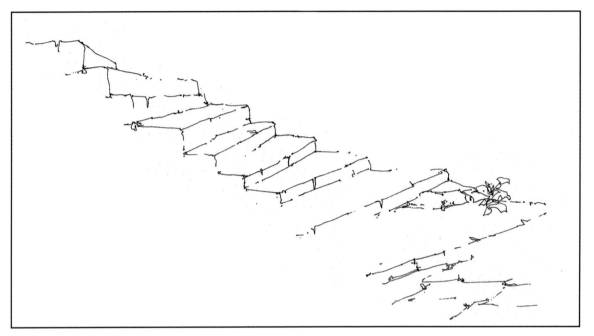

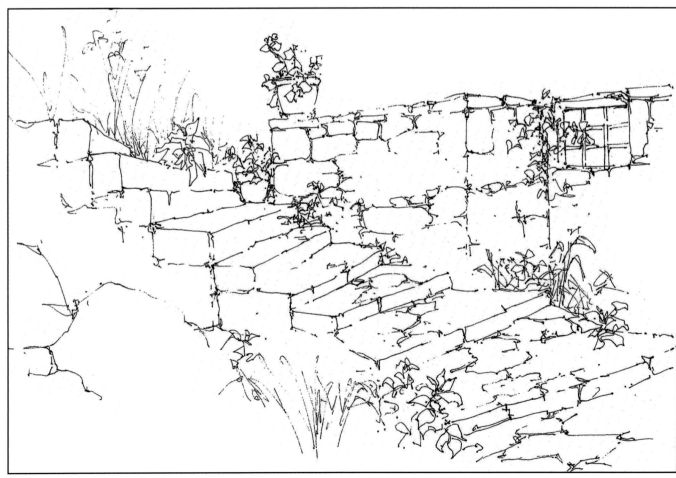

Do not be a slave to a literal interpretation

Roofs can be a very complex subject. Trying to draw a tile roof can be so labor intensive that you feel like you are building the roof one tile at a time. By analyzing the major directional movement, you can suggest a sense of artistic design and rhythm. Do not draw every tile; draw only enough tiles to suggest the subject. Draw more tile shapes close to the focal area and fewer and fewer as you move toward the edges of your paper. Make every line of movement end at a different length.

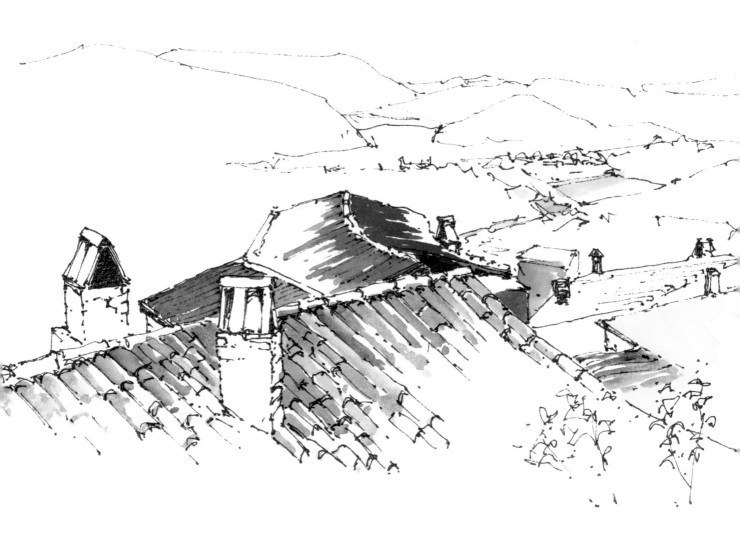

Leading the viewer into the focal area using lines of perspective combined with shadows

Always try to place your most interesting areas where lines of perspective intersect. In a subject like this scene in South West France, there is light bouncing back and forth into the shadows. To accomplish this look, add the color of the subject to the wet shadow area and

the color will glow through the grays. Cobblestones, stone walls, roadways, gates or any kind of entrance are perfect subjects that help create an entrance into your composition.

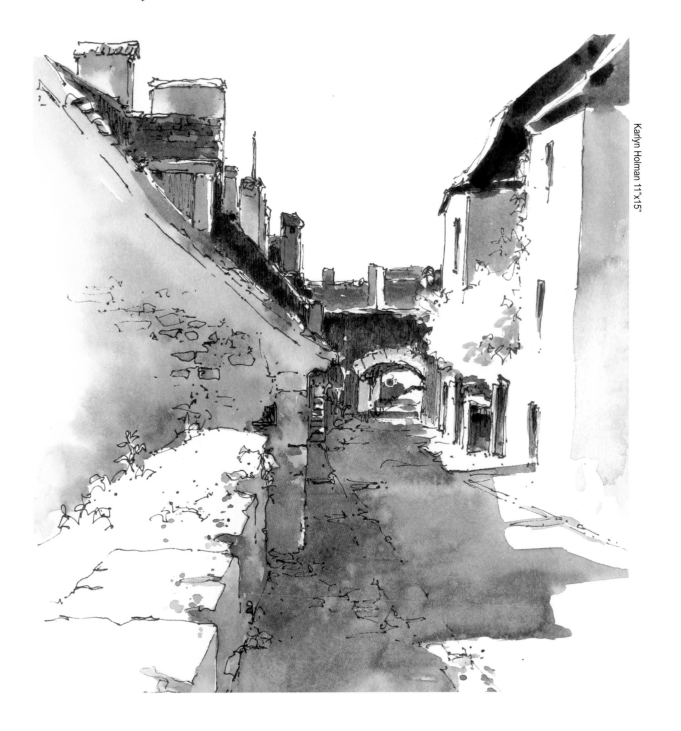

Karlyn Holman 11"x15"

Using dynamic shadows to entertain the viewer

Shadows are crisp, dynamic shapes of color and value that create a counter-movement to the vertical and horizontal shapes of the subject. When you draw your subject with a pen, sketch the physical objects only. Do not draw the atmospheric background subjects or shadows. These illusive shadows will be revealed by the *alla prima*, dynamic energy of the brush.

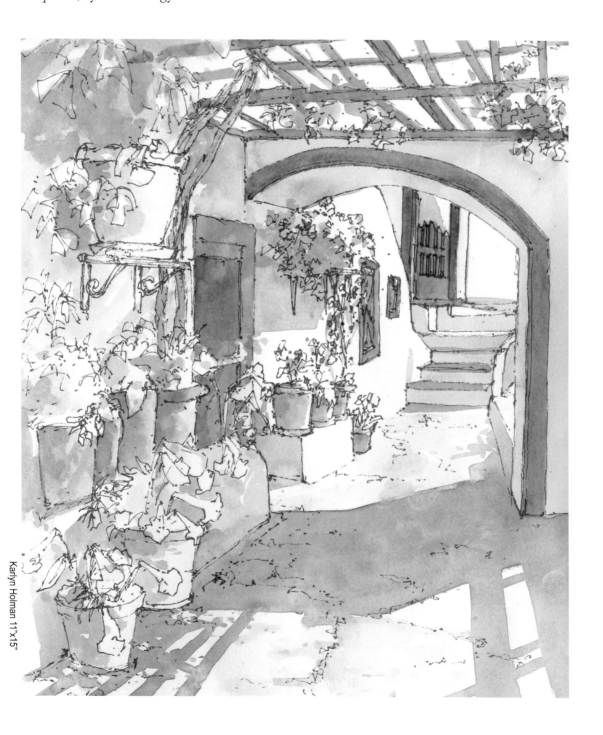

Karlyn Holman 11"x15"

Using foliage—a fantastic way to frame your subject

This typical worker's home in New Zealand is framed with a variety of foliage. If you minimize the detail in your foliage, it is far more effective than drawing every leaf and limb. You can add foliage as shapes of shadows, or shapes of color or shapes of movement. Foliage is the perfect tool for framing your focal area.

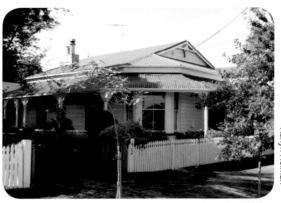

Karlyn Holman

1 This stage shows how I created the shadows on the house by mixing cobalt with a little orange in order to gray down the color. The gray shadows depicting the dappled light on the picket fence was thrown on with an oriental brush.

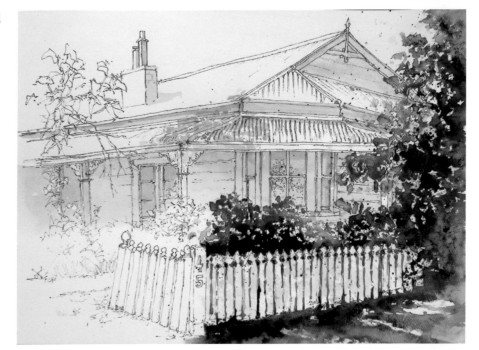

2 At this stage, the foliage on the left is nothing more than a dark suggestion of the actual tree. The foliage on the right is in full sunlight with vibrant yellows and greens. The foliage around the picket fence was thrown and then negatively painted around the fence. The foliage was created using Winsor yellow, quinacridone gold and Antwerp blue. quinacridone burnt orange was added at the end to warm up the foliage (page 146-149).

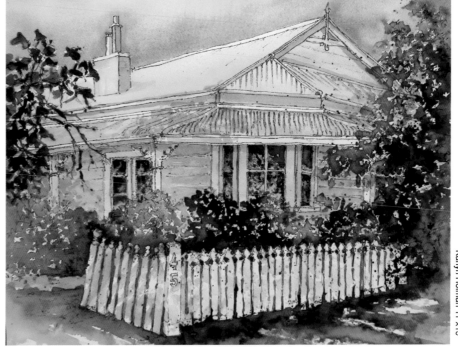

Karlyn Holman 11"x15"

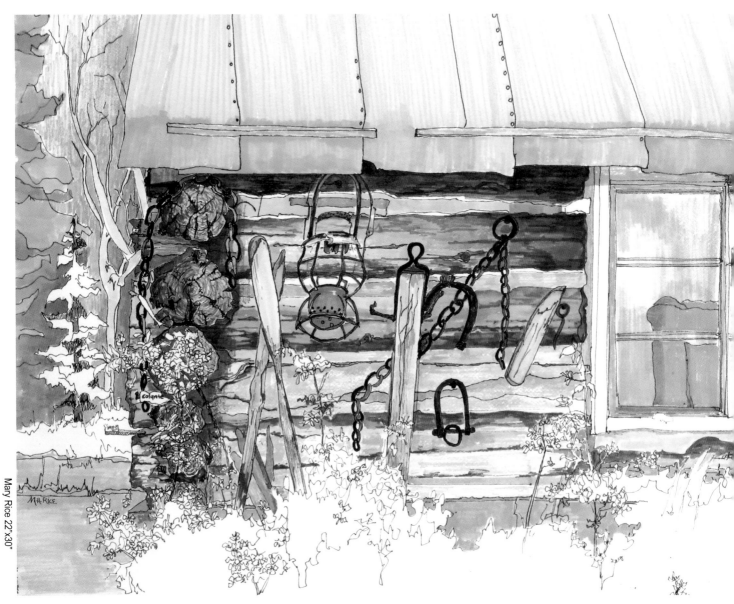

This lovely drawing by Mary Rice immediately draws
you into a beautiful wall of memories. She accomplished
this by minimizing the detail in the roof and by merely
outlining the foliage, thus forming an effective frame
around the focal area.

Learning to edit your composition is an essential step for success

Editing your painting will result in a much stronger composition. Whenever I paint on location, I always begin composing my piece by looking through my camera viewfinder. This step helps me make critical decisions such as whether to use a horizontal versus a vertical format, or a panoramic versus a close-focus view point. By choosing only the elements you like, exaggerating some parts and actually eliminating others, you will make your composition much more interesting.

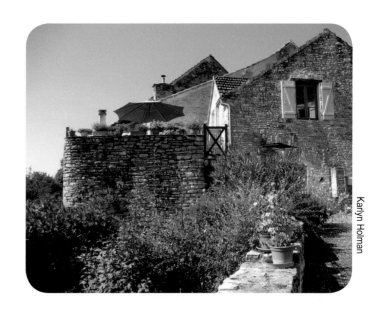

Karlyn Holman

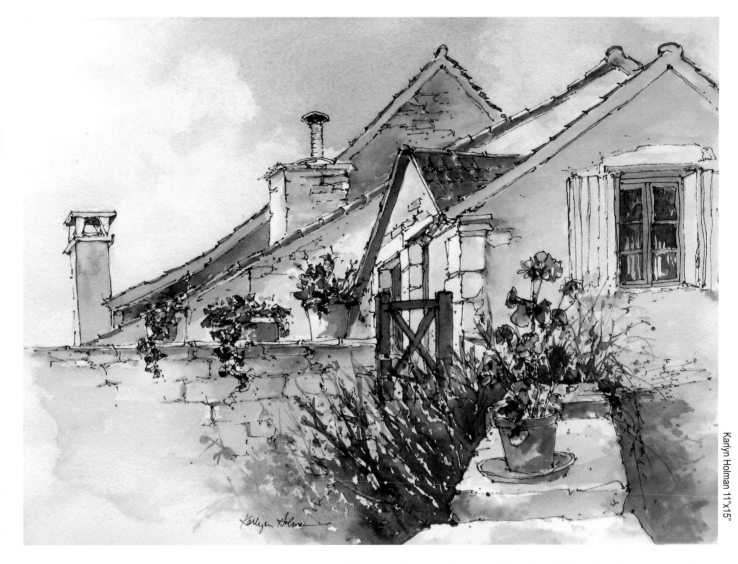

Karlyn Holman 11"x15"

This painting was improved by simplifying the sky, exaggerating the chimneys, eliminating many of the flowerpots and the umbrella and minimizing the foliage.

Editing is such a freeing experience. Use your artistic license and eliminate all the non-essential details. I had no interest in painting all the chairs and tables in the restaurant behind the boats, so I simply took elements from the background and made up some dark shapes to complement the white boats. The objects on the dock were added to overlap with the background. The size of these objects was exaggerated purely for entertainment value.

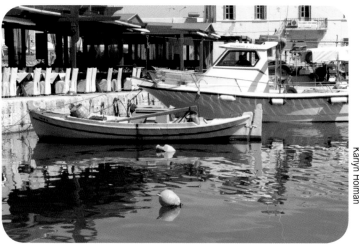

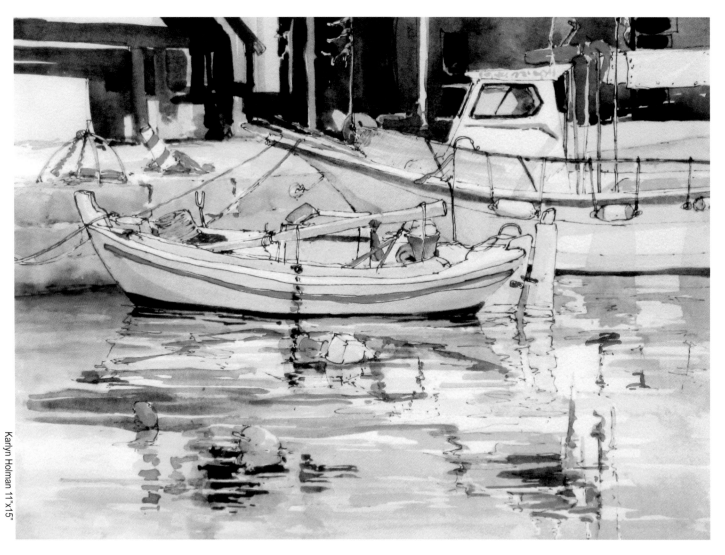

While painting this subject in Crete, Greece at an ocean-side restaurant with my students, I accidently dropped my watercolor palette into the ocean. Thanks to our waiter and a tall artist named Connie, the palette was retrieved as it was tumbling into the depths. After my palette was rescued, this painting was completed with an *alla prima* style of direct painting. The light was perfect and the subject so inviting that the traditional approach was a perfect choice for the day. The color of the subject was simply mixed and applied to the composition. The constantly moving boats in the water kept changing the dynamics of my composition and called for an *alla prima* or "just go for it" approach.

Choosing the colors you want to emphasize in your focal area

Complementary colors

Complementary colors provide the greatest contrast because they share no common color. For example, if you take a primary color, its complement will be composed of the other two primaries. All complements are made up of both a primary color and a secondary color.

Complements have two effects: in this painting, used side by side, they create a visually exciting vibration. The complements used in the Český Krumlov painting on the next page are mixed together to create neutrals, but are also placed side by side to accentuate the focal area.

In this abstract painting, the blue background is the pure primary, derived from nature or man-made in a laboratory and the orange is a secondary color created by blending the primary colors of red and yellow.

There are no right or wrong choices regarding color. Choose colors that will best set the stage for the emotional feeling you want to evoke

Karlyn Holman 7 1/2"x11"

Mixing complements creates neutrals

This subject was painted on location in Český Krumlov, Czech Republic. The windows, flags and people were the only areas of the composition I elected to paint. I chose only complementary colors and placed them in a very small section of the painting. By selectively painting only certain elements and downplaying the rest of the composition, you can create a well-defined focal area with very little effort.

Karlyn Holman

Phthalo green and alizarin crimson are complementary colors that create a full range of values because each color has strong tinting power. These colors are opposite one another on the color wheel. In their pure form, they create exciting tension, but when mixed together, they can produce a full range of grays to black. The flags were painted green and the windows were painted in harmonic variations of red to draw attention to them. The mixed red and green was used in the sky and on tonal washes connecting to the edges of the paper.

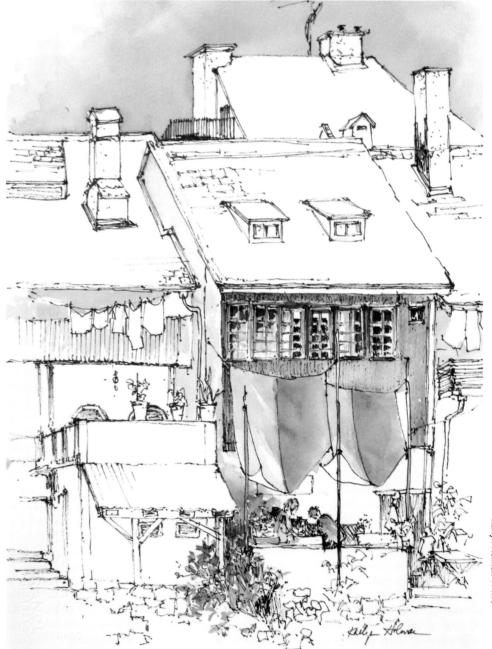

Karlyn Holman 11"x15"

One color

Try using only one color in a painting as a way of accentuating your underlying drawing.

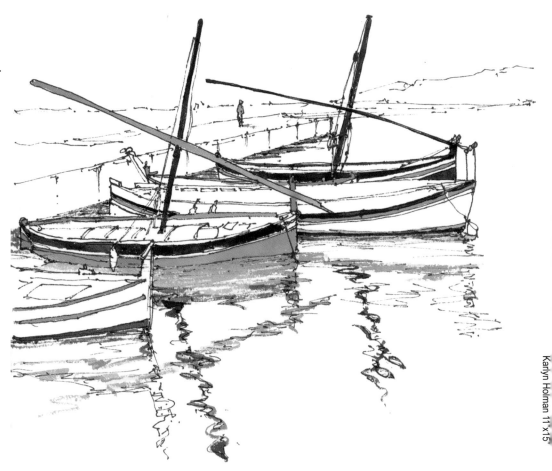

Karlyn Holman 11"x15"

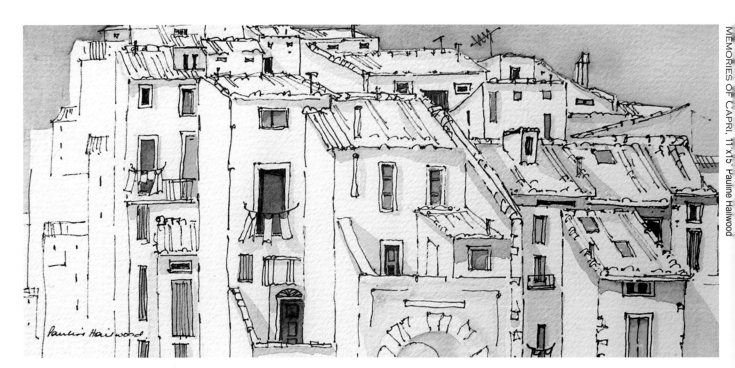

MEMORIES OF CAPRI, 11 x15 Pauline Hailwood

This painting, conceived on location in Capri, Italy by Pauline Hailwood, focuses on the blues and blue-greens in the windows. Her elegant presentation effectively evokes the atmosphere and spirit of the Mediterranean.

Harmonic colors

This painting is made up of harmonic colors—colors that are adjacent to each other on the color wheel. Harmonic colors evoke soothing and gentle emotions in the viewer. Friendly colors do not clash—they always get along. Use your own intuition to choose colors that feel right to you.

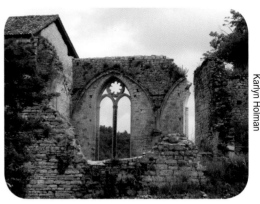

Karlyn Holman

1 These lovely ruins were drawn on location in Abbaye Nouvelle, France with a STAEDTLER® Lumocolor® permanent pen, #313-7 in a sepia tone.

2 The underpainting was painted on dry paper using the harmonic colors cobalt blue and permanent magenta to capture the cast shadows (page 34-35).

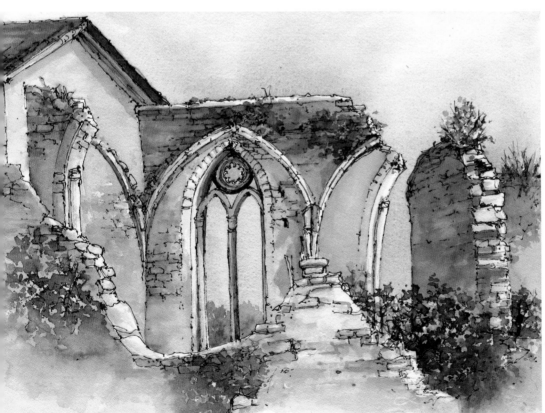

3 A range of harmonic warm colors from raw sienna, quinacridone gold and quinacridone burnt orange applied over the blue and magenta underpainting made the interpretation of the ruins glow. The use of manganese blue in the sky and the addition of some foliage completed the painting.

Karlyn Holman 11"x15"

Starting with a range of values

Neutrals are generally grays, blacks and whites. Grays can be warm or cool, or dark or light. In watercolor, mixing any complements together will create lovely grays. These monochromatic paintings are very striking, even though they are created by using neutrals. Painting with a wide range of blacks or neutrals can be a very freeing experience. It almost forces you to concentrate on only the design element of value. My early training in abstract expressionism taught me a great appreciation for paintings with strong tonal contrast and drama and paintings with large portions of white space.

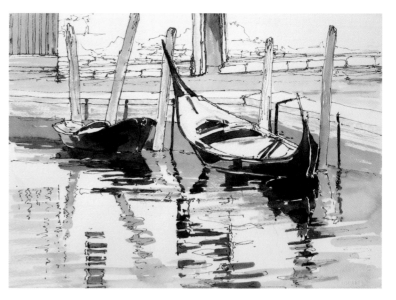

1 While painting on location in Venice, I found this site out of the sun. The reflections and gondola had such strong value contrast, I decided to paint the subject in values of black, white and grays first. I used alizarin crimson and phthalo green to make the black and grays. Both of these colors have strong tinting powers and are transparent.

2 Later, I added the dynamic blue of the gondola and the reflections.

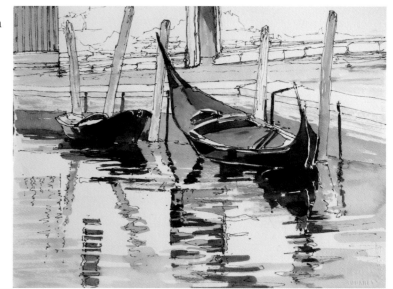

3 I almost did not add any further color but decided the complementary oranges would create interesting contrast in the final interpretation.

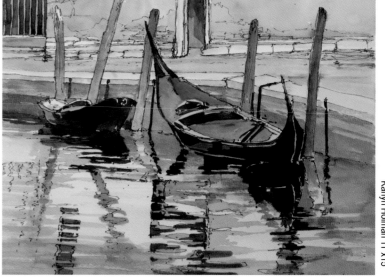

Karlyn Holman 11"x15"

Value is so important to incorporate into your painting while painting *en plein air*. I usually start by painting the cast shadows in the cool colors of permanent magenta and cobalt blue. When the underpainting dries, I layer warm colors over it to combine into colorful grays. As I sat on this street in Veliko Turnover, Bulgaria, I suddenly saw the scene as black and white. This feeling inspired me to mix phthalo green and alizarin crimson into a black. Using water to dilute this mixture into grays, I placed warm and cool values on my drawing to create the blacks and grays. This very quickly pulled my sketch into a full-value painting. When these values dried, I added the accent colors.

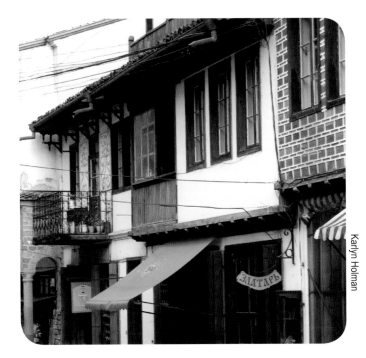

Karlyn Holman

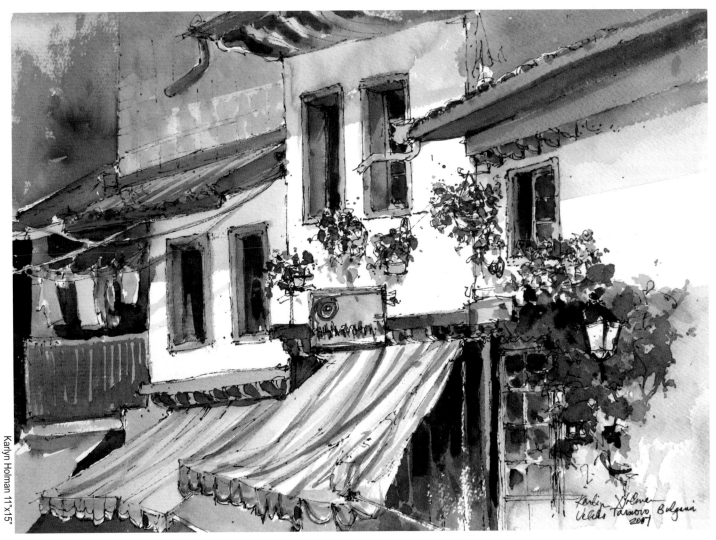

Karlyn Holman 11"x15"

33

Layering color—a roadmap for success

Now that you have been given a basic introduction to help you compose your subject, let's move on to actually painting your composition. First, I will show you a traditional approach, and then together, we will explore a non-traditional start. The lovely cast shadows in this scene are fleeting. In order to capture the essence of these shadows, focus only on painting the cast shadows and layering the warm colors over later. While walking throughout the small 2,500 year old hill town village of Civita di Bagnoregio, the light touching this doorway and the dancing shadows from the foliage drew me into this scene. The drama of this ordinary subject sparked a passion and energy in me to get out my paints and begin painting.

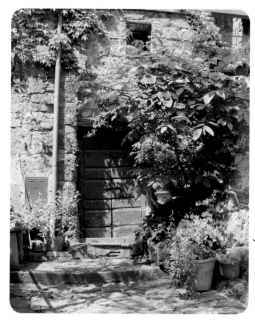

Karlyn Holman

Layering color over color on dry paper is a traditional and very effective approach to beginning your artwork. Layering the placement of cast shadows and darks is like creating a roadmap for a successful painting.

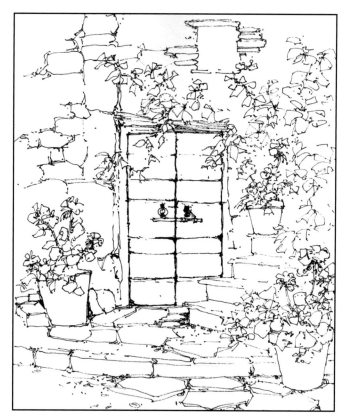

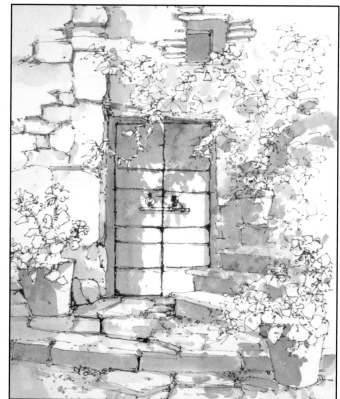

1 When you separate the shadows from the actual color, you can capture "a moment in time" in the most efficient way. In about twenty minutes, you can lock in the excitement and playfulness of these momentary shadows without concern for the actual colors of the scene. You can spontaneously capture the essence and mood of the scene and not have to rely on your memory of the cast shadows or wait for a photo reference. This is truly an *alla prima* experience. If you choose all transparent pigments for the subsequent layers, the previous layers will glow through in the finished painting.

2 When placing the shadows, use cobalt blue in areas that will be orange, use permanent magenta in shadows that will eventually be golden in color and the premixed cobalt blue and orange to form a gray on the stone entrance. In their final interpretation, the blended colors will appear gray. This step shows the cobalt cast shadows on the orange door, the permanent magenta cast shadows on the golden colored wall and the premixed grays on the whitish stone entrance.

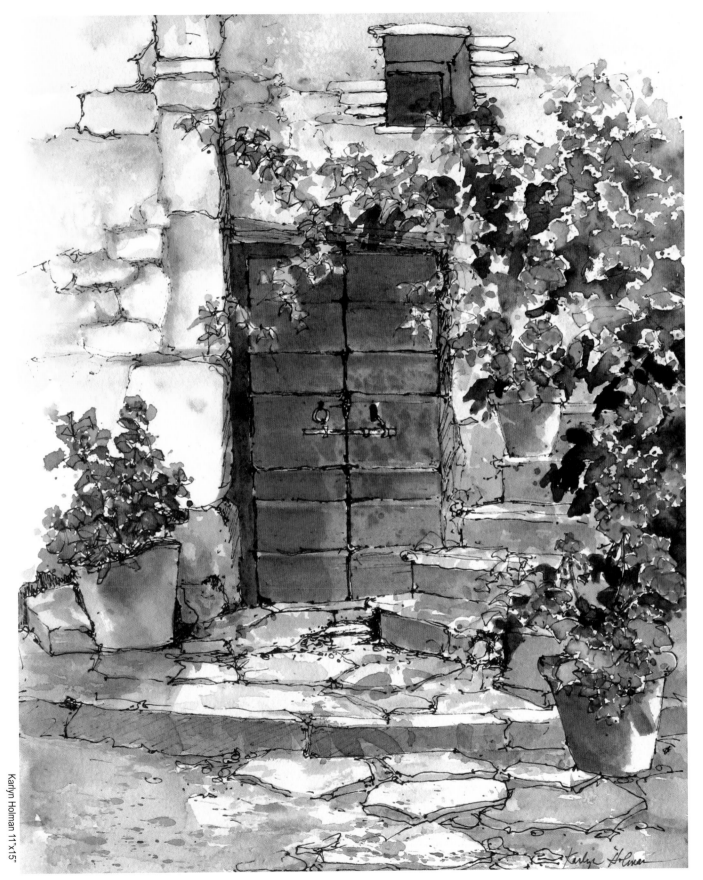

3 The splashy shadows are complete, now layering the warm, transparent colors of raw sienna, quinacridone gold and quinacridone burnt orange is simply fun.

Wet into wet—an exciting way to start a painting

This lovely cafe in a quiet piazza in Venice was a marvelous subject to paint wet into wet. A group of us sat at a nearby restaurant drinking cappuccino in the shade, and as we began to draw the subject with a permanent pen on 140# cold press paper, opportunities arose. A dog wandered in and sat in the foreground and an elderly gentleman came out and watered the flowers. To catch the perfect light, we returned several times and then picked our favorite patterns of shadows.

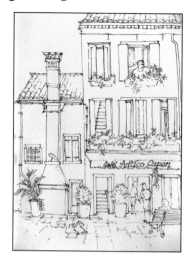

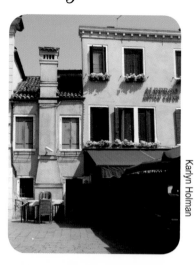

Karlyn Holman

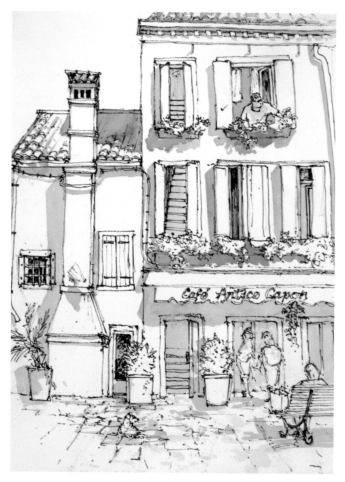

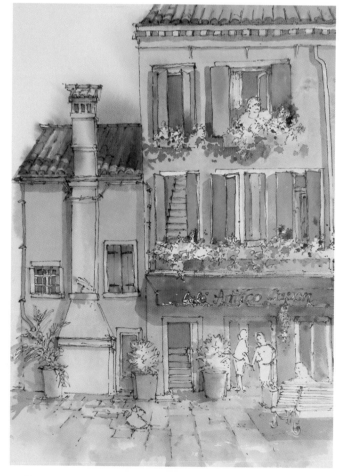

1 After our drawings were completed, we captured the cast shadows on dry paper. Cobalt blue and permanent magenta worked well for this task.

2 Now came the exciting part. Instead of layering color over the cast shadows and working in control on dry paper, it was fun to wet the entire surface and paint the colors onto the slick surface. When working on your painting, remember that the paint will move at its own pace, depending on whether it moves or does not move in water (page 72). Be sure to add a lot of harmonic enrichment and enjoy the excitement of these moving, soft colors that seem to have a life of their own.

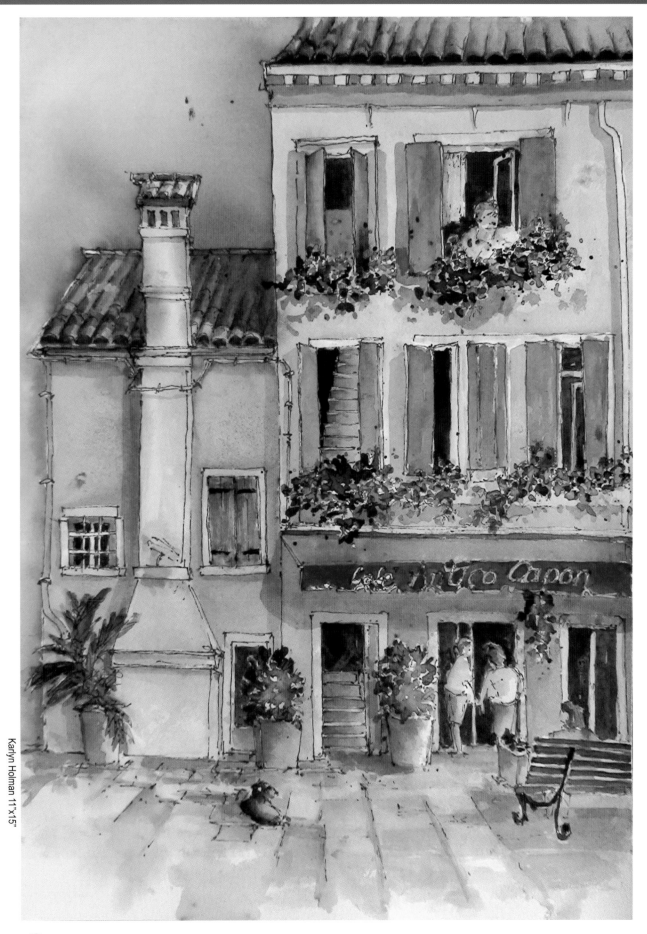

3 The final interpretation usually needs a few more darks and lights painted in control on dry paper. This soft, "watercolor look" is my favorite way to paint on location.

Combining traditional with non-traditional

The little village of St. Cirq Lapopie, France is the subject of the following four demonstrations. I used a sepia tone STAEDTLER® Lumocolor® permanent pen #313-7 to draw the scene. Do not draw any outlines of the atmospheric distance with your pen; simply paint this area with soft color lost edges to capture the atmospheric feeling.

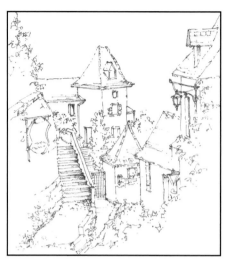

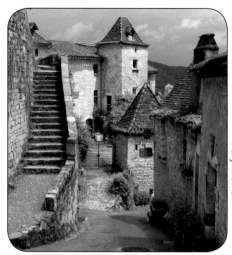

Karlyn Holman

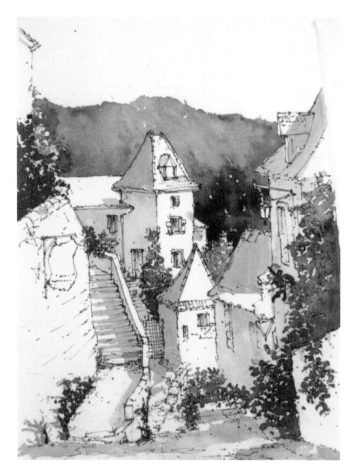

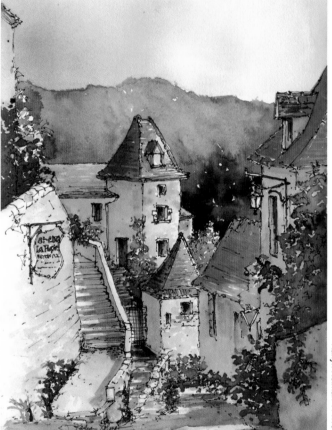

Karlyn Holman 11"x15"

1 The first interpretation of this scene was accomplished using the traditional, layered method of capturing the light on the subject by painting in cobalt and permanent magenta on dry paper (pages 34-35). This approach is not difficult, yet requires a great deal of control because you are working almost entirely on dry paper. This step shows the cast shadows and the freely tossed foliage (pages 148-149).

2 After this layer dries, you can add as many layers as you want of the warm colors over the top. The warm colors over the cool create beautiful neutralized grays. Try to save some actual whites of the paper in your final interpretation.

Inventing a "path of light" on wet paper

The next approach is done on wet paper. The nature of watercolor is fluid and this technique really illustrates the serendipitous nature of using a wet beginning to give your finished works a fresh and spontaneous look.

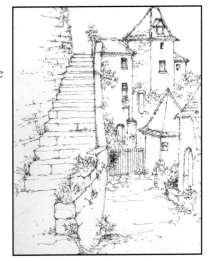

1 This illustration shows the wet underpainting revealing a "path of light" in the focal area. The warm colors of raw sienna, quinacridone gold and quinacridone burnt orange and the cool color of cobalt blue were used in this underpainting. Color sanding was added while the paint was wet.

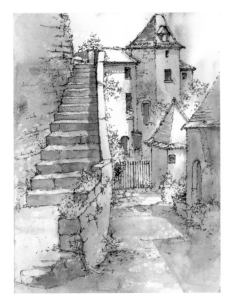

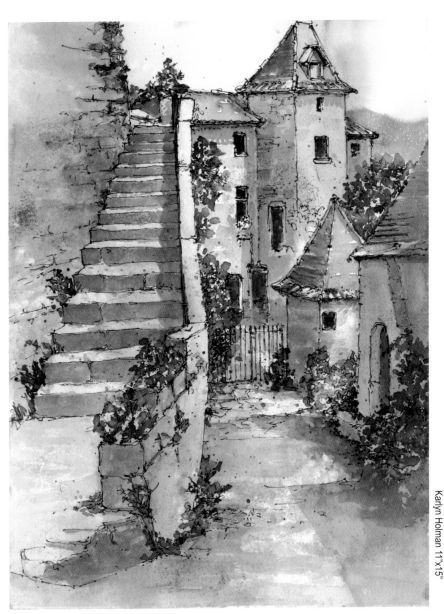

Karlyn Holman 11"x15"

2 The traditional approach of layering cobalt blue and permanent magenta on dry paper was used to capture the shadows (pages 34-35).

3 The painting was completed by adding the foliage and the final layering of complementary colors to create varying warm and cool grays.

Inventing a "path of light" on dry paper

1 To paint the same scene, I walked down the hill to change the perspective. This time the underpainting was freely painted on dry paper using quinacridone gold, quinacridone burnt orange and cobalt blue, leaving a "path of light" through the focal area.

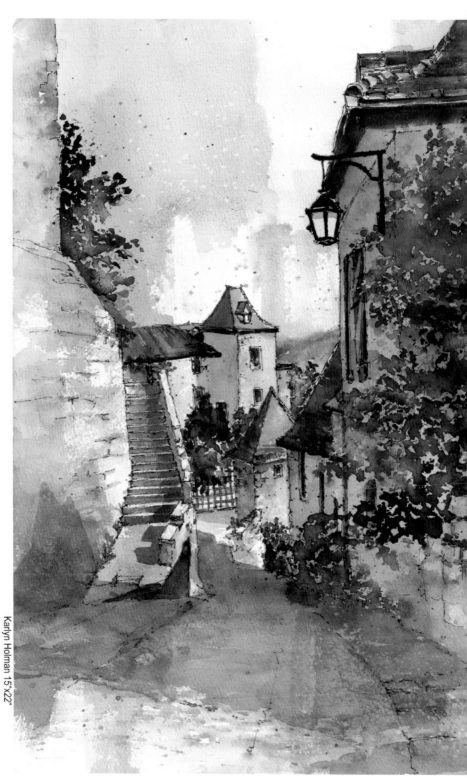

Karlyn Holman 15"x22"

2 When the underpainting dried, the shadows were interpreted using varying mixtures of cobalt blue and permanent magenta (pages 34-35). The foliage was thrown onto the dry surface using an oriental brush.

3 The warm stone colors were layered over the shadows and the suggestion of distant hills was added. The finished painting uses elements of the light pattern but now can take on a life of its own.

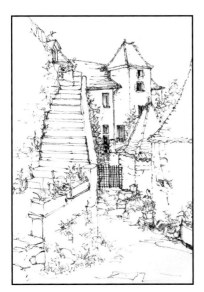

This drawing was drawn on location using the Elegant Writer® pen (pages 160-165).

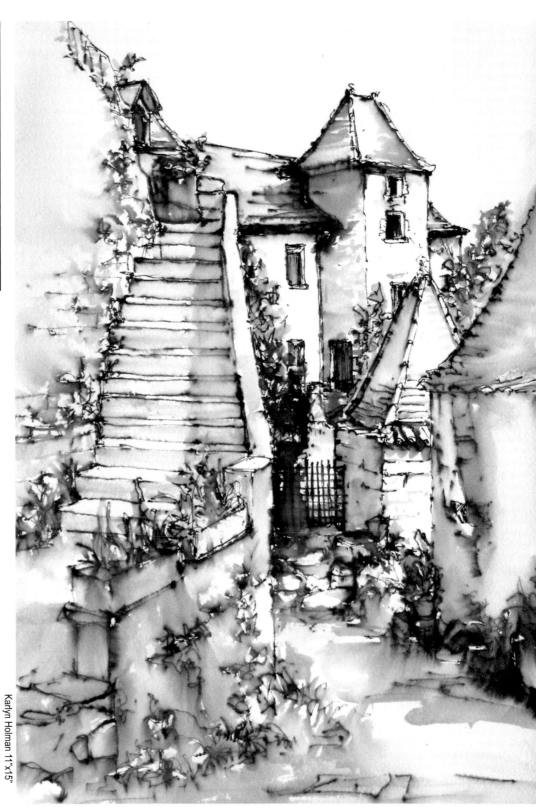

Karlyn Holman 11"x15"

This image shows the values created by using a round brush to add water to activate the lines and create a dynamic drawing to which you may also add watercolor (page 163).

Revealing a "path of light" on a wet surface is easy and fun

Our group of on location artists fell in love with the textures and colors on this lovely door in Crete, Greece. After finishing our initial drawings, we waited for the light to come around so we could capture the cast shadows. Realizing there would never be any direct light on our subject, each of us created our own "path of light" as the basis for our paintings. When I teach this lesson in my workshops, I call it "how to paint where the sun don't shine."

The key to success in this style of painting is to determine the focal area and save some lights or whites in the underpainting and link these white or light shapes to the edges of your paper. After you establish this initial "path of light", you can use traditional techniques to finish the painting by studying your subject and adding the darks, lights and actual colors. When you have finished the painting, the light or white shapes you saved in your underpainting will help illuminate the focal area.

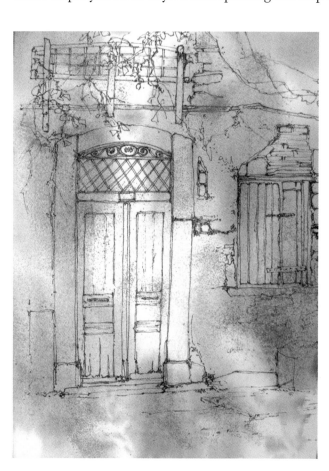

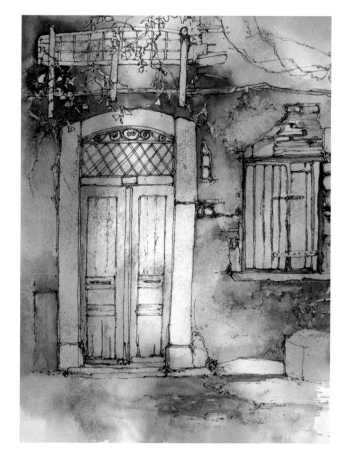

1 To begin, wet both sides of a piece of Arches® 140# cold press paper and place colors wherever you desire. Be playful and develop a spontaneous design motif by focusing light on the actual subject and creating a "path of light" that connects to the edges of the paper. This illustration shows the addition of raw sienna, quinacridone gold and quinacridone burnt orange. Cobalt blue was added near the edges of the paper to gray the colors. While the painting is still wet, try adding texture by color sanding, a perfect technique for adding surface depth to medieval buildings.

2 The next step is to work on a "path of dark" that starts from one edge of the paper and passes through the focal area and touches at least two other edges of the paper. This dark path adds strength and visual interest to your painting.

3 Here is an idea to add variety to your windows if they have bars. Start by painting the bars as positive shapes and then reverse this process by using a dark color to paint the negative shapes behind the bars. Try to avoid beginning the reversal near the center of the window. This technique adds depth and a sense of mystery as to what lies within the building.

4 After you have established the light and dark values, you can finish the painting using traditional methods. Keep in mind that saving more lights on your subject and keeping your brightest brights and darkest darks in the focal area will create the greatest impact.

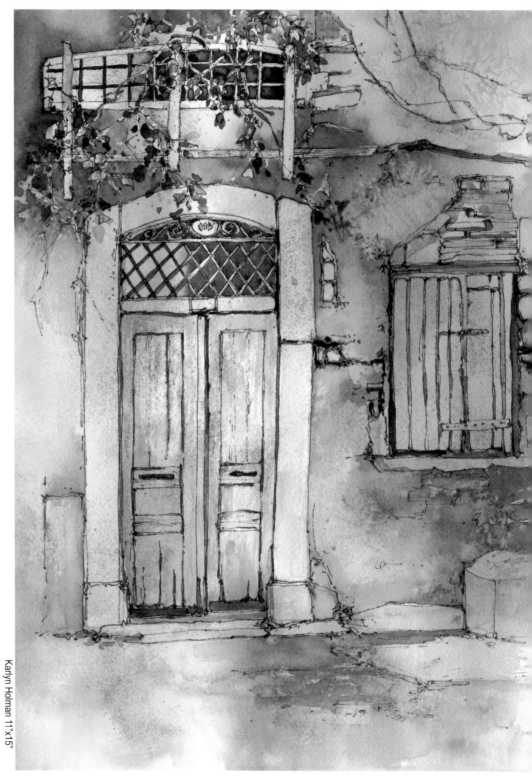

Karlyn Holman 11"x15"

Revealing a "path of light" on a sunny day is also easy and fun

We visited this site in South West France on a beautiful sunny day. I wanted to achieve a more expressive finished painting, so I used the "path of light" approach on wet paper, rather than just painting the colors as I saw them.

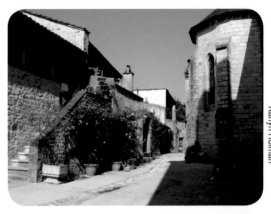

Karlyn Holman

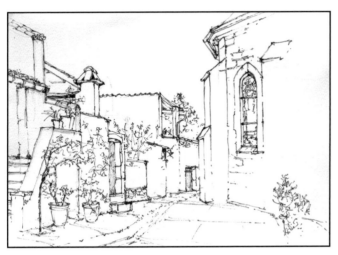

1 First I sat in the shade and sketched this lovely scene with my STAEDTLER® Lumocolor® permanent pen in sepia tone.

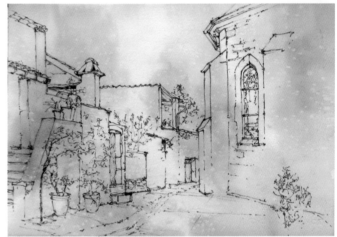

2 I wet the paper and enjoyed the excitement of just floating in any colors, anywhere. I used my favorite palette of raw sienna, quinacridone gold, quinacridone burnt orange and cobalt blue.

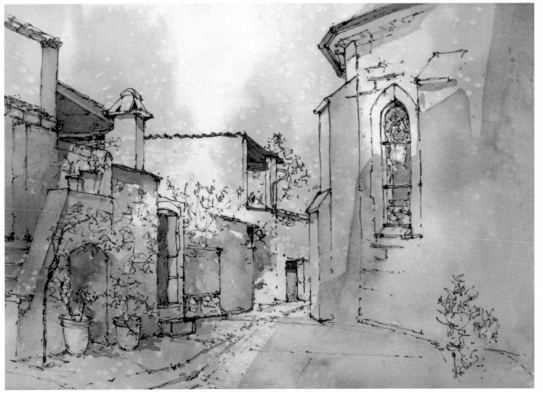

3 This step shows the actual cast shadows painted in a traditional way using cobalt blue and permanent magenta on dry paper (pages 34-35).

4 The foliage was added by throwing on Winsor yellow, quinacridone gold and Antwerp blue paint.

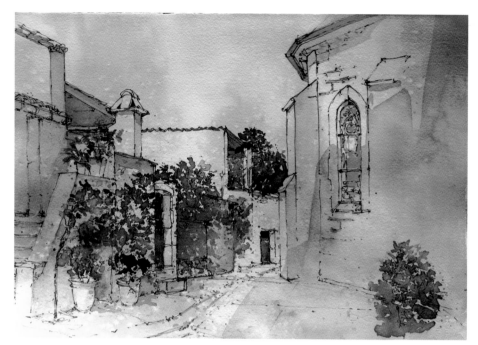

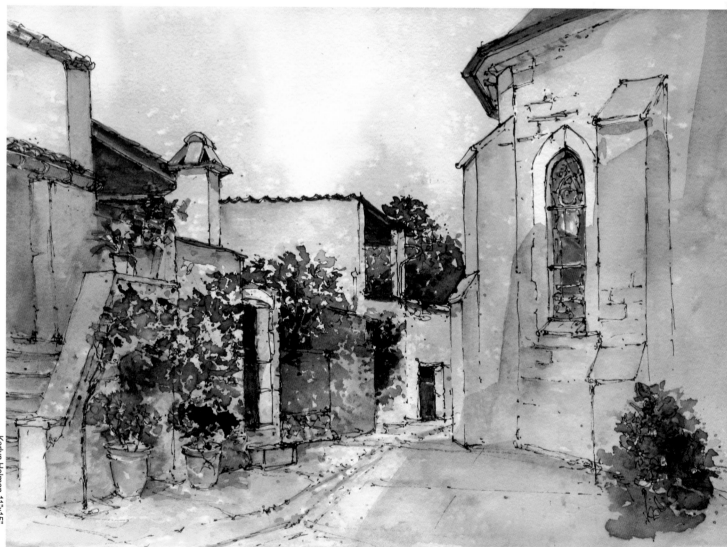

Karlvn Holman 11"x15"

5 The final picture shows additional warm colors added. I decided to not paint the sky blue because I preferred the underpainting colors.

Creating a "path of light" on dry paper— learning to color "outside the lines"

This subject was drawn on location in the Czech Republic. We were not blessed with good light and day after day, we never saw the sun. A lack of cast shadows inspired us to create our own "path of light" in the focal area. We each drew our own subject and then added interesting shapes of color over our drawings. Instead of following the traditional technique of "coloring within the lines", we placed color without regard for the lines and the colored shapes began to take on a life of their own.

Karlyn Holman

1 Again, the secret to success is to save some whites and lights in the focal area to form a "path of light" throughout the painting. This underpainting was created by using a limited palette of colors; namely quinacridone gold, quinacridone coral, alizarin crimson and cobalt blue. The paper was dry when I applied these colors, so I tried to make dry brush effects in the connecting whites. To create a dry brush effect, continue to paint until the paint is almost gone from your brush and you are working with a very limited amount of color. These dry strokes help create sparkling whites in your focal area.

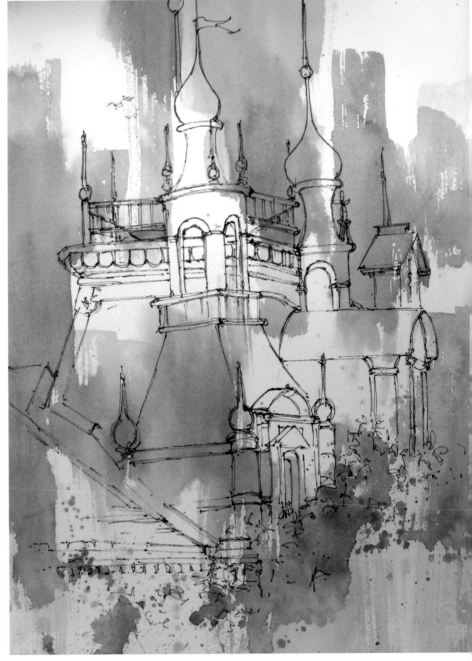

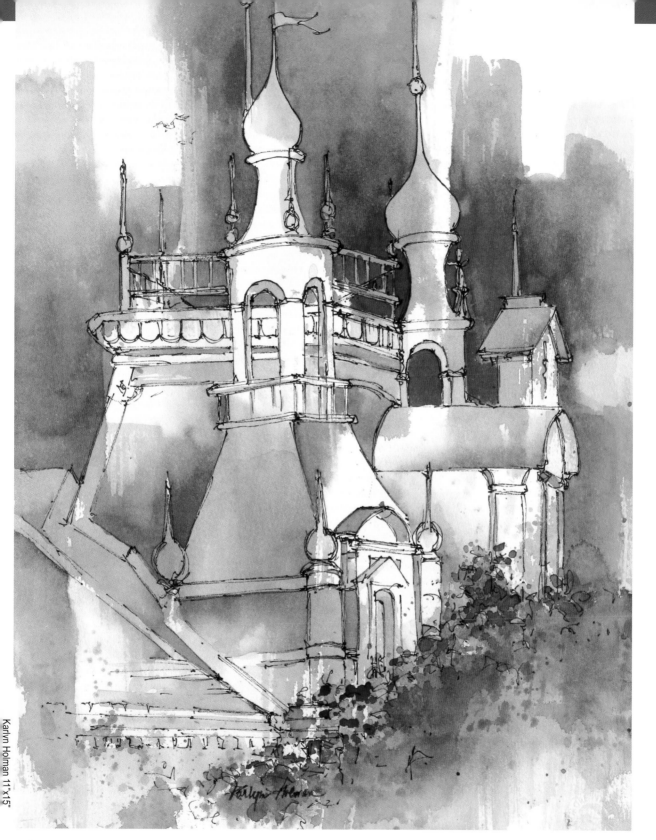

2　Layering more of the same warm and cool colors later on dry paper creates intriguing qualities of luminosity and transparency. You could never achieve this same glow by mixing warm and cool colors on your palette and applying these colors on the dry paper. To finish this painting, I used more intense mixtures of the same colors to emphasize the shapes and textures of the subject. To add more depth to the warm colors, I used alizarin crimson. Mostly negative shapes were used to "pop out" the onion domes of this Eastern European architecture. Some positive areas were painted to add depth and some texture was added in the lower right corner to suggest foliage. This approach to painting allows you to respond emotionally to your subject and frees you to paint what your feel, and not necessarily what you see.

Using shapes of color to reveal a "path of light" on dry paper takes courage

Many artists fall into the trap of trying to make every stroke look realistic. Gather up your courage and try using shapes of color to create an exciting "free" look. Because your natural instinct may be to use a coloring book approach, you may really have to talk yourself into using color with this much abandon.

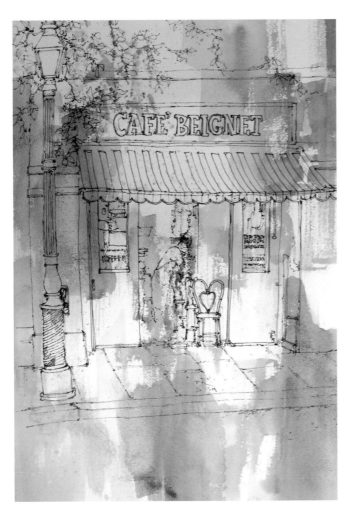

1 This colorful café in New Orleans provided an intriguing subject. On dry paper, I stroked on Winsor yellow, quinacridone gold, quinacridone burnt orange and cobalt blue. As more and more shapes were added, some of the colors began to form soft edges. Sanding in some textures with watercolor pencils while the paint was still wet added texture and surface interest. Let your emotions determine the colors you are going to use and freely splash them onto your drawing. Although this may seem difficult at first, take a chance and experiment. Paint through the shapes, not around the shapes. The key element for success is to use spontaneous shapes of color to frame the "path of light" in the focal part of your painting. Linking these shapes of color to the edges of the paper will lead the viewer into the focal area. This "shape separate from the line" theory is only a beginning. You can be neat and tidy later, but right now, only think about preserving the "path of light."

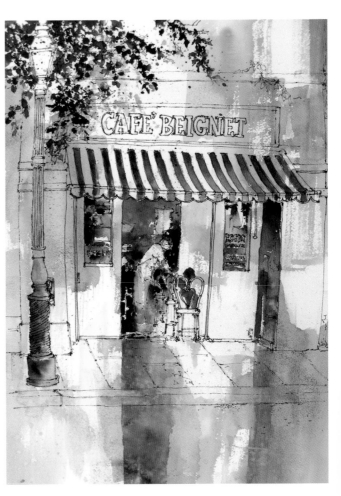

2 You can now give yourself permission to add some carefully chosen touches of realism. I painted the red stripes on the canopy with alizarin crimson and phthalo green and framed in the subject with foliage. When painting the darks inside the café, I first applied a dark mixture of quinacridone burnt orange mixed with ultramarine blue, and while this mixture was wet, I charged in pure alizarin crimson and quinacridone gold to provide an inner glow.

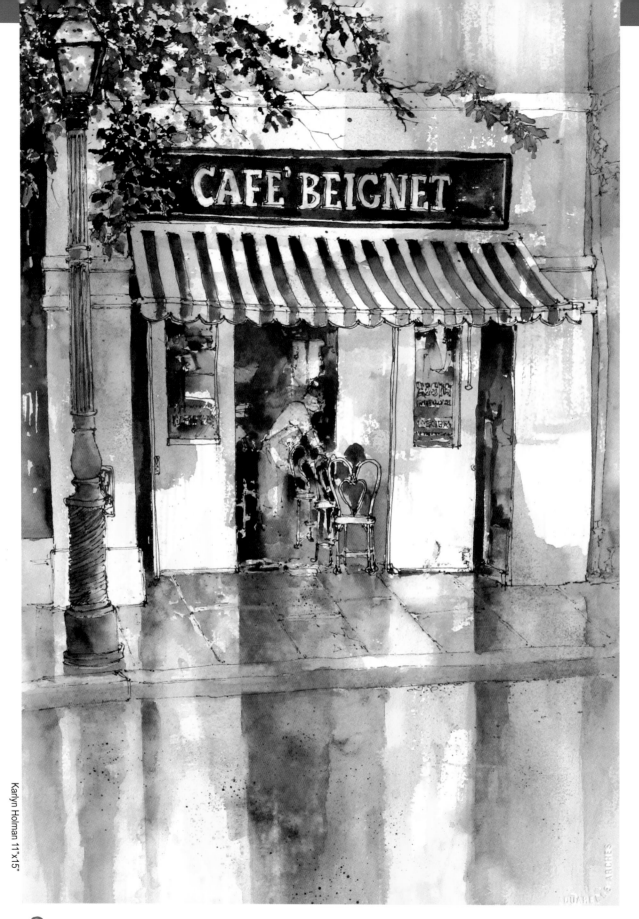

3 By adding a few more darks in the windows and doorway and by emphasizing the surrounding bright colors, I was able to draw the viewer into the focal area. If you establish a strong path of light in your underpainting, that light will shine through the finished piece and will strengthen your composition. Use restraint when adding final details. In some cases, less is more.

Interpreting your subject using free shapes of color in the first wash

We happened upon this charming, back street in Crete, Greece on a beautiful, sunny day with perfect lighting. This on location scene had all the qualities that an artist would hope to find. When a situation like this occurs, I usually start painting exactly what I see. This time, I wanted to take advantage of the expressive qualities of watercolor and just splash color onto the dry paper without being a slave to the actual colors on the scene. I was trying to interpret a more abstract and textural approach to the subject.

Karlyn Holman

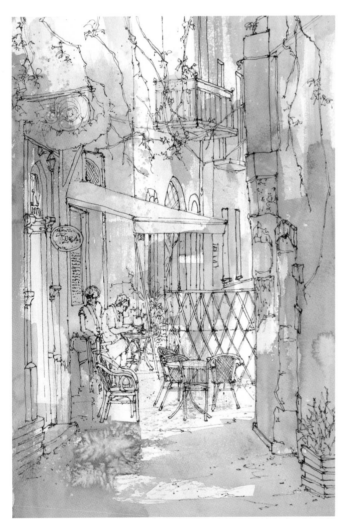

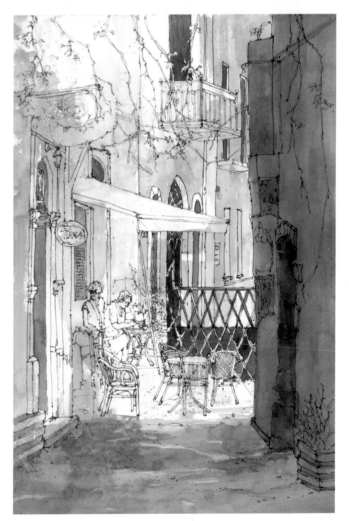

1 Dry brushed edges will help create a softened look in your white shapes and help to avoid a "cut out" look. This effect is achieved by using or brushing away most of the paint from your brush and then continuing to stroke the brush, leaving somewhat dry-looking shapes. These white shapes produce perfect texture for an old world setting. The addition of salt also creates wonderful textural effects, particularly when added next to the white shapes.

2 The next step is to capture the dark patterns of cast shadows and create a degree of definition in the somewhat chaotic composition. Using these dark shapes will immediately help organize the composition and draw your attention to the subjects in the focal area.

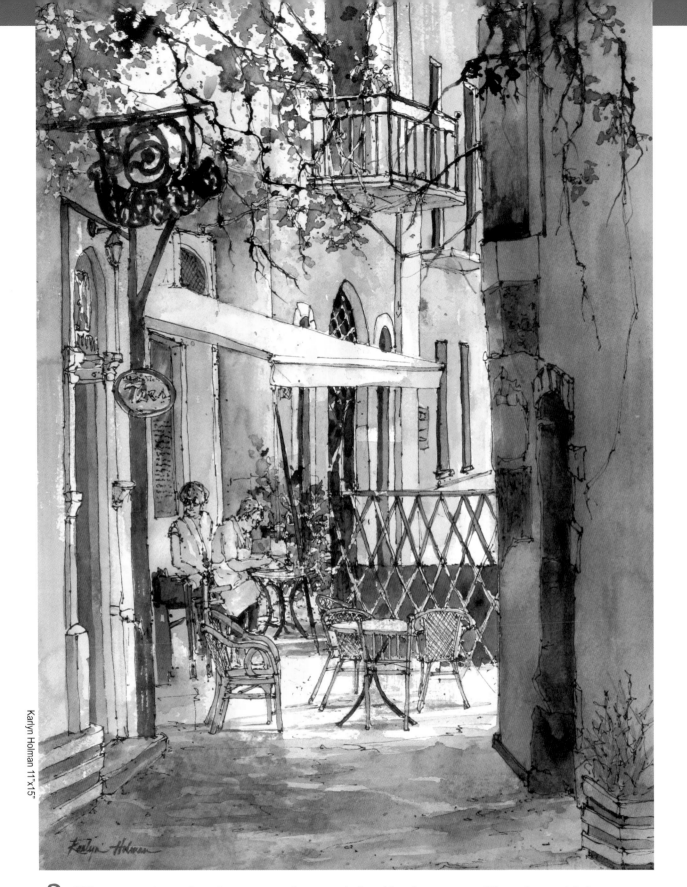

3 When you paint on location, you may be overwhelmed by the amount of factual material that could be incorporated into your painting. You might consider beginning your painting on site and finishing it in your studio. By separating yourself from the actual scene, you are free to develop your own interpretation and emphasize more abstract and textural elements. Finishing this painting in the studio made it easier for me to color sand, flick paint, scratch into the surface, spray and, in general, try many different techniques.

Try starting your painting by using only shapes of color on dry paper

After you have some success with painting outside the lines using shapes of colors that frame your "path of light," you may find it hard to go back to a traditional start. There is a tendency for artists to tighten up when they are beginning a painting, but this approach leads to a fresh look with many surprises. The use of random shapes and pure color creates a lively and expressive underpainting as a basis for your finished work.

Karlyn Holman

1 Start by giving yourself permission to toss color on the paper with abandon. Try not to interpret the scene literally. Use your artistic license and select and push colors that appeal to you.

2 The next step will probably bring you back to a more familiar comfort level. Now you can use all your skills and paint the traditional cast shadows and begin to interpret the actual values that are in the scene.

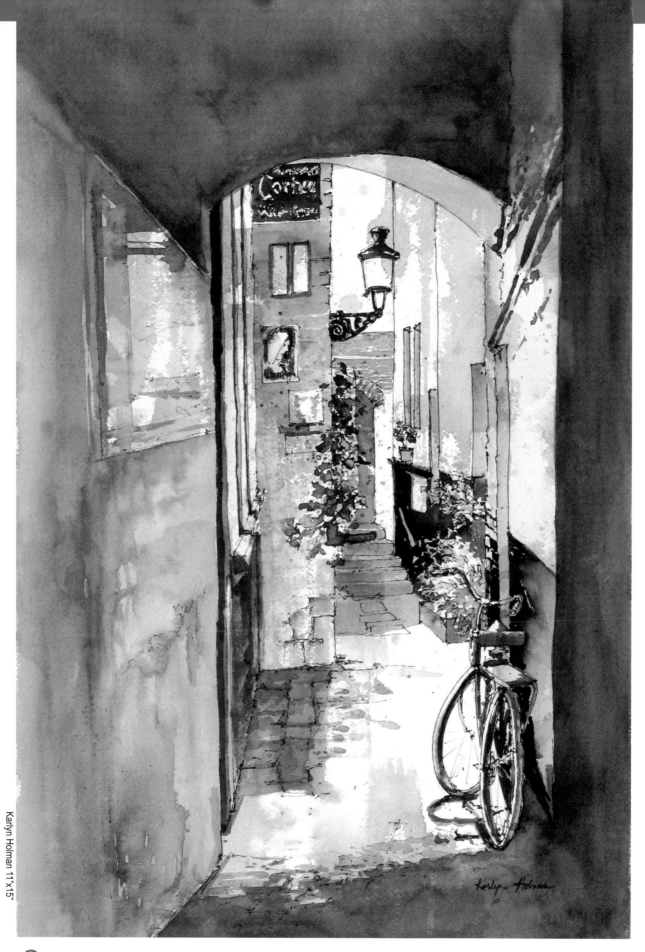

3 The final washes really pull the painting together. If you look carefully, the underpainting washes are still evident and add a spark of freshness that could not be accomplished any other way.

Creating exciting textures using collage

After years of approaching *en plein air* painting by starting with the actual color of the subject, this "free shapes of color approach" provides a breath of fresh air. Instead of analyzing your subject, try looking at it from a purely emotional standpoint. Any subject, not only a landscape, can be interpreted using this free approach. Some textures are simply created visually, but do not have a tactile surface. Try creating an actual tactile surface by adding collage. Whether the tactile surface is real or *trompe-l'œil* is not important. What is important is the visual interest you are creating in your composition. I like the collage to look integrated with the composition. The process of creating a prepared surface before you begin the finished image does just that. The finished painting looks unified and natural.

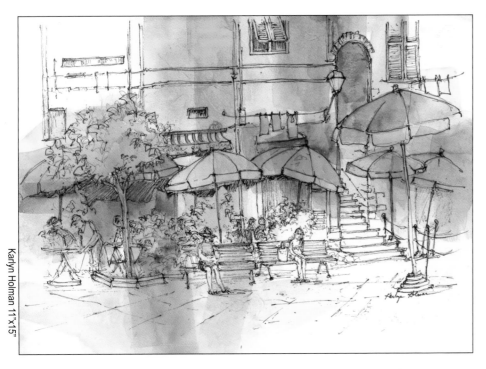

Bright colors are used to evoke the ambience of this busy street scene in Italy. Make the first strokes simple and then add detail in the succeeding washes of color.

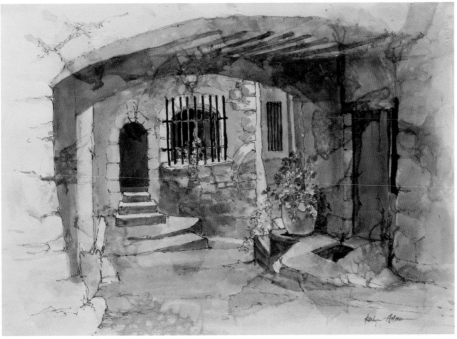

Medieval villages are perfect subjects for added texture. This subject was painted over a randomly prepared underpainting. Many sizes and shapes of Ogura, Ginwashi and unryu were glued onto Arches® cold press paper using thinned Yes! Paste™ (page 55). I frequently take these prepared underpaintings with me on location and when I find the right subject, I simply paint over these papers and watch the surprises happen as the color grabs the textures and creates an exciting surface.

Try adding collage to enrich your "path of light"

This quiet hillside village in Northern Umbria is a perfect subject for adding collage textures and line. Remember, any subject can be interpreted using this "path of light" concept.

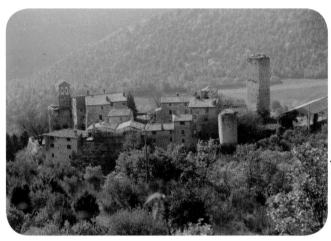

Karlyn Holman

1 Consider the earthy and glowing colors in this photo of a small Umbrian hill town. To interpret a scene like this, wet your paper both on the back and the front. This technique will keep the paper flat and allow you more time to play with the colors. Think only about the emotion you feel as you view your subject and translate this emotion into shape and color. Use a large brush and float in large shapes of color.

2 Place pieces of Thai white unryu (10-gram) paper and Ogura paper in and out of these shapes of color. Spray with a fine mister to encourage the paper to absorb the color and allow these colors to dry. The papers will lighten considerably during the drying process. When dry, glue the collage paper down with thinned Yes! Paste™. Yes! Paste™ is a thick paste, so all you need to do is mix water with it until it becomes the consistency of milk. The Yes! Paste™ will leave a completely workable surface when dry. The color will return somewhat when you glue the papers down.

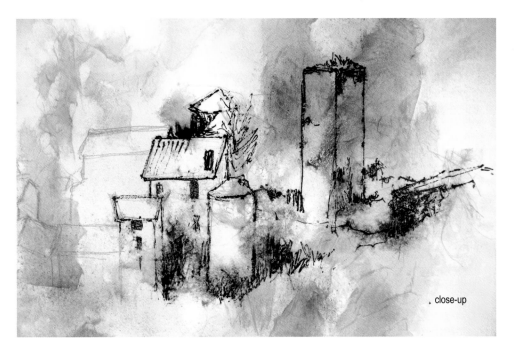

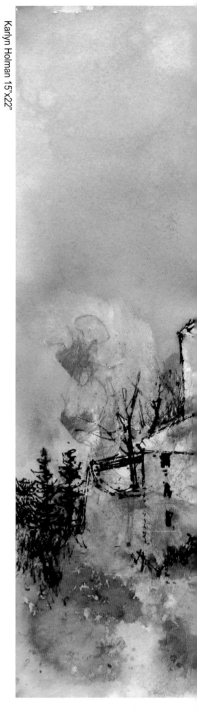

Karlyn Holman 15"x22"

. close-up

3 Now draw whatever your heart desires. The lines should have a visual life of their own. The color and texture are already entertaining the viewer, so make a statement with your lines. Let the emotional quality of the colors or the textures suggest your subject. These warm colors reminded me of Italy and the textures evoked the hill towns of Tuscany and Umbria. Draw without being inhibited by the textures and shapes of color—keep your heart open. Make the line drawing using any technique you choose and work without boundaries. I chose to use a gutta bottle with black acrylic paint (page 143) because the heavier lines worked better on the textured background.

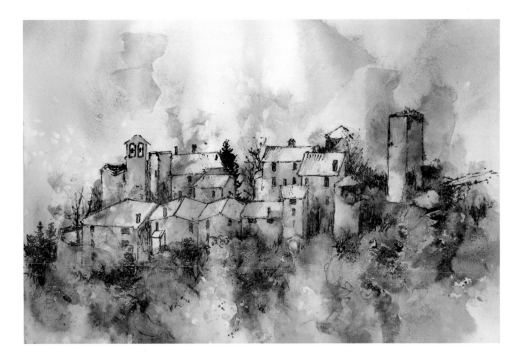

4 The cast shadows on the buildings were painted with mixtures of cobalt blue and permanent magenta (pages 34-35). The foliage was flicked onto the underlying textures (pages 148-149). Several light paths were purposely left in the foliage to lead your eye into the focal area of the painting.

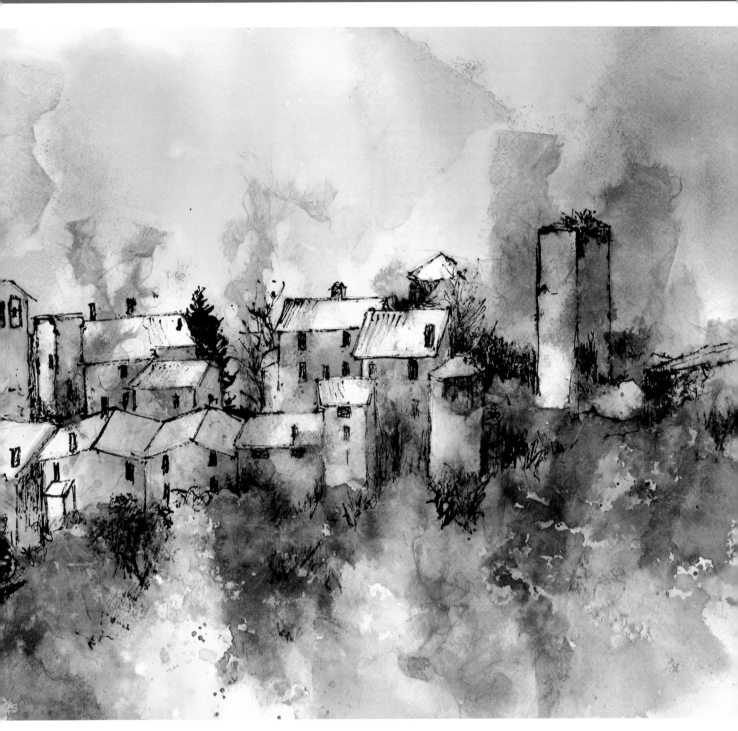

5 Warm colors of raw sienna, quinacridone gold and quinacridone burnt orange were layered over the buildings. The sky was created by wetting only the sky area and painting in a focus of light using Winsor yellow and quinacridone burnt orange in the center and cobalt blue on the edges.

Color portrays emotion

This entrance to the ruins in Antigua, Guatemala was drawn over layered oriental papers that were glued down with thinned Yes! Paste™. I used colors that would represent the warm tones you would find at this ancient site. With no attempt to catch the light or create a likeness to the actual scene, I simply mixed pleasing colors together to form shapes and values completely independent of the lines.

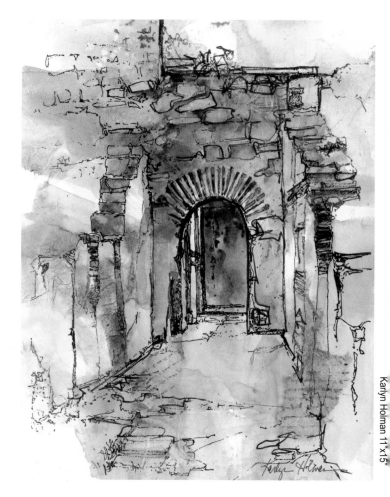

This chateau shimmering in the sunlight with mysterious windows and doors was painted on location by Sue Primeau in South West France. She started with a prepared, cool underpainting that saved a "path of light" and allowed this to dry. She drew over this random underpainting and added the specific shadows in cobalt and permanent magenta. The final layers were the complementary warm colors. This combination of warm and cool created intriguing qualities of luminosity and transparency. Pre-mixing warm and cool colors on your palette and applying them to your painting could never create the glow achieved by layering color.

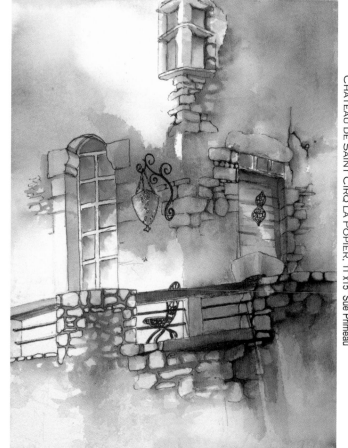

Designing textures and color with line

This flat-lit scene from the Algarve in Portugal has dramatic shapes but the light is bouncing all over the place. To paint this scene in the traditional approach of layering color to capture the light would be difficult. To approach the subject as shape and color only is much easier.

Karlyn Holman

1 Cool colors were painted onto a wet surface of Arches® paper and then random pieces of 10-gram white unryu paper were added into the wet color to create an interesting background. After the papers and color dried, matte medium thinned slightly with water was used to glue the paper to the surface. This leaves a slick surface that is perfect for drawing on with a permanent pen. Draw with abandon and do not be influenced by the shapes of color.

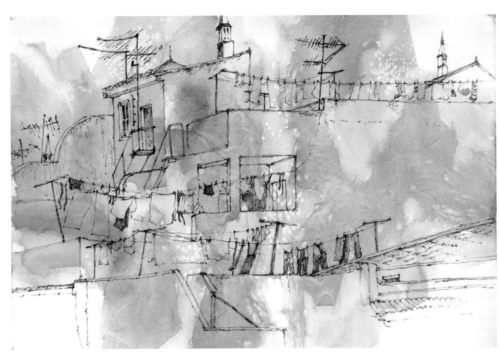

2 Now for the difficult step. How can you add more color to "pop out" some of the subject without giving the viewer too much information? To avoid moving into realism, merely enhance the shapes of the buildings without taking away the sense of mystery that the painting has at this stage. Think of the shapes and colors as an abstract painting with lines on top. The matte medium will create unexpected resist when you add the color. Just enjoy the surprises.

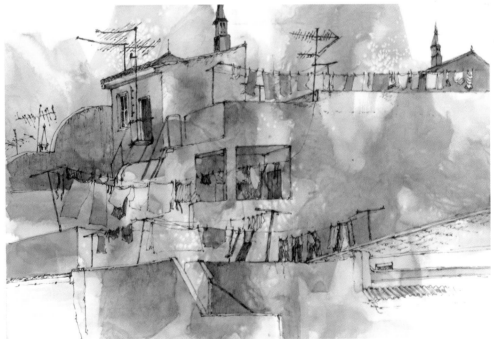

Karlyn Holman 15"x22"

59

Using primary markers as a primary source of color

My friend, Paul Dermanis, is an architect with phenomenal drawing skills. On several of my on location painting trips, he used only four felt-tip markers to create beautiful, linear compositions. Most people think of felt-tip markers as useful tools for a quick yard sale sign, but for Paul these markers turn line into a work of art. To implement this simple formula for success, he carefully selected water soluble, high quality Pantone® Tria® markers by Letraset® in the three primary colors, plus black. This minimal selection produced a range of full-spectrum colors. Blending these four colors also provided him with a range of cool or warm, gray or bright and even dark and light.

1 Paul first used a black marker to draw this lovely street scene in Český Krumlov, Czech Republic.

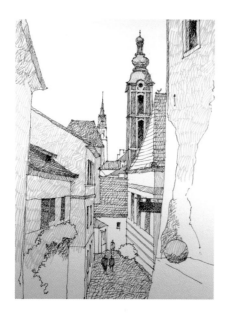

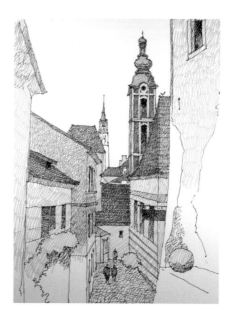

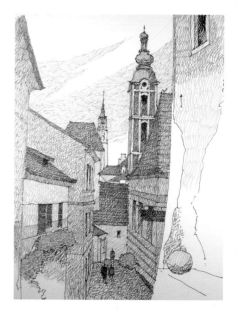

2 He evaluated the scene and used crisscrossing lines, placing the color yellow wherever he needed oranges, greens and pure yellow.

3 He next added some areas of pure red. He also used red over yellow to produce orange and in areas that eventually would become purple.

4 Blue was then added over yellow to produce greens and over reds to produce purples. Blue was also used over yellow and reds to produce gray tones.

Paul has really captured the warm colors so prevalent in Český Krumlov, Czech Republic. This lovely city has well preserved old world charm and is on the UNESCO list of World Natural and Cultural Heritage.

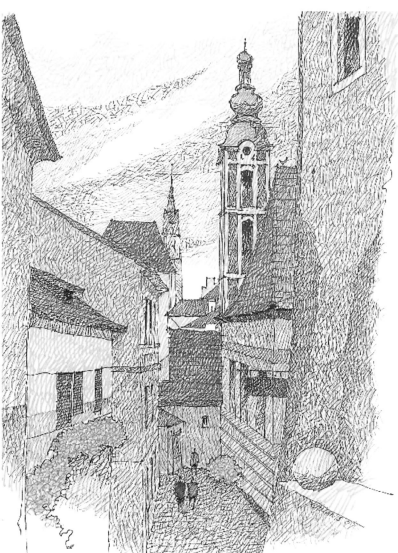

CHURCH AT ČESKÝ KRUMLOV, 10 1/2"×13 1/2" Paul Dermanis

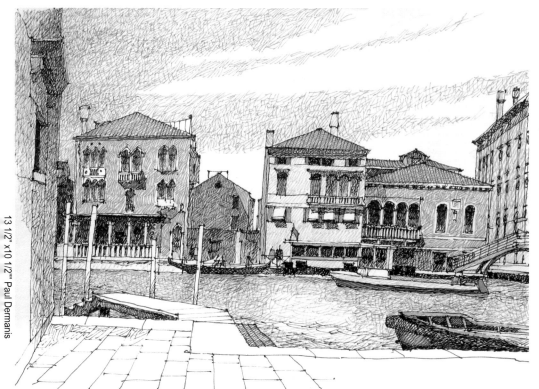

13 1/2" x10 1/2"" Paul Dermanis

This lovely painting of the Grand Canal was painted on location in Venice, Italy. Paul captured the unique colors of Venice with these layered colors. The contrasting pattern of movement and color in the sky provides a perfect complement to this lovely Venetian scene.

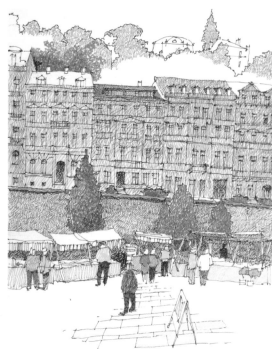

This market scene in the spa town of Karlovy Vary, Czech Republic features an amazing backdrop of apartment buildings that only a talented architect would tackle. Note the inviting, well-designed foreground leading us into the market.

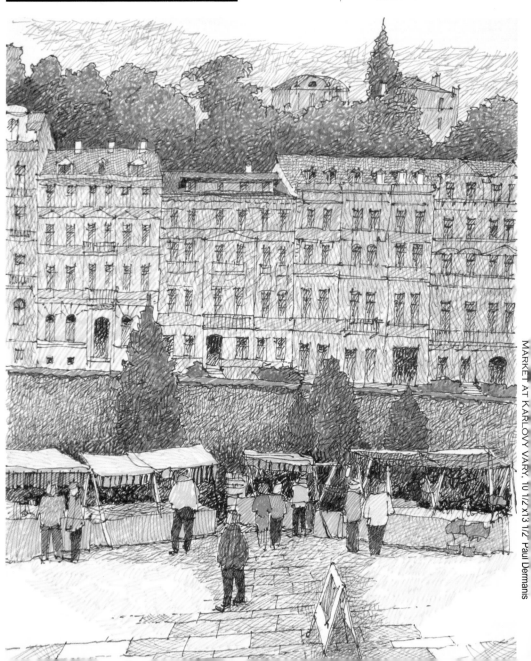

MARKET AT KARLOVY VARY, 10 1/2 x13 1/2 Paul Dermanis

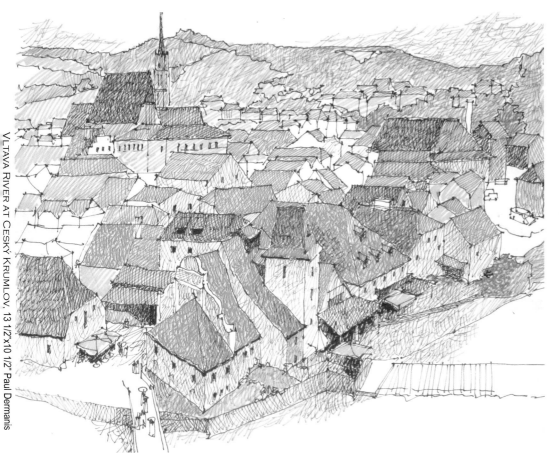

This view of the Vltava River with its many bridges and century-old buildings with red roofs makes this a truly unique composition of Český Krumlov, Czech Republic. Paul has captured an atmospheric effect with his layered approach by adding more layers of red for greater intensity. Note how the color red becomes less intense as the roofs recede into the background.

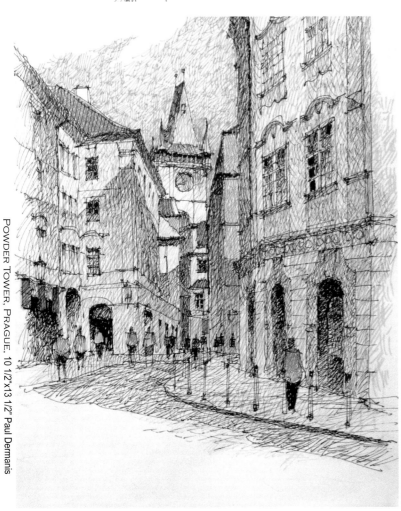

Paul used buildings and shadows to frame this unique view of the landmark Powder Tower in Old Town Prague, Czech Republic.

Blending realism and abstraction using photographs printed on tissue paper

Tara has combined her love for travel and on location painting with her photography skills. On a return trip to the Le Vieux Couvent in South West France, Tara brought along photographs she took in 2003 that she had printed on tissue paper. The photos on tissue paper were used to create collages which she used as the basis for these paintings.

Collage, montage, assemblage, found art or whatever you want to call this exciting art form is alive and well today. Collage, from the French word, "coller," means "to stick." The combination of elements of realism, color and texture create an exciting painting. Collage can tell a story, evoke a mood or express an idea better than most techniques. Collage is like a "work of art" within a work of art.

Tara Moorman

1 To print the photos on tissue paper, you need a piece of white tissue paper cut into 9½" by 12", a piece of 8½" by 11" cardstock, adhesive tape in a matte finish and an inkjet printer. Use the cardstock as the carrier to feed the tissue through the printer. The tissue paper is cut one inch larger than the cardstock and needs to be folded over all the edges and taped in place. Make sure that all the tissue paper edges are completely covered by tape. Any loose pieces may catch in your printer and can be very difficult to remove.

When you prepare these images, keep them attached to the cardstock until you are ready to use them so you will know which side is the printed side. Because inkjet ink is water-soluble, the printed inkjet image must be placed face down touching the watercolor paper to avoid smearing the image.

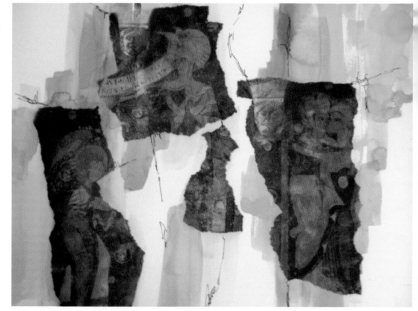

2 Using 140# Arches® hot press paper, Tara toned the paper using complementary colors and allowed the paper to dry thoroughly. She then brushed glue on the dry paper surface and placed the printed inkjet side of the image onto the paper using thinned Yes! Paste™ (page 55). She tore the images into interesting shapes, keeping the torn edge rather than a cut edge. These shapes were arranged into a design that created a path of light throughout the focal area. The inkjet colors became more intense with the gluing. Ink lines were also incorporated into the design. More color was layered to form the mid-range values.

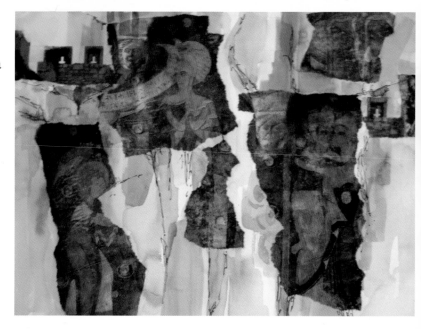

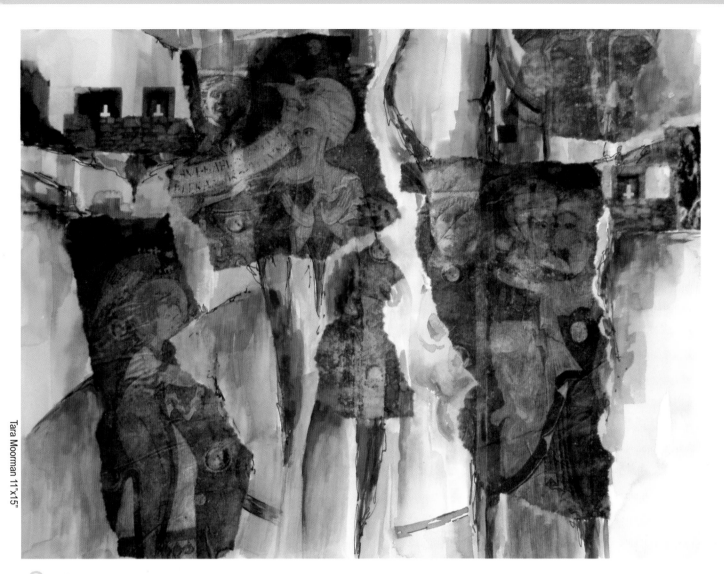

3 Tissue paper adds a depth and mystery as well as authentic imagery
to your painting. A blend of abstraction and realism can encourage
you to try a new and very exciting way to express your feelings.

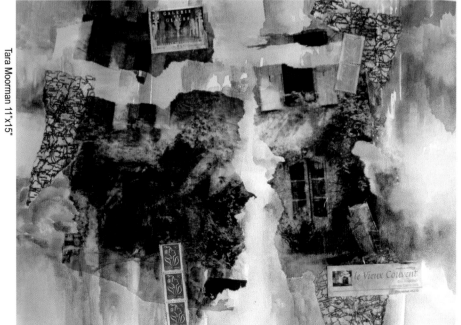

This memory painting of the grounds
of Le Vieux Couvent in South West
France also incorporates memorabilia
like stamps and maps. These special
items can be glued on and integrated
into the final painting using
watercolor washes.

Enrich your painting with creative writing

Painting and travel opened doors for Connie Cuthbertson and the experience was life-changing. While on an art adventure to Crete, Greece, Connie started journaling about the subjects she was painting. Combining the two art forms of writing and painting made her feel complete and gave her an almost spiritual sense of well-being. Paintings are like a story; they have something to say. Writing about the act of painting is a challenging and fulfilling way to bring together the technical and emotional elements of creating a work of art.

Connie had a show titled, "The Awakening—Memories of Greece", featuring her work from her trip to Crete. This is the piece she wrote to accompany the opening of the show:

Connie Cuthbertson

"I found writing very challenging, yet necessary to fill in the something that was missing. There had to be more than just imagery. I wanted to nail down the feelings I had when I was on location in Greece. Tying together the words with my paintings was the key. By writing about my art, I hope to engage my viewers on a more personal level so they might understand a bit more about me and, in turn, perhaps a bit more about themselves. Now when I am in the act of creating, I feel complete and my soul is satisfied."

Connie Cuthbertson

The Awakening
I have come to this place across the sea. I have been transformed- as if to another world,
another life. I feel as though I have been here before. How is this possible? Have I dreamed so big that I have actually lived a previous life? The light is so pure, soft, calm and exciting all at the same time. Have I lived all of my life to finally make my way here?
Is it simpler than that?

Perhaps we but have to accept the doors we must cross through in life to be able to accept and experience what it is we have for today. For if I was to come here as a child – without all of my life's "goods and bads" and see Greece for the first time, I would not be able to breathe the light, the air and taste life again in a new way. A way that is, I am sure, intended for us each day.

Today I will live in the "stigmi"…(moment).

Sisters of Rethymnon
"I found these doors in Old Town Rethymnon on the Isle of Crete. As I sat and sketched them in the light of the early morning, I could almost imagine all of the people who have passed by them for more than one hundred years. There they have hung, one green and one blue; different, yet the same. Just like sisters. On the last day I was there enjoying their beauty, small children passed by on their way to school. Some were curious to see my drawings, others caught up in their own world, others laughing with their friends, not a care in the world, the way life should be for the child in all of us."

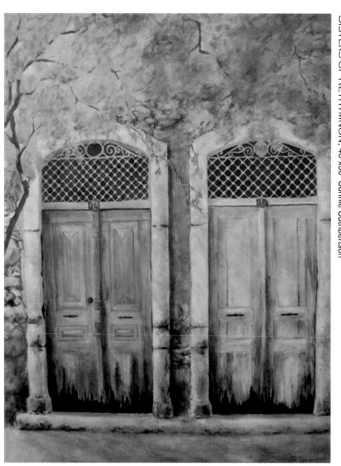

SISTERS OF RETHYMNON, 48"x36" Connie Cuthbertson

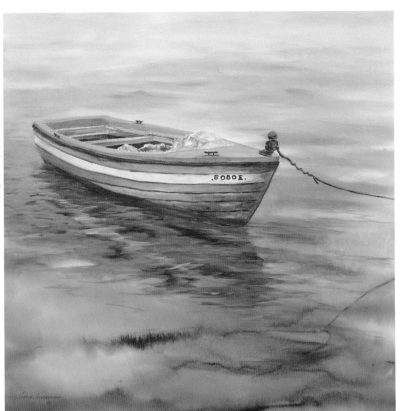

Boat of Pappous

"Walking along the harbour in Chania early one morning, I came across this quaint little fishing boat. I imagined it belonged to *Pappous*, a grandfather taking his grandchild out to help him with the catch of the day. The small harbour was filled with many vessels of all shapes and sizes. This one caught my eye. Complete with a net and painted in the traditional colours of blue and white, this was a perfect subject to paint. The Greek letters on the boat were the perfect finishing touch. You can almost hear the water lapping on the side of the boat."

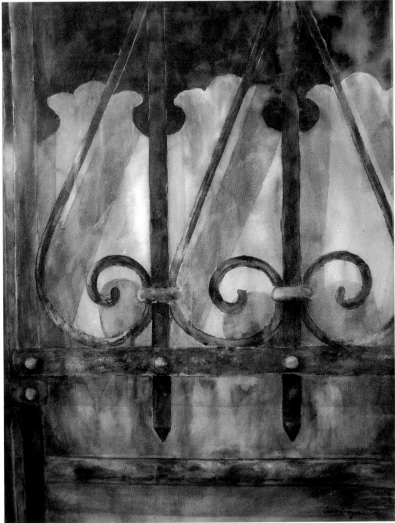

Tapestry of Time

"As I passed by this old garden gate, I was mesmerized by the small flecks of blue paint that hadn't quite rusted away, revealing remnants of what it once must have been. I am glad to have seen it now, after the rain and intense sun took their turn on the iron scroll work. As I sit here and write about this old door, I am reminded that people are much the same. We become more interesting with the passing of time. Always look for opportunities to sit and talk with someone who has been on this earth longer than you. You will be amazed at the knowledge they possess. They too are rich with the colours of life."

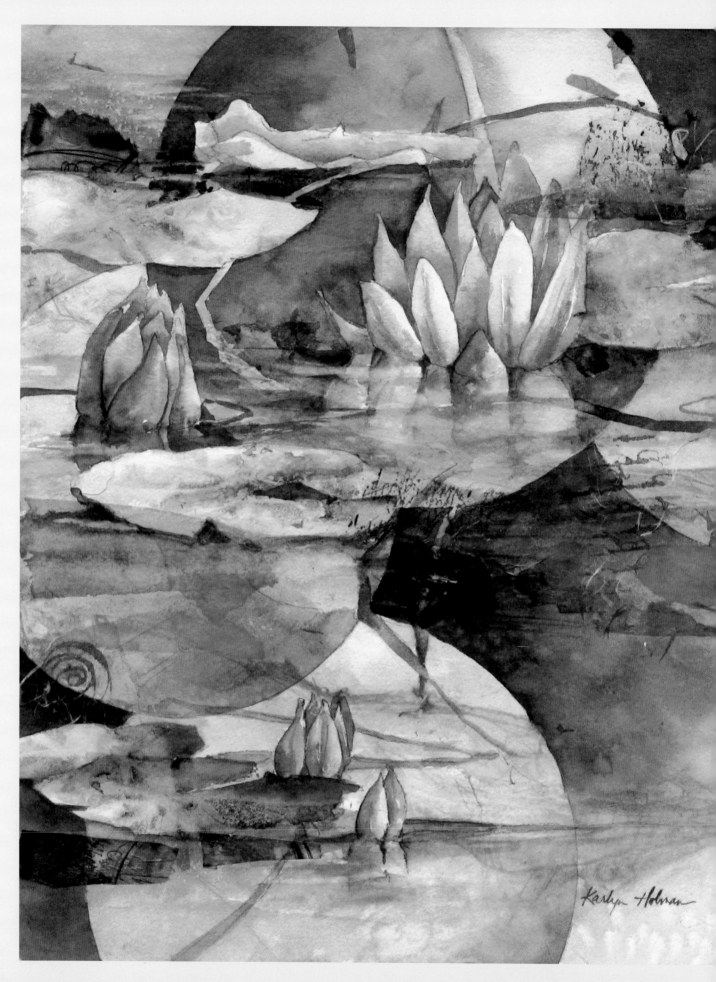

Watercolor Without Boundaries ❖ Karlyn Holman

Getting started in floral and still life design

Most paintings are derived from multiple sources, such as photographs, life, memory, imagination and now computers. Embrace this diversity and do not be afraid to deviate from conventional or traditional methods. You really need to break away from the comfortable and familiar route and learn by playing with the media. Almost every demonstration starts with one idea and then expands into variations to enrich your experience. Start with the basics and as you gain confidence, add the enrichments.

The background decision does not need to be all black or white. Using a variety of surfaces, values and textures is always a good idea. Try many approaches and your own personal style will eventually emerge. Planning a background does not need to be a difficult decision. Generally, the colors already in your subject could be incorporated into the final choices. Then there are choices like painting crisp shapes on dry paper or wetting the surface and starting with a wet into wet look. Generally, my preference is a loose, wet into wet start that will complement, rather than take over the mood of the painting.

In this chapter, we start with no background, then we move into wet into wet. Eventually we add collage, color sanding and other textural effects. Enjoy.

Karlyn Holman 15"x15"

Starting with only the subject

Starting your painting with only the subject, with no concern about the background, is an easy "formula for success." Actually, only concerning yourself with painting the flowers and achieving this botanical look is very appealing. One of the ways you can enrich the surface and add an exciting textural look is to try the technique of color sanding.

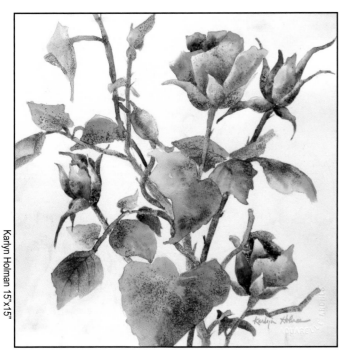

Karlyn Holman 15"x15"

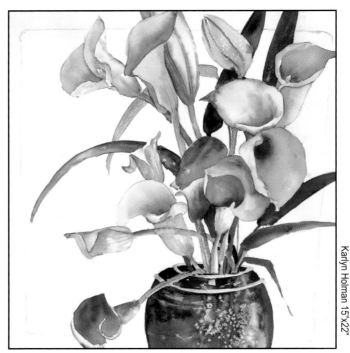

Karlyn Holman 15"x22"

These calla lilies were picked in New Zealand. I had no idea that this flower came in so many incredible colors! My main interest was to paint only the individual flowers. After I drew them, I wet each shape and floated in rich color. Unless the flower was touching another flower, I just enjoyed the simplicity of painting only the subject with no background.

Painting only your composition is always a good choice because you can then revel in the colors and textures of your subject without worrying about relating it to a contrasting background. This painting was really enjoyable to paint—very freeing.

This is a simple process accomplished by sanding a watercolor pencil on a 100-grit piece of sandpaper and allowing the powder to fall onto the wet paper. Tap away any extra powder directly into the garbage. Do not blow the powder away as you may draw unwanted chemicals into your body. Depicting the flower stems was the most intriguing challenge of this painting. I wet the stems and leaves, one at a time, starting with Winsor yellow, adding Antwerp blue and then color sanding red pencil onto these wet areas. The roses in the painting were painted with colors that do move on a wet surface. I wet each petal and used Winsor red and alizarin crimson to create the warm and cool reds in the rose. While the paint was wet, a little black pencil was sanded into the rose for contrast.

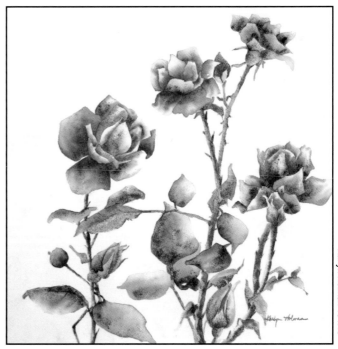

Karlyn Holman 15"x18"

Painting only the subject can produce a stunning result. This simple close up of birch trees by Nikki Johnson illustrates a beautiful blend of warm and cool colors.

Notice how the warm colors appear to come forward and the cool colors appear to recede.

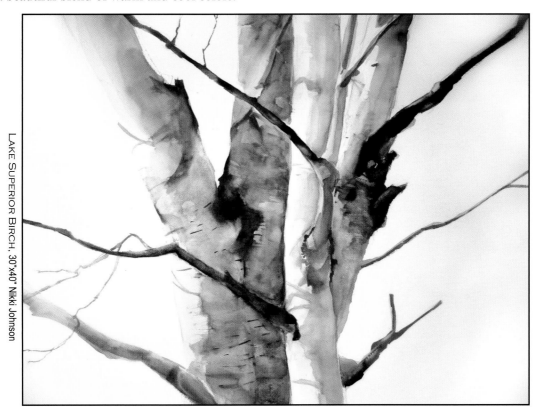

LAKE SUPERIOR BIRCH, 30"x40" Nikki Johnson

Nikki also collaborated with Joy Morgan Dey to create an award winning children's book titled, *Agate: What Good Is a Moose?* All the artwork was painted on YUPO® paper with no background. This slick plastic paper creates a unique surface that is perfect for Nikki's spontaneous and "jewel-like" colors. The paint does not absorb into the surface and slowly air-dries. This delayed and uneven drying almost always creates a unique look.

'AGATE' WHAT GOOD IS A MOOSE, 20"x30" Nikki Johnson

Starting wet into wet with colors that move very little on a wet surface

There is really nothing to compare to the free-flowing mingling of color when wet paint touches wet paper. This exciting start can create the unexpected, the indistinct and an atmospheric look. Painting wet into wet gives you the most freedom and the greatest range of expression.

Painting on a dry surface always gives you more control. The results also look more controlled. If you are striving for a more spontaneous look, then you are ready to start your painting wet into wet.

The key to a successful wet into wet under painting is to understand the concept that some pigments move on a wet surface and other pigments remain stable on a wet surface. I would like to recommend that instead of using maskoid, you use only colors that remain stable on a wet surface. For example, all the Holbein colors do not move on a wet surface because they contain no ox gall in their composition. The ox gall is the component that makes the color move. You need to test the colors you use to determine if they move on a wet surface. I personally like having some colors that move and others that do not. For example, alizarin crimson and Antwerp blue move a great deal when they touch a wet surface, while other colors, like manganese blue or quinacridone gold, do not move much at all. Of the colors that I have on my personal palette, the following colors move very little on a wet surface: manganese blue, cobalt blue, French ultramarine blue, permanent magenta, permanent rose or quinacridone rose, quinacridone coral, quinacridone burnt orange or burnt sienna, scarlet lake, and quinacridone gold.

Karlyn Holman

1 This still life background was painted with quinacridone burnt orange, manganese blue and permanent rose. All these colors move very little on a wet surface and no masking was used. The soft color that moved ever so slightly into the light shapes added character to the subject.

2 On dry paper, the path of dark was enriched by adding similar, harmonic color to pop out the crisp edges. The checkerboard pattern was drawn in with a similarly colored watercolor pencil and then painted in with watercolor.

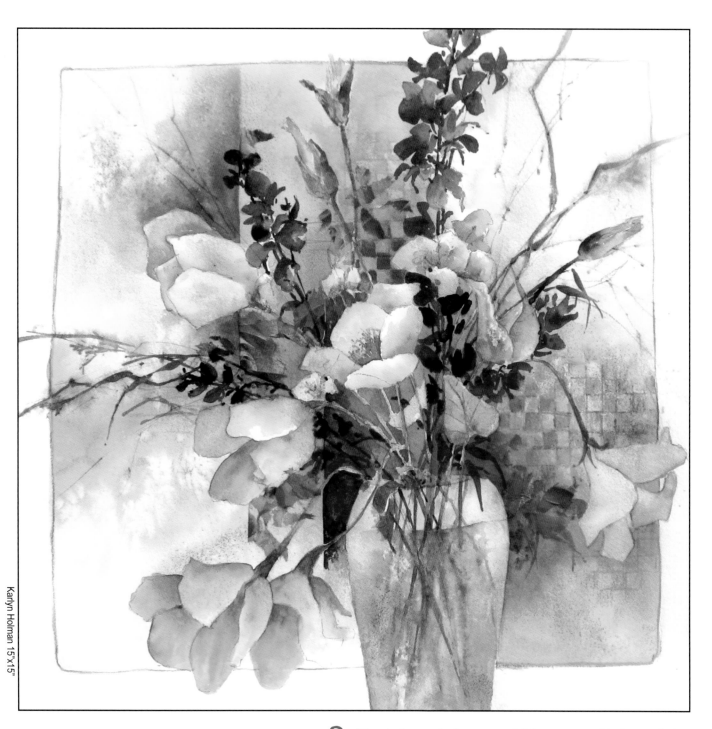

3 The dark purple flowers and foliage were added to pull the painting together. Alizarin crimson, French ultramarine blue and permanent rose created the warm and cool purples. This combination of lost and found edges is really the most desirable look in a finished painting.

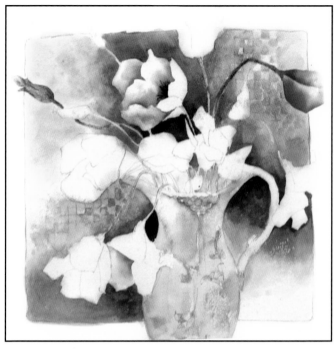

1 This still life painting was composed using the same photo reference as on the previous page. This time I chose a cool dominance for the path of dark. This background was painted wet into wet using manganese blue, permanent rose and aureolin yellow.

2 On dry paper, the dark path was accentuated by the addition of Antwerp blue, quinacridone gold and quinacridone coral.

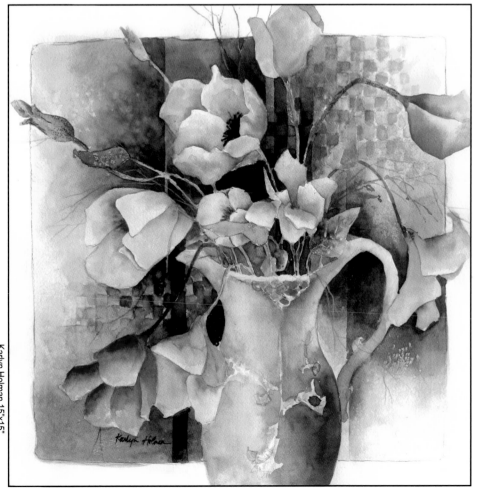

Karlyn Holman 15"x15"

3 To finish the painting, flowers that were not in the path of dark were then painted dark against the light path. The flowers in the dark path were interpreted as light flowers. The final darks were added in the form of strips and checkerboards to enliven the background. Notice how the vase reverses to light against dark and dark against light. The warm checkerboard provided strong contrast to the cool dominance of the background.

Adding pattern and repetition to create exciting backgrounds

Adding a contrasting background to your subject is the traditional way to paint a watercolor. If you want to push your boundaries, try making up a pattern in your background. Think about the possibilities of adding strips, checkerboards, polka dots, or any rhythmic design—even lettering can prove to be entertaining. After all, as an artist, your job is to entertain the viewer.

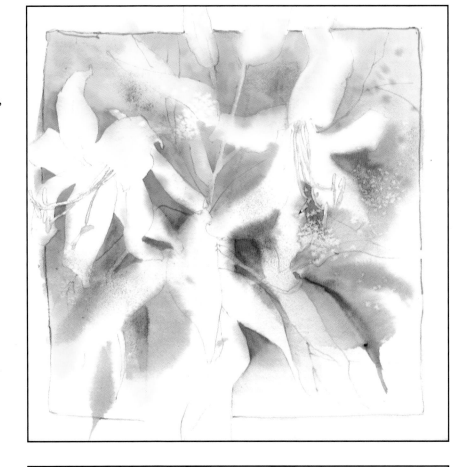

1 This wet into wet underpainting has a path of dark that is painted with quinacridone burnt orange, quinacridone gold and scarlet lake, all warm colors that move very little on a wet surface.

2 When this underpainting dries, punch out the crisp edges with similar colors and then add a simplified vase shape to create a dark area. This dark area is echoed in the background in the dark strips and patterns behind the flowers. To add visual excitement, try adding a checkerboard pattern using watercolor pencils in close harmonic colors. When the checkerboards are painted, the pencil lines will melt into the design.

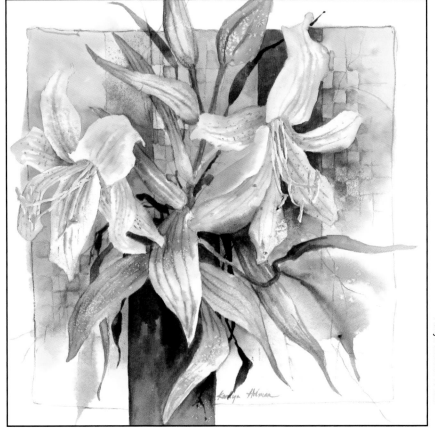

Karlyn Holman 15"x15"

1 This wet into wet start features manganese blue, permanent rose and aureolin yellow. These colors move very little on the wet surface and provide the soft edges in the underpainting. The pistils and stamens are masked with clear maskoid before wetting the paper. The framed in edge is drawn with a colored watercolor pencil while the paper is still wet.

2 On dry paper, only the path of dark is crisped up using similar colors. The diagonal strip adds tension and also a contrast to the checkerboards. After you complete the negative background, remove the maskoid and finish the painting by painting the positive shapes of the leaves and flowers.

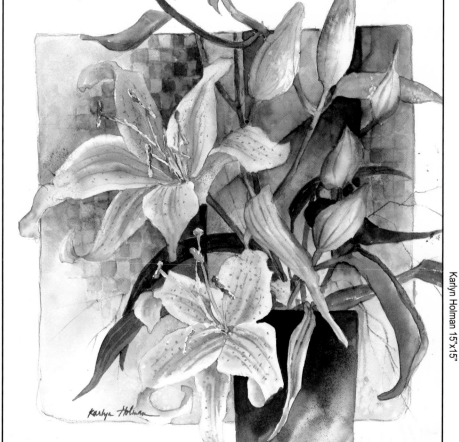

Karlyn Holman 15"x15"

Playfully painting outside the lines

Any subject can be painted using this easy formula. Begin by painting shapes of color, leaving a path of light through the focal area and finish your painting using traditional techniques.

This free and loose underpainting was executed on dry paper incorporating the same colors as those used in the poppies. After the underpainting dried, the poppies were painted one at a time and no attempt was made to paint any negative areas in the background.

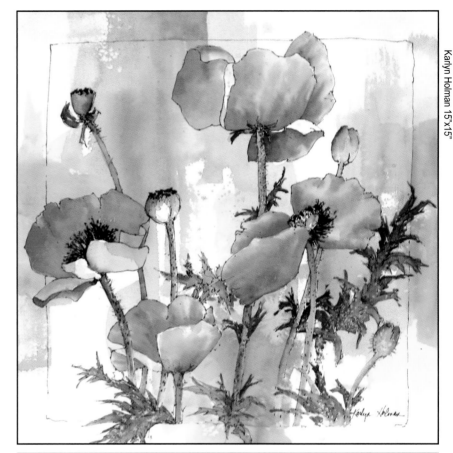

This painting of fuchsia was done the same way using shapes of color on a dry surface and finishing the painting in a traditional style.

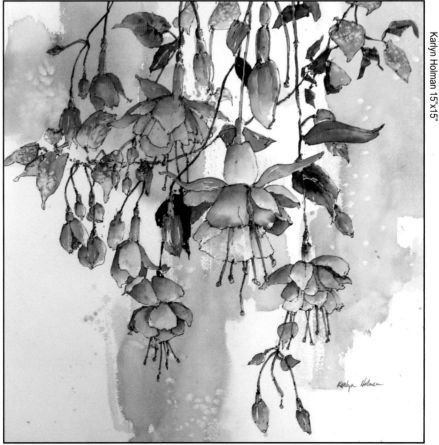

Experimenting with a diamond shaped composition

Draw your subject using a permanent ink pen on Arches® 140#
cold press paper. My favorite pen is the archival STAEDTLER®
Lumocolor® permanent pen, #313-7 in a sepia tone. I used
all the traditional compositional ploys, such as interlocking
the flower shapes, designing a variety of size relationships and
allowing some shapes to extend to the edges of the paper.
I actually designed the shapes to fit a diamond format,
adding a line to enclose the composition, thus creating a
frame within a frame.

1 When you are ready to begin painting
your shapes of color, remember
to save a path of light in your focal
area. Add the colors completely
independent of the lines. Think
only in terms of your emotional
response to the subject. Challenge
yourself by starting on dry paper. This
approach will provide more contrast and
allow you to work with dry-brush effects. The
first colors I applied were Winsor yellow and
quinacridone gold.

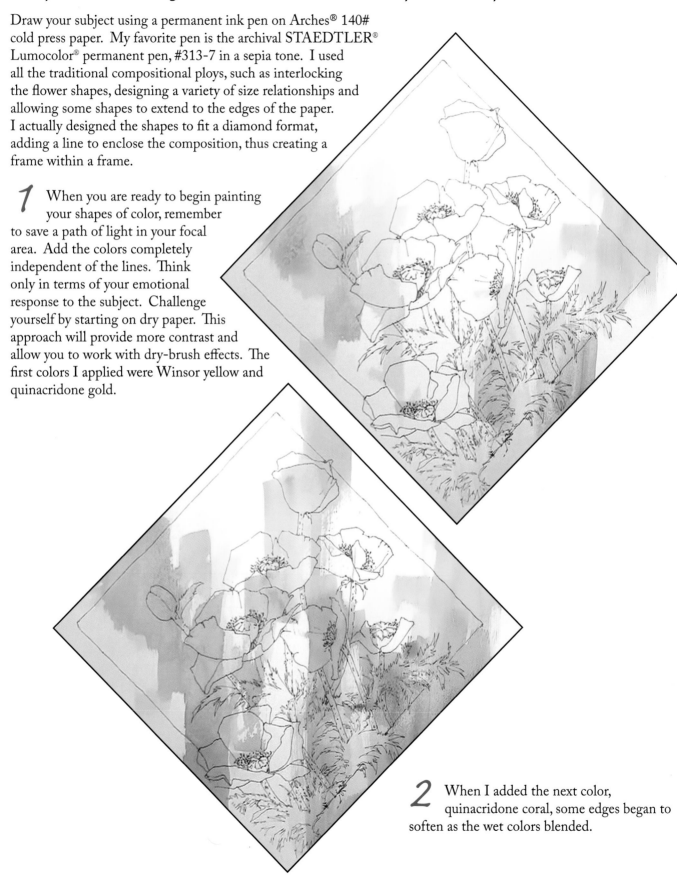

2 When I added the next color,
quinacridone coral, some edges began to
soften as the wet colors blended.

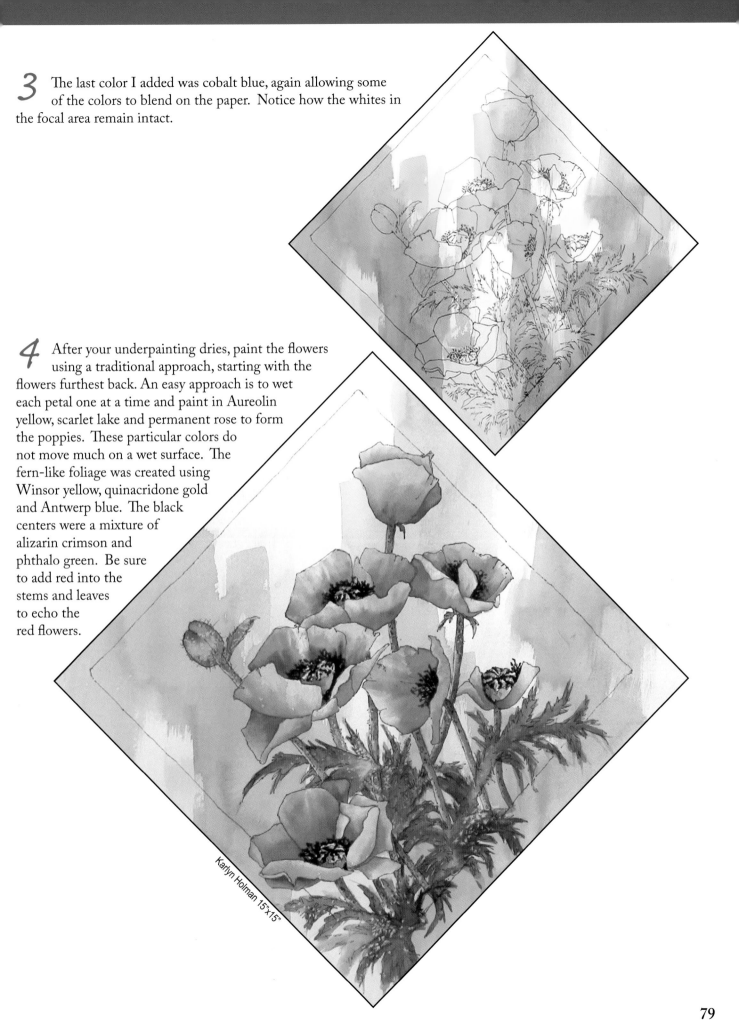

3 The last color I added was cobalt blue, again allowing some of the colors to blend on the paper. Notice how the whites in the focal area remain intact.

4 After your underpainting dries, paint the flowers using a traditional approach, starting with the flowers furthest back. An easy approach is to wet each petal one at a time and paint in Aureolin yellow, scarlet lake and permanent rose to form the poppies. These particular colors do not move much on a wet surface. The fern-like foliage was created using Winsor yellow, quinacridone gold and Antwerp blue. The black centers were a mixture of alizarin crimson and phthalo green. Be sure to add red into the stems and leaves to echo the red flowers.

Karlyn Holman 15"x15"

79

Creating a "path of light" in the background

This simple technique is used to save the lights in the central part of your composition and create visual strength in your painting. Think of it as setting the stage for a big production and plan the placement of the white shape, leading the viewer's eye to the center of interest. All subsequent additional enrichments will take a back seat to the original drama you have created.

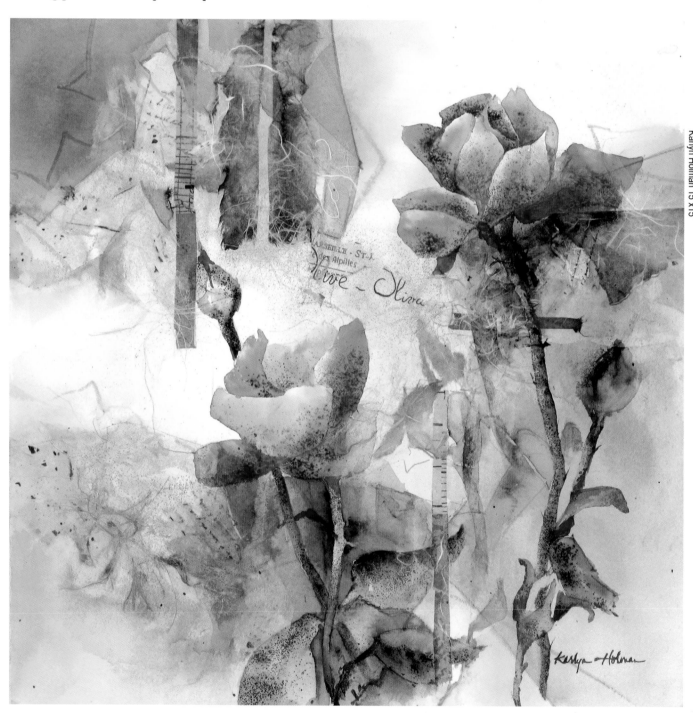

Karlyn Holman 15"x15"

This rose painting was my first attempt to create a planned "path of light." As the painting evolved, the negative areas became more important. The real excitement in this creative process became the surface enrichments. I used cut and torn oriental papers, color sanding, napkins and even found collage papers and glued them over the dry surface with thinned matte medium. As I added subsequent layers of colors, I experienced a resist that resulted in varied and exciting surface enrichment.

This lily painting illustrates the technique of using more negative painting in the background.

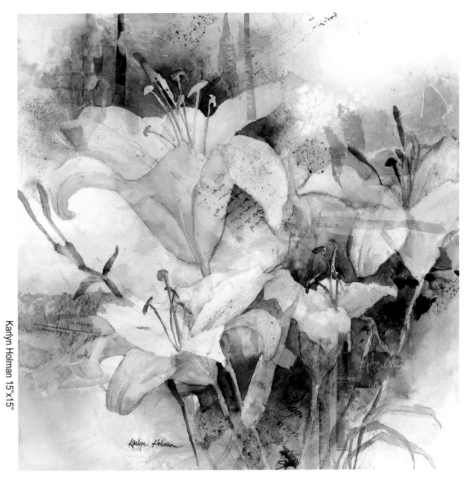

Any subject will work for this simple dramatic ploy. These geraniums show the depth of both negative and positive areas. Negative and positive painting techniques can be confusing. To make this process more understandable, I have broken this demonstration down into purely negative and purely positive steps to clarify the difference between these two techniques. The best part of this lesson is that in the process of combining negative and positive painting techniques, a wealth of magical textures and colors begin to appear.

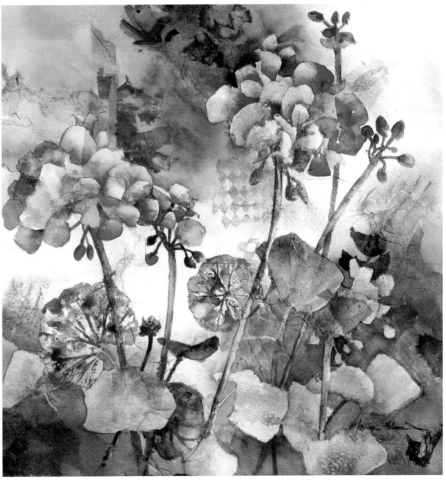

"Path of light" using a traditional theme

1 This is an underpainting created by Lee Fidler. Lee saved the lightest lights in the focal area and kept the entire underpainting within a value range of one to four. She used colors in their fresh, pure form to achieve a glowing final interpretation. A little salt was added for texture.

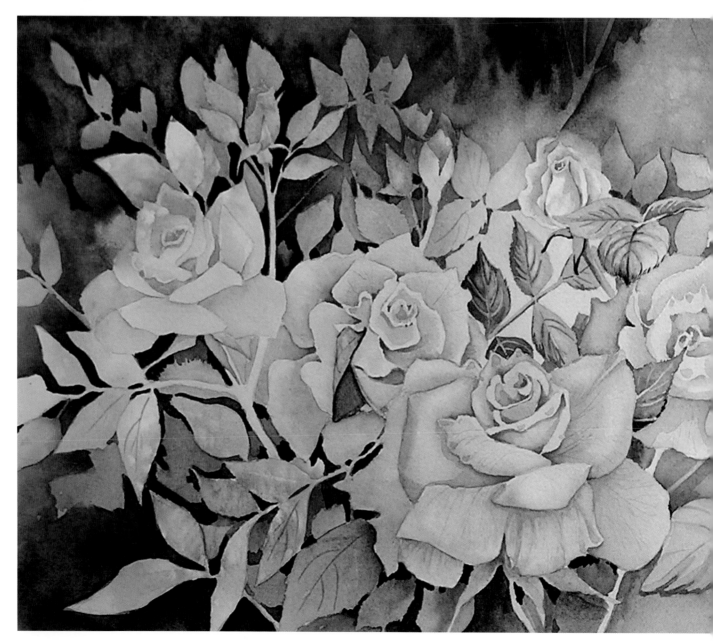

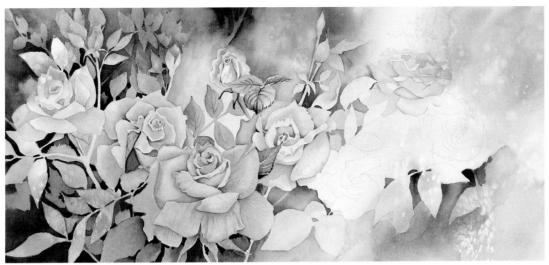

2 This step shows the progression of her composition. Lee started with a layer of negative leaves and then added additional layers to achieve depth.

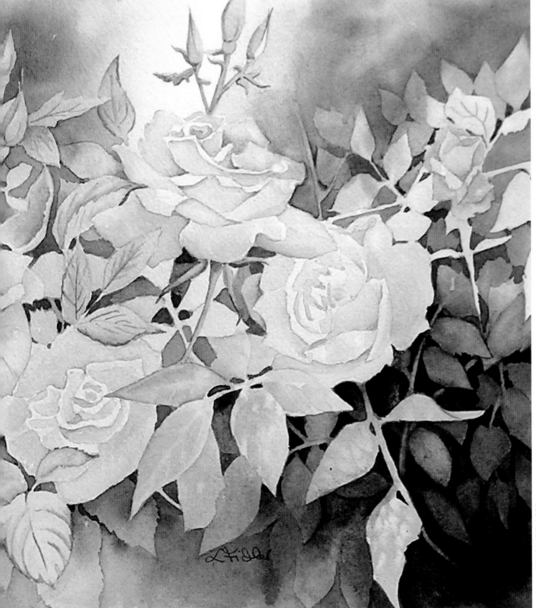

3 The final painting reflects great depth of value and expert negative painting. Lee developed a strong focal area on the left by painting the roses larger and using deeper colors. The roses are also accentuated by the use of darker darks in the negative painting surrounding them.

Lee Fidler 10"x22"

Starting with a two-value sketch

A two-value thumbnail sketch is critical for the success of this lesson. This sketch only takes a few minutes, but the real importance is that it makes you aware of the source of your background light. Make several sketches, then use your favorite sketch as a reference, but be sure to allow for accidental elements of surprise. Wet your paper on both sides and add color only in the dark areas of your sketch and save the white of the paper in the light areas.

1 Be sure to add color all the way to the edges of the paper. I chose to paint hollyhocks into my white areas, so I used yellows, oranges and pinks in my background. I also wanted to use some cool colors such as greens and blues. Be sure your colors are fresh and pure and allow them to mix on the paper surface and not on your palette. Next, rip up some 10-gram, Thai white unryu oriental paper and small pieces of Ogura and add them to the wet surface. Cut some shapes and tear other shapes for variety. Think of these papers as transitional shapes creating movement in and out of the central white shape. The use of these papers can add surprise, depth and energy to your painting. Simply drop the paper onto the wet surface and watch the energy exchange as the paper absorbs the color. Each paper produces a different texture. While the composition is still wet, softly color sand into the white areas to add depth and enrichment. This subtle dusting of color adds a perfect transitional touch to your composition. For example, connect the yellow in one corner to the yellow in the adjacent corner and the blue from one corner to another adjacent corner. Add salt, if desired, in the transitional areas of the whites. When the underpainting is wet, the collage papers appear dark. When the papers dry, the color lightens considerably.

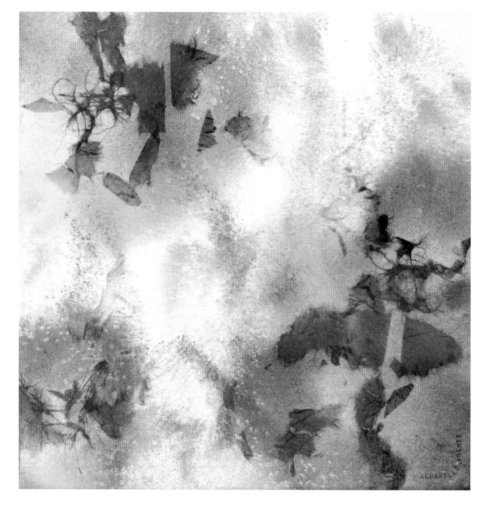

2 After the underpainting dries, glue the dried unryu paper in place with either thinned Yes! Paste™ (this leaves no resist later when you apply more watercolor) or thinned matte medium (the medium will provide some surprises later when the color is layered over). Once again, allow the work to dry.

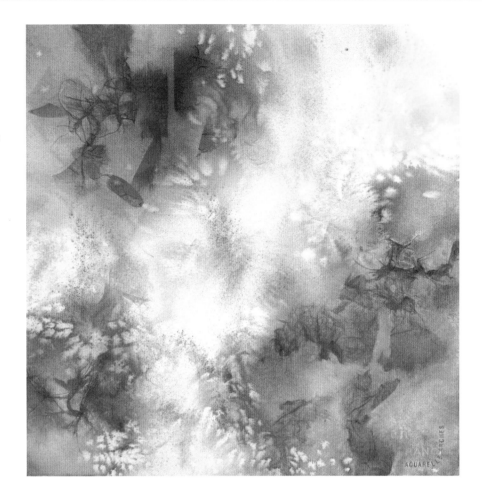

3 Now, draw the image of your choice over the wonderful surface you have created. Hollyhocks were a perfect choice for this painting because I was able to extend their tall shapes into the upper corners. My goal was to draw in the areas of white as well as overlap into the textured transitional shapes. Do not be intimidated by this surface. Draw with abandon.

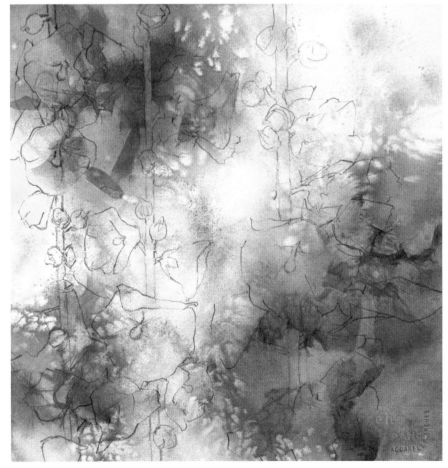

4 This is the best part. All your preparation pays off as you layer color over this surface and watch the surprises that magically happen, such as washes of color that will appear darker over the collage or an unexpected resist from some thick glue. As you layer darker color over the underpainting, stay in the same color range. For example, in cool areas, use a harmonic range close to the underpainting color. As you move from gold to blue, be sure to merge the colors to create smooth transitions to green before you go to blue. Color harmony is a key factor in enriching your painting. Soften all the edges that touch the white shapes.

So many magical things happen in watercolor, I always feel "it's a miracle"

5 Before you start the next layer, take a minute to stamp textures and words on 10 gram unryu paper using your watercolor paints. I never stamp directly on my paintings. I like this intermediate step because it allows you the option to move your collage pieces around before you actually glue them down. Stamping directly on your painting is risky and can overpower your composition. These lovely additions of stamped designs glued exactly where you want them can create beautiful transitional areas and blend into your composition. Allow these textures to dry.

Select several ripped pieces of the stamped oriental papers and place these pieces partly in the light area and partly in the dark area as transitional textures on your painting. Using thinned Yes! Paste™ will leave a workable surface when dry. Sometimes these lovely transparent, transitional textures look great glued over part of the image.

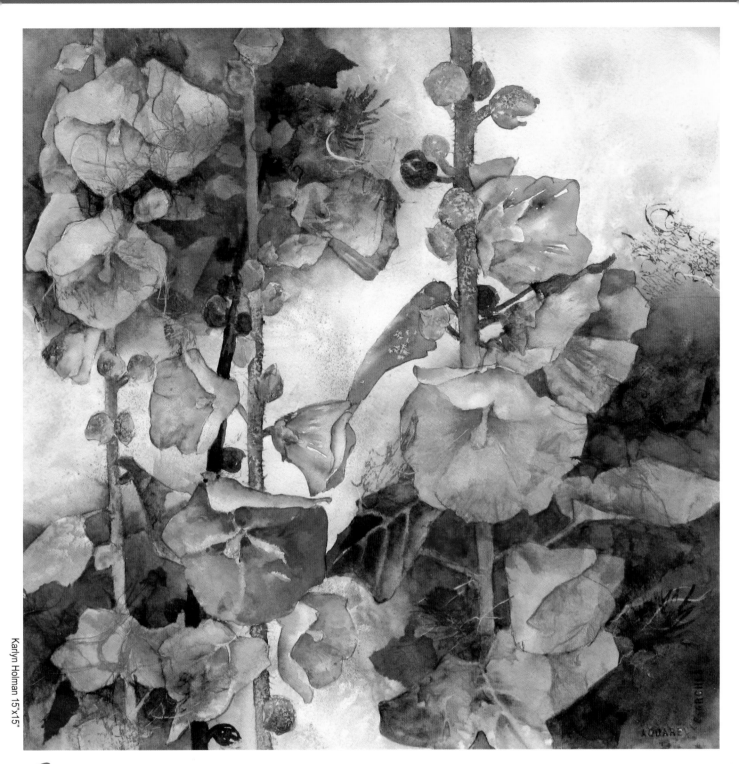

6 To finish your painting, paint the subject positively in the white areas. The shapes you negatively painted around require very little additional painting. In fact, leaving these areas as "ghost-like" is the best choice. Remember to add darks against the light background and preserve lights against the dark background.

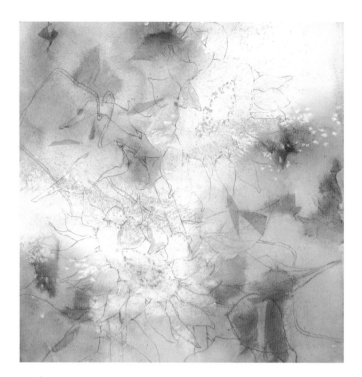

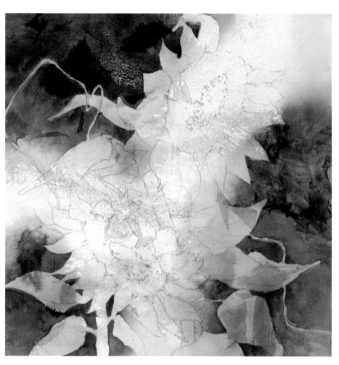

1 This underpainting was created with Winsor yellow, quinacridone gold, quinacridone burnt orange and Antwerp blue. These are compatible colors that always achieve glowing results no matter how they are mixed.

2 This step shows how painting negative areas revealed the path of light.

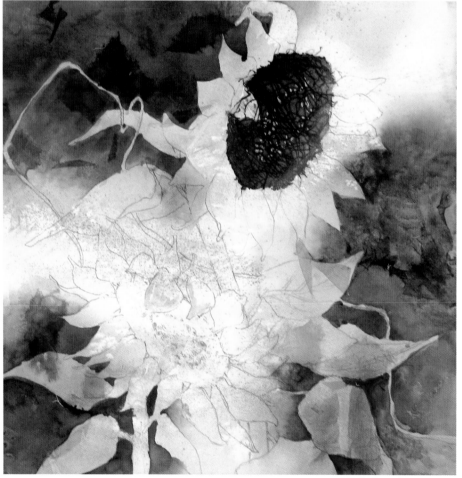

3 The centers of the sunflowers were textured by wetting only the center and placing a single layer of cotton medical gauze onto this wet surface. Rich color was added by harmonically working from light to dark warm colors. I used a sequence of Winsor yellow, quinacridone gold, scarlet lake, quinacridone burnt orange alizarin crimson and finally Antwerp blue. A final touch of ultramarine blue ensured that the colors would sink through the gauze and create the dark lines in the centers.

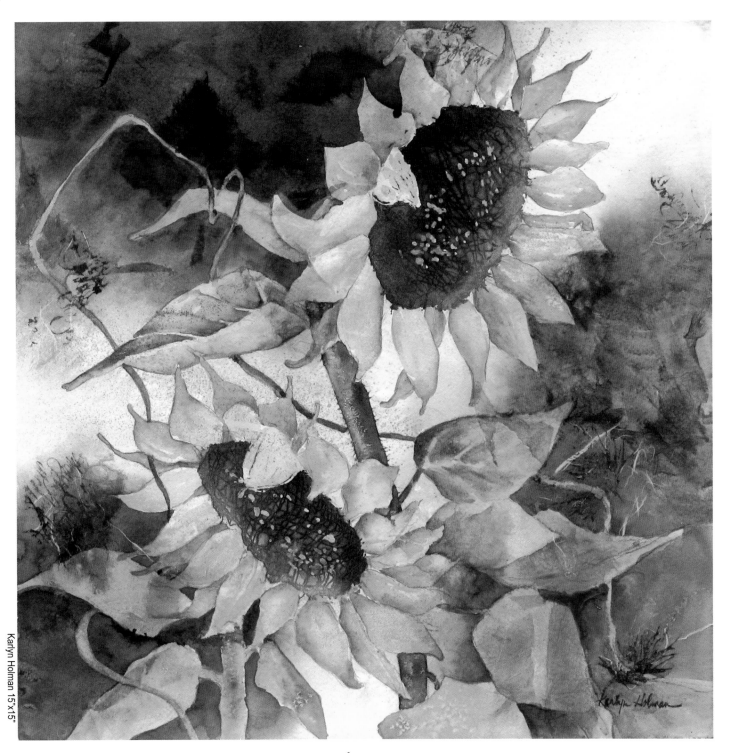

4 The gauze was removed and the positive shapes were painted. The final touch was to balance the darks against the lights and the lights against the darks.

1 The path of light was created using a hint of the colors that are appropriate for a morning glory painting.

2 The colors in the negatively painted areas were pushed as dark as possible for optimal contrast.

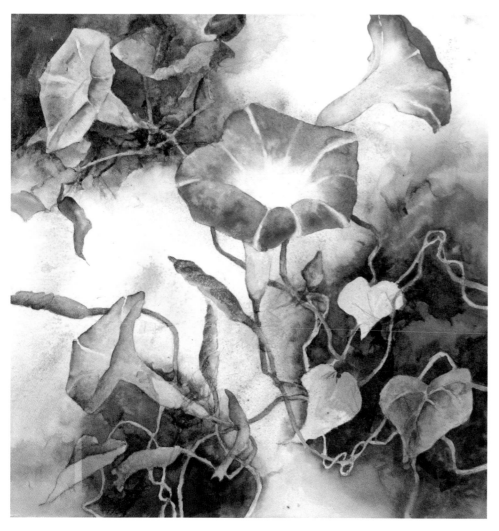

3 After the positive shapes were painted in the light path, I felt the white contrast was too stark.

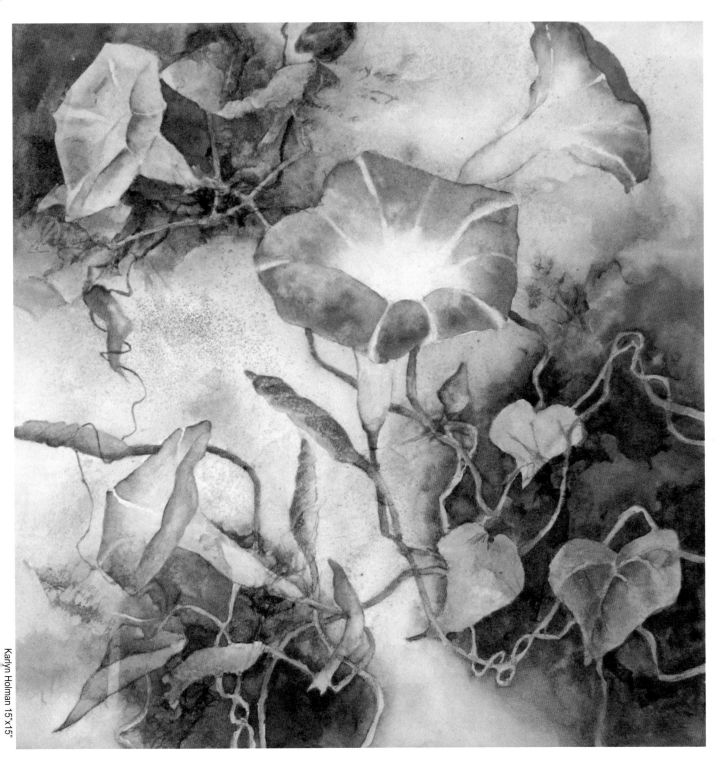

4 To remedy this whiteness problem, I simply wet the white areas,
gently pulling in the adjacent colors and adding a little more
color sanding, thereby creating soft highlights and giving the painting
a finished look. If your painting needs more balance and connection,
simply add more color and soft texture.

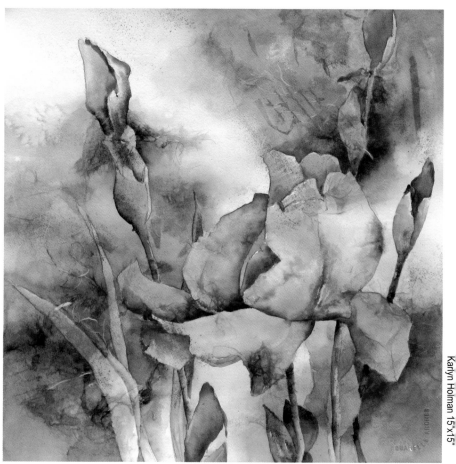

This shows the underpainting and finished painting of an iris.

This illustration shows the underpainting and finished painting of red roses. The combination of collage and watercolor is such a perfect partnership to create exciting surface textures and color enhancement. Choose any subject and try this positive/negative approach to create drama and enrichment in your paintings.

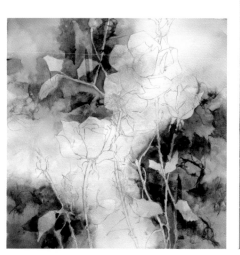

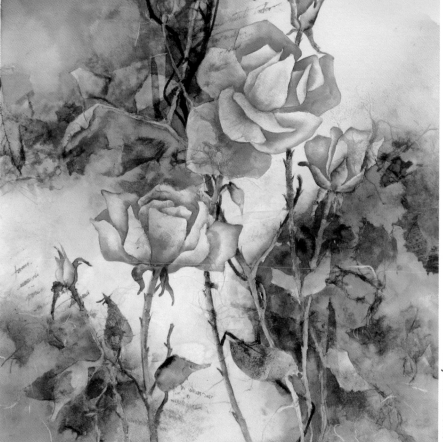

Karlyn Holman 15"x15"

Karlyn Holman 15"x15"

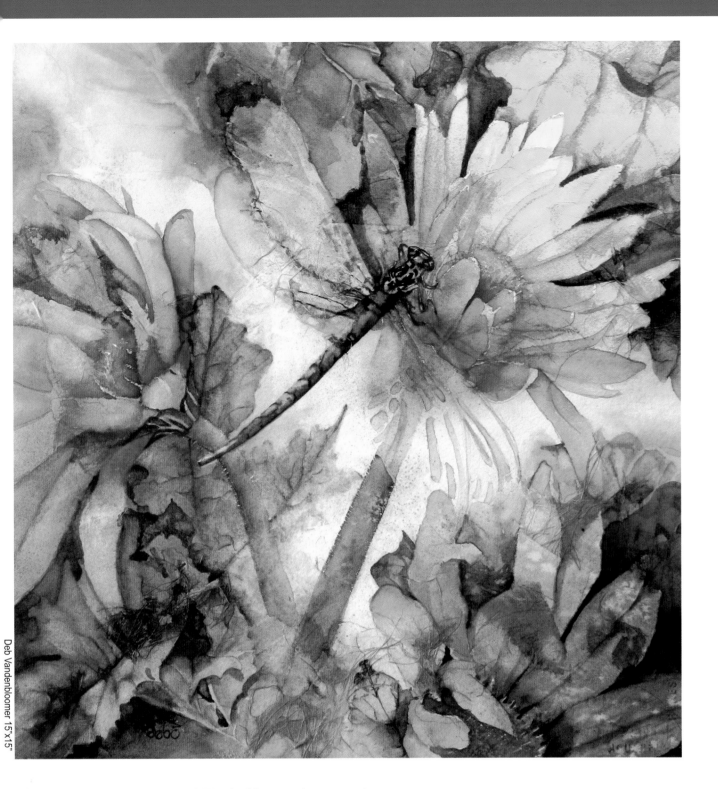

This beautiful watercolor by Deb Vandenbloomer showcases the
subtlety of a dragonfly against the beautiful colors of the flowers.
The placement of the dragonfly's body, partly in the white area and
partly in the negative area, creates a striking focal point and ties the
composition together.

Combining color sanding with a traditional layered approach

This subject was found on the grounds of Le Vieux Couvent, a seventeenth century convent in South West France. Sue's goal was to render a moody painting with high texture and intense, deep color.

Sue Primeau is an innovative colorist with a fresh style of direct painting. She loves to push the boundaries of watercolor by combining techniques.

Sue Primeau

Sue Primeau

1 This step shows the traditional underpainting created by layering several washes of cobalt blue and permanent magenta to form the cool cast shadows. To create the finished colors of the watering can and the background, Sue used complementary colors in the preliminary underpainting. Permanent magenta was used for the golden watering can and cobalt blue was used for the orange background.

2 This step shows the effect of adding warm complementary colors using the technique of color sanding. Sue wet the area she wanted to work on and using 100-grit sandpaper, she rubbed watercolor pencils on the sandpaper and dropped the shavings onto the wet surface. **Caution:** when using this technique, do not blow away extra shavings; instead, remove them by gently shaking them into the garbage.

3 The color sanding captured the rough texture of the stone walls, the intense warm colors and the heavy shadows cast by the setting sun. The amount of pigment sanded from the pencils and the number of colors layered at one time determined the texture and intensity of the color saturation.

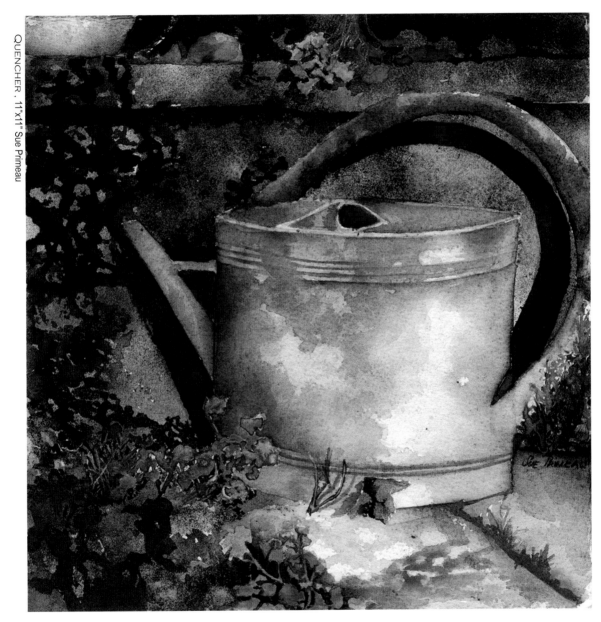

QUENCHER , 11"x11" Sue Primeau

4 Note the rich sanded colors of yellows, oranges, golds and greens in the stone wall behind the watering can. After the first layer dried, Sue rewet the areas of darkest shadow and sanded in dark greens, blues, purples and browns. Rewetting can be a problem depending on the type of pencils used. Generally, when the pencil color is well dried, you can rewet the area without reactivating the color. To be on the safe side, choose darker colors when rewetting the surface. The

watering can was completed with layered watercolor to show the cool, smooth metal of the can and to provide a contrast to the stone tiles. When Sue painted the can, some of the invisible particles of sanded watercolor pencils were reactivated by the water, creating a reflected look on the surface. The use of sanded watercolor pencils produced a surface that could not be achieved with a brush alone.

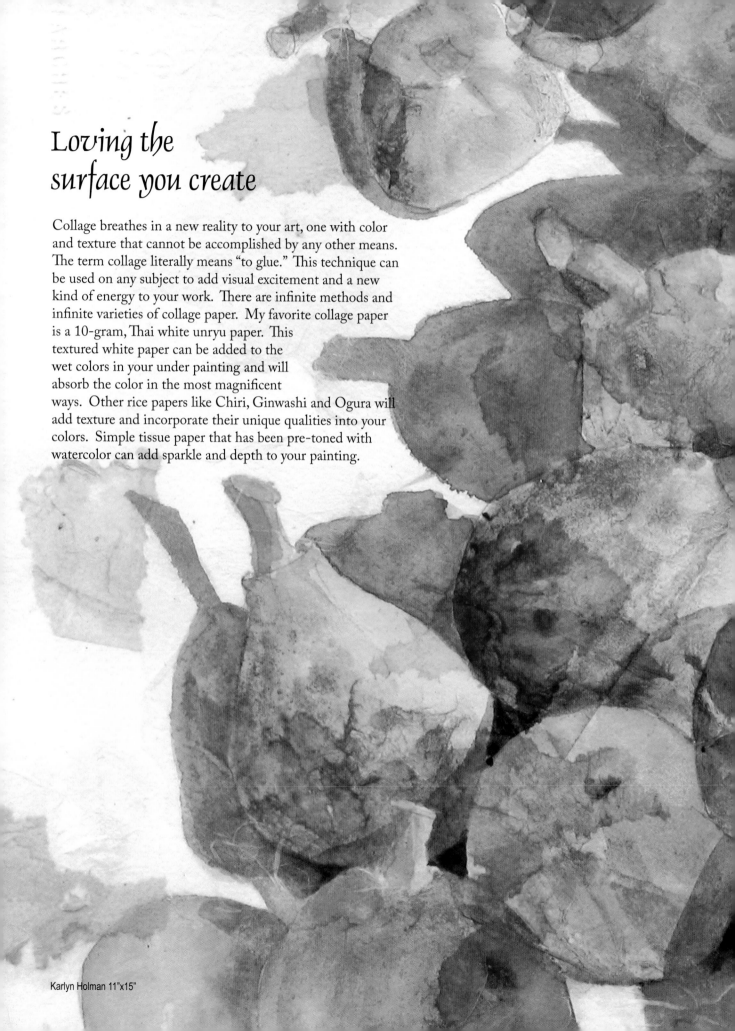

Loving the surface you create

Collage breathes in a new reality to your art, one with color and texture that cannot be accomplished by any other means. The term collage literally means "to glue." This technique can be used on any subject to add visual excitement and a new kind of energy to your work. There are infinite methods and infinite varieties of collage paper. My favorite collage paper is a 10-gram, Thai white unryu paper. This textured white paper can be added to the wet colors in your under painting and will absorb the color in the most magnificent ways. Other rice papers like Chiri, Ginwashi and Ogura will add texture and incorporate their unique qualities into your colors. Simple tissue paper that has been pre-toned with watercolor can add sparkle and depth to your painting.

Karlyn Holman 11"x15"

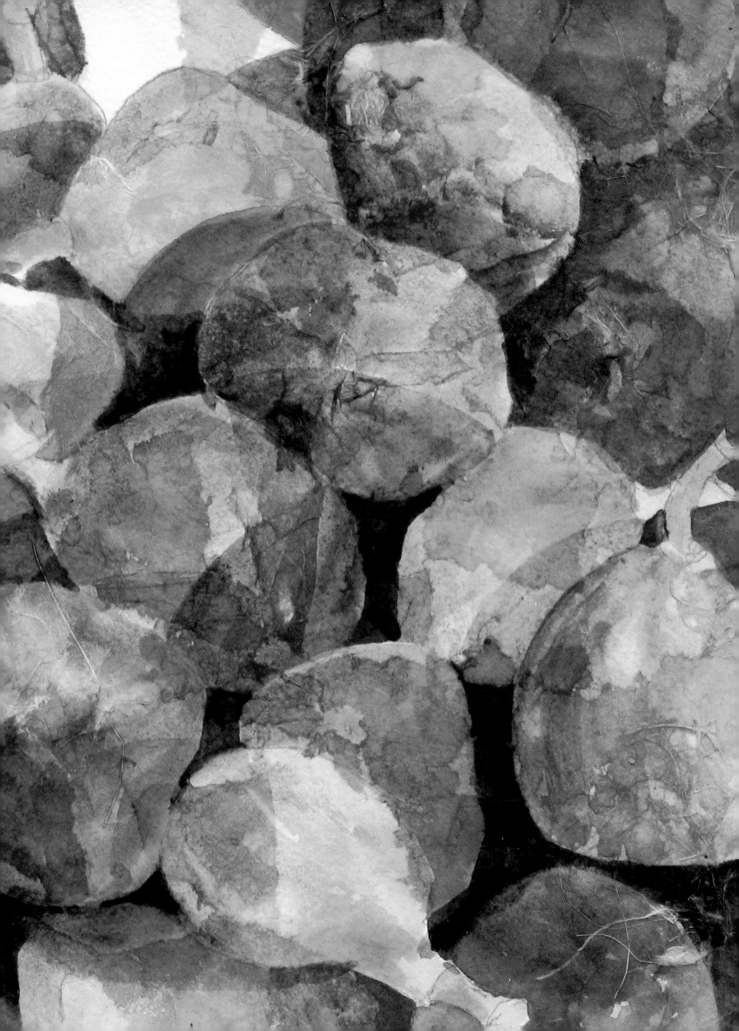

Achieving vibrancy with tissue paper

Tissue paper collage creates a range of textures and colors that are limitless. The results from adding this texture are often better than anything you can achieve by using only watercolor paints. There is always an element of surprise that emerges when you combine pre-stained tissue paper with watercolor.

Karlyn Holman

1 The color, cast shadows and overlapping shapes of these onions provided a perfect subject for combining tissue paper and watercolor. When interpreting a subject, some planning is usually a wise choice. Capturing the shadows in a traditional way by using cobalt blue and permanent magenta to establish the cast shadows is an easy start. Now let intuition and creativity take over.

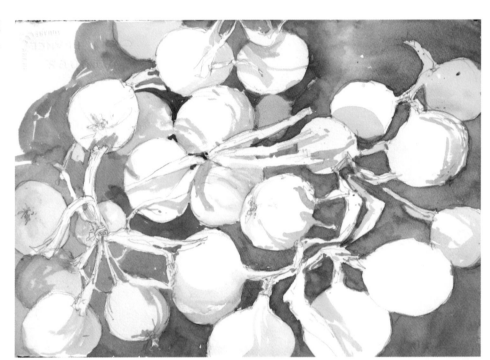

2 Next, layer in more darks, pushing all the way to a value nine.

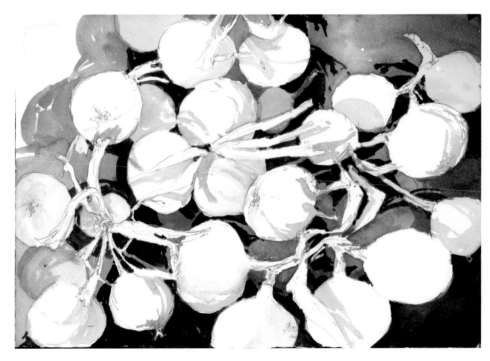

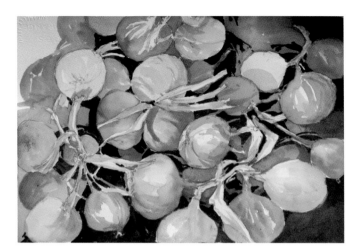

3 Next add raw sienna, quinacridone gold, quinacridone burnt orange and scarlet lake for harmonic enrichment over the onion shapes.

4 Prepare the tissue paper by placing the tissue over a white plastic bag. Paint pure pigments of light to mid-tone values onto the surface, choosing colors you would like in your finished painting. When this dries, the paper will peel free from the plastic.

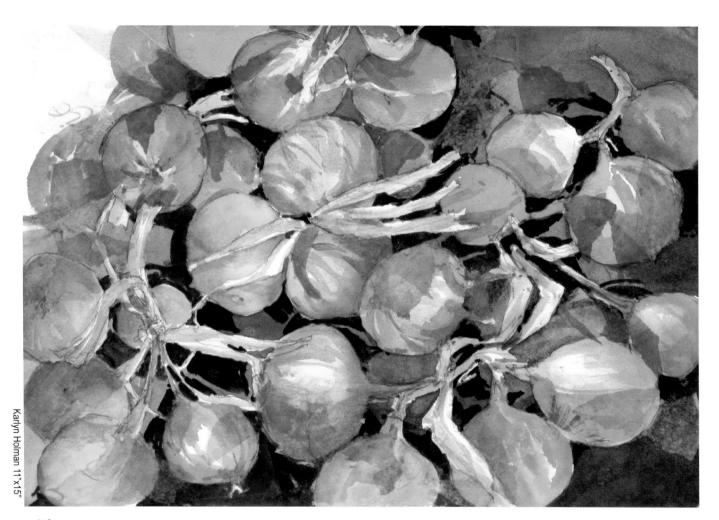

Karlyn Holman 11"x15"

5 These colorful, archival papers are then glued over the underpainting using thinned Yes! Paste™. Do not make these values too dark. By gluing down these pigmented tissues, you are building up an archival surface of glowing color. Some pieces are placed specifically where you may want them and others may be glued down in a random fashion. Additional color may be added over the papers and with each layer, new and exciting surprises will be revealed.

Complementary colors are the greatest contrast

1 The mushrooms were started with permanent magenta. To further enrich this underpainting, cobalt blue was added for color harmony.

Karlyn Holman

2 To continue, quinacridone gold, raw sienna, Winsor yellow and quinacridone burnt orange were applied over the dry surface. This layering process creates glowing saturated color, far better than blending yellow and purple.

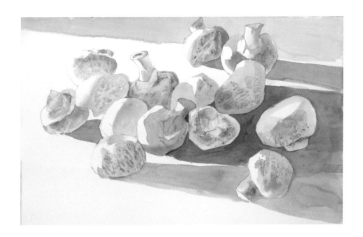

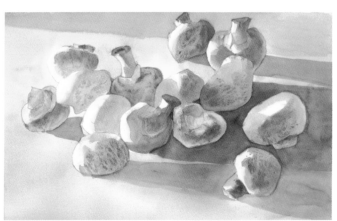

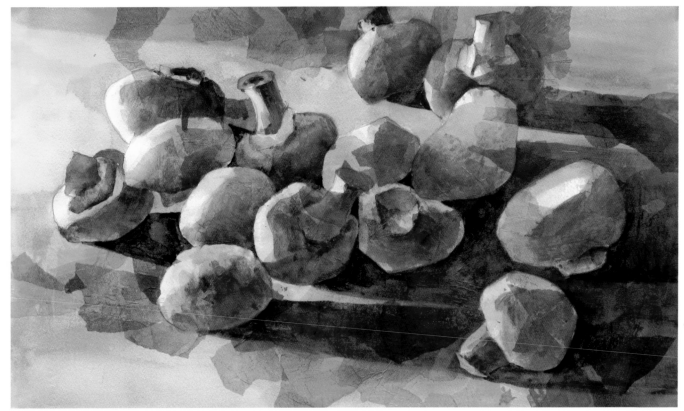

Karlyn Holman 15"x22"

3 The final painting was finished with pre-toned tissue paper and layers of transparent watercolor. When you layer on the tissue, try to glue "outside the lines." Move from the control of the underpainting to the spontaneity and joy of gluing down these colorful papers. Connect the papers to the edges of the composition. Freely add light tissue over the dark colors and dark tissue over the light colors.

Figs in a market

The color, cast shadows and overlapping shapes of these fresh figs in a market in Cahors, France caught my eye and provided a perfect subject for experimenting with pushing color and texture by combining tissue paper and watercolor.

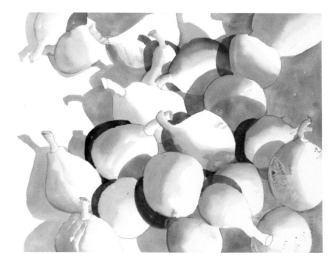

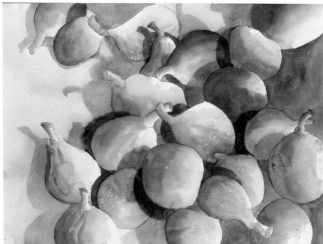

1 The next step after drawing your subject is to capture the cast shadows in a traditional way by using cobalt blue and permanent magenta. After you have established the cast shadows, you can capture the volume of the figs by placing the dark color on the shadow side and losing the edge on the sun side.

2 Next, layer in a broad range of complementary warm colors like yellows and yellow-greens, all the way to oranges and reds. This is the fun stage to see the figs come alive with the warm colors. If you really like your painting at this stage, simply quit.

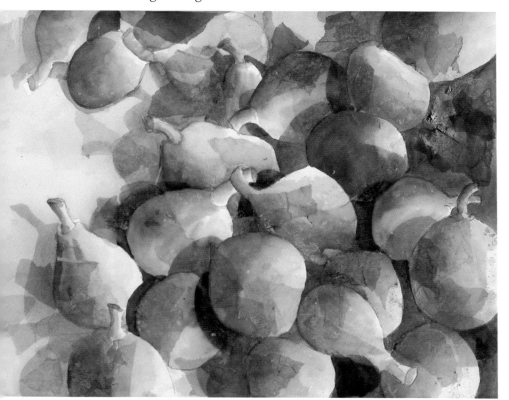

3 Pre-tone some tissue paper with your watercolors. Keep the value of these colors on the light side. These colorful, archival papers are then glued over the under painting using thinned Yes! Paste™. By gluing down these pigmented tissues, you are building up an archival surface of glowing color. Some pieces are placed specifically where you may want them and others may be glued down in a random fashion. Additional color may be added over the papers and with each layer, new and exciting surprises will be revealed.

Karlyn Holman 15"x22"

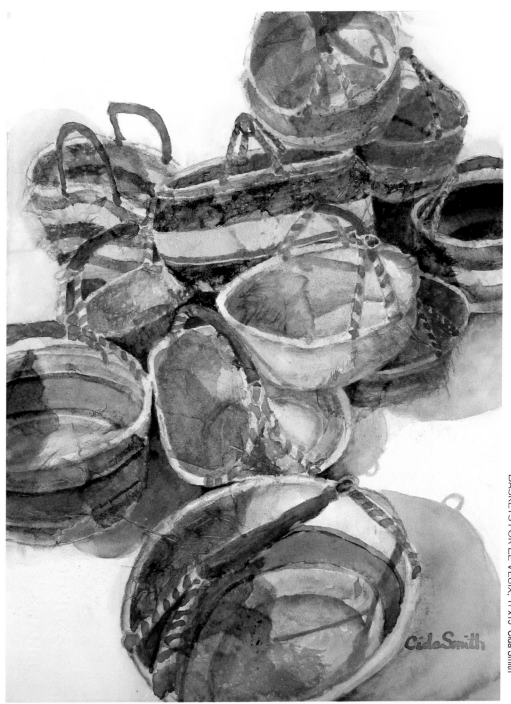

BASKETS FOR LE VEUIX, 11"x15" Cida Smith

Cida Smith has a great eye for subjects and found these haphazardly stacked baskets at an outdoor market in South West France. She achieved this highly textured interpretation by first capturing the shadows and then gluing pre-stained tissue paper over her underpainting. She used Yes! Paste™ so the surface would not resist successive layers of watercolor.

Cida Smith

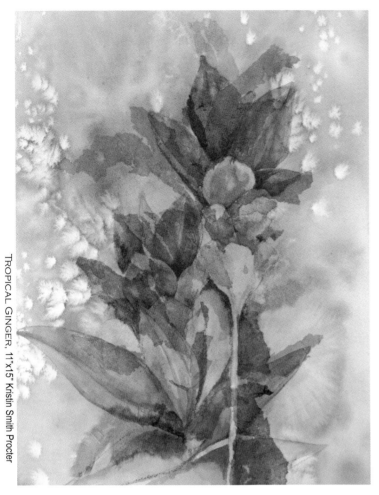

Kristin Smith Procter loves color and texture and used her skills to interpret this unusual ginger flower that she saw in a window at a seventeenth century convent in France. She started with a wet into wet underpainting and used kosher salt to begin to establish texture. After this dried, she layered ripped pieces of pre-stained tissue paper, gluing the tissue paper with thinned Yes! Paste™. The textural effects achieved by layering the papers really captured the delicate nature of this lovely flower.

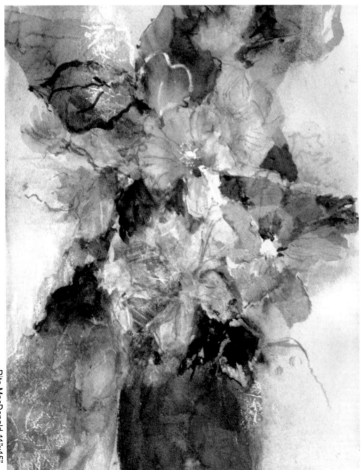

This fresh painting by Rita MacDonald was completed using pre-stained tissue paper and the addition of lines with Caran d'Ache® water soluble crayons. These warm colored crayons added a perfect linear touch which emphasized the delicate tissue papers.

Many artists are drawn to collage by its tactile quality. This technique appeals to a viewer's sense of both sight and touch. In this painting, napkins, stamped unryu, metallic gold spray and even webbing spray were used to create texture.

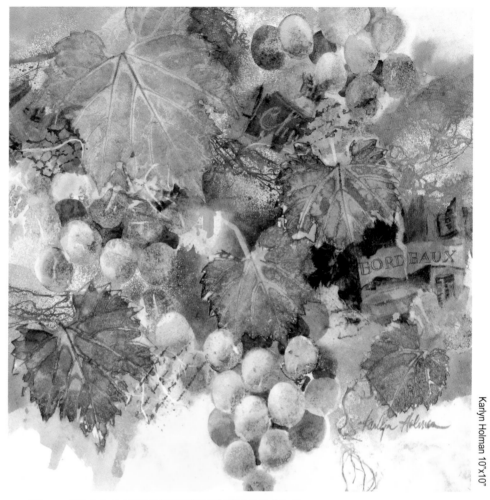

Karlyn Holman 10"x10"

This artichoke painting was created by gluing pre-toned tissue collage and drawing with a gutta bottle filled with yellow-green acrylic paint.

Collage adds such depth to your artwork—every time you look at it, you see something new.

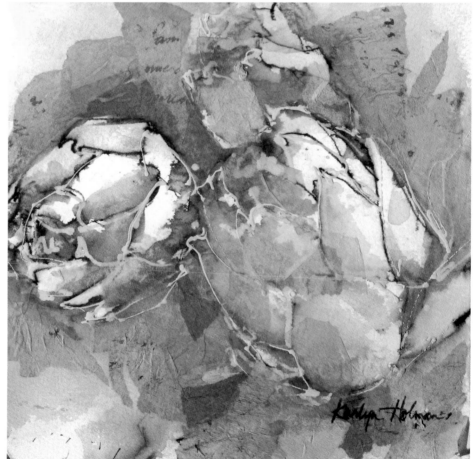

Karlyn Holman 10"x10"

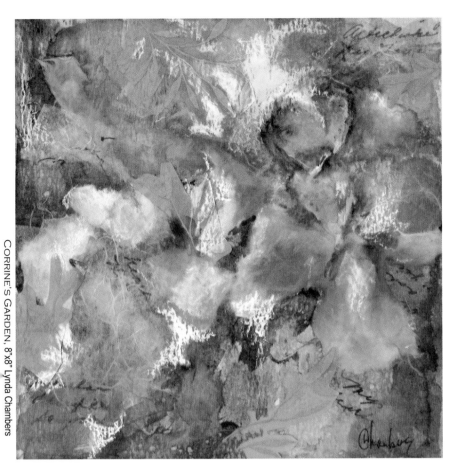

This abstracted floral painting by Lynda Chambers features pre-stained tissue papers, Caron d'Ache® water soluble crayons and freely painted watercolors splashed and mixed together to suggest flowers.

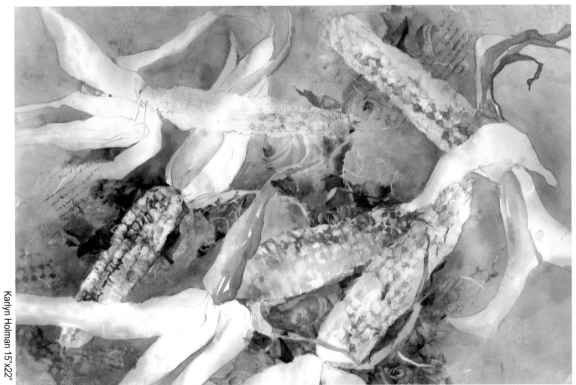

This painting of late harvest corn is full of texture and color. As I was gluing on napkins and collage materials to create the path of dark throughout the painting, I suddenly stopped working on the painting and decided I had said all I wanted to say. The painting felt complete even though the light shapes that formed the sheaths of the corn were unfinished. Sometimes you have to go with your intuition and just stop. Whenever you use non-archival materials like napkins, be sure to apply a coat of gloss or matt medium or spray the finished painting with either gloss or matte acrylic spray to seal the surface and make it archival.

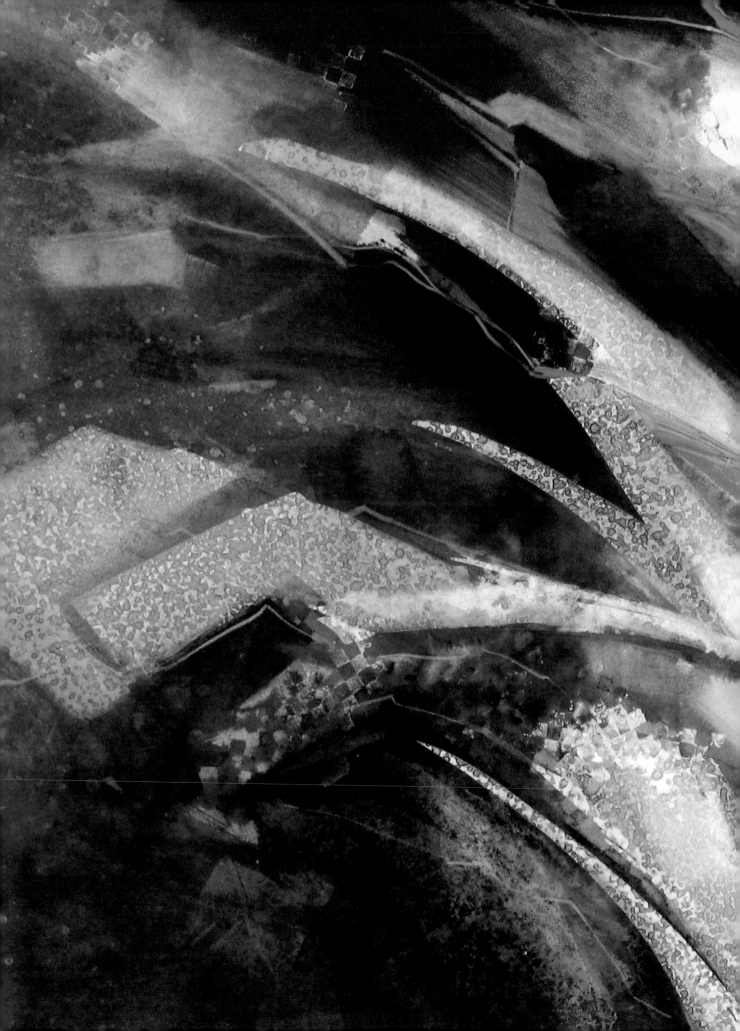

Opening the door to explore in mixed media

In this final chapter, anything goes. The media of watercolor invites you to try experimental approaches and can lead you on unexpected adventures in visual communication. The art market offers us new tools, paints and mediums almost daily. The following lessons offer only a small sampling of the methods, tricks and ideas available to help expand your creative self and open the door to a whole new world of visual possibilities. Mixing media is like embarking on a trip without a map. Open the door to explore, improvise, experiment and discover how this wealth of information can be adapted into new and exciting approaches. Take the road less traveled, and as you work without boundaries, you will begin to see and nurture your own personal touch in your artwork. Maintain a spirit of spontaneity and watch your creative world expand.

In pursuit of good design

All painting styles and subjects can be evaluated on the level of pure design. Design is the overall arrangement or layout of your composition. There are six elements that underlie this structure and these elements are the determining factors that make your painting visually dynamic. The six elements of design are line, color, shape, value, movement and texture. If you paint in an abstract manner, you will become more aware of these elements of design.

Planning an abstract painting

The hardest part about painting an abstract is getting started. I find it helpful to work from a compositional reference. The time it takes to make little thumbnail designs is really worth it. These ideas only take a few minutes, but may give you the confidence you need for the inspiration behind a painting. A great deal of composition just happens intuitively as your work evolves, but a little planning is always a good idea. There are many ways to generate a compositional idea reference.

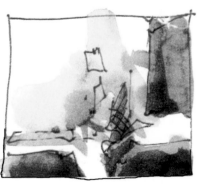

Using a simple cruciform design is a wonderful "formula for success." The more you design using this format, the more the process will become intuitive. Start with something as simple as a tic tac toe graph. Choose any three cross-sections to develop your cruciform design and leave the fourth cross-section as a rest area.

Try a two-value or three-shape reference

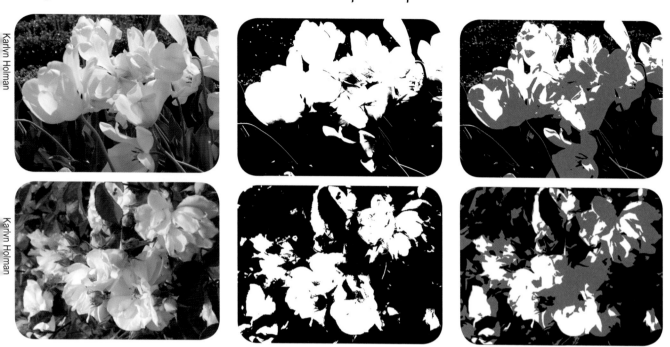

Another exciting option for a reference is a simple two-value or three-shape black and white design made from a photographic reference. These visual diagrams can help you design your beginning values and shapes. Although many artists use pencil to create thumbnail designs, your computer can achieve these compositional references in short order and may prove to be a fantastic aid in the planning process. After you get started, you can enrich and further define the surface using collage, crayons or whatever works. The real joy in painting an abstract is in enjoying the fun you have along the journey. With the help of these designs, you are mapping out directions for success in your finished painting. The colors, lines and textures you add will fall into place as you explore. Instead of putting on the brakes, take a free-wheeling approach to painting your composition. The journey of painting an abstract is as much fun as the destination.

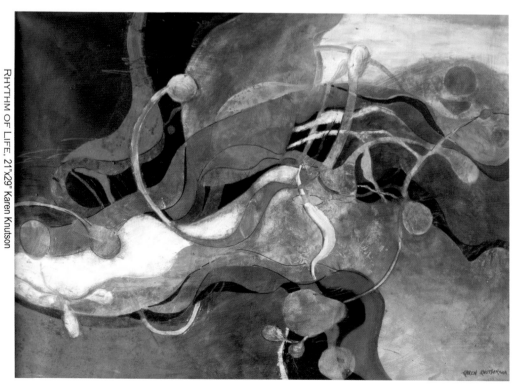

This painting by Karen Knutson titled *Rhythm of Life* was inspired by looking at a still life of green plants. Karen started with a black and white design sketch, took the still life away and concentrated on portraying only exciting color and movement. The interlocking horizontal and vertical design resulted in an exceptionally beautiful cruciform composition featuring a warm dominance contrasted by a touch of cool harmonic color.

An easy way to begin an abstract or semi-abstract design

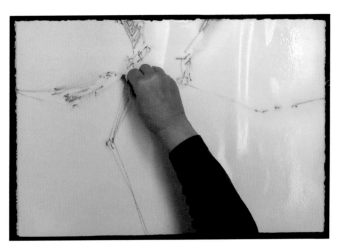

1 Wet both sides of a piece of 140# cold press Arches® paper and draw your major shapes of movement using a watercolor crayon. I used a Caran d'Ache® crayon.

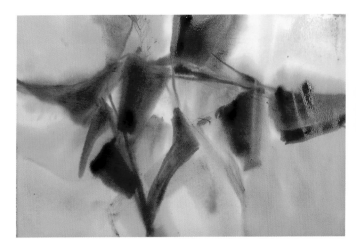

2 Paint in mid-tone harmonic colors and add a complementary color for contrast. Most importantly, save some areas of white paper. To ensure an even light distribution of water, be sure to move your arm when spraying; do not point and shoot.

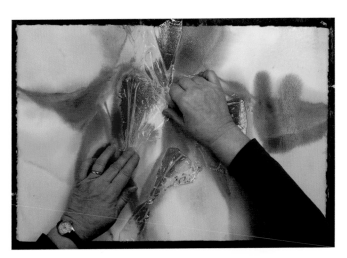

3 Next, stretch pieces of plastic wrap and place them in and out of the white shapes. I prefer to use the original heavier transparent Saran™ Wrap instead of the newer cling style.

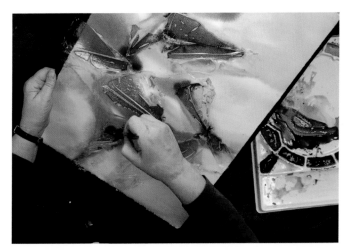

4 The fun really begins when you tip the board and feed darker valued colors under the Saran™ Wrap. Try to link these darker shapes using a fluid movement and connect them to the edges of the paper.

You will discover that your intuition comes into play when you are working on an abstract composition

5 Stretch medical gauze into the wet paint to create linear movement. While the surface is wet, a plastic card loaded with paint may be stroked across the painting to create additional lines of movement. If you really like the way your painting looks at this stage, you can let the paint dry. When you remove the gauze and Saran™ Wrap, you will have a transparent watercolor.

6 If you choose to move into mixed media, you may now add colored metallic spray into the wet paint. This technique works particularly well when the spray is applied directly over the gauze. Be careful not to overspray because subsequent layers of watercolor will resist the metallic spray. I used an eighteen carat gold spray on this particular painting.

7 When your painting dries, remove all the texturizing devices. This is the time to save the parts you like and change the areas that need more development.

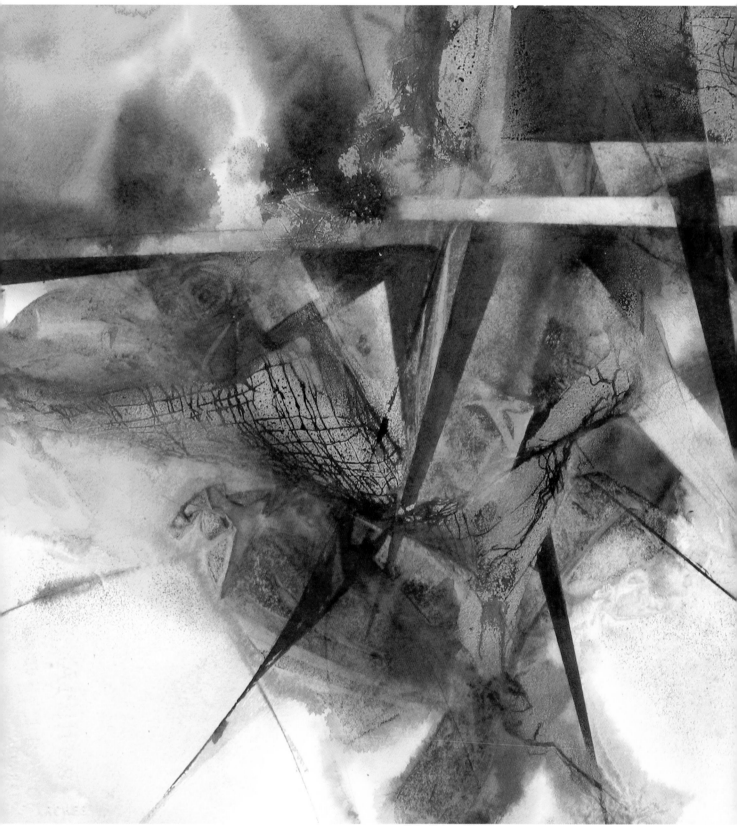

Karlyn Holman 15"x22"

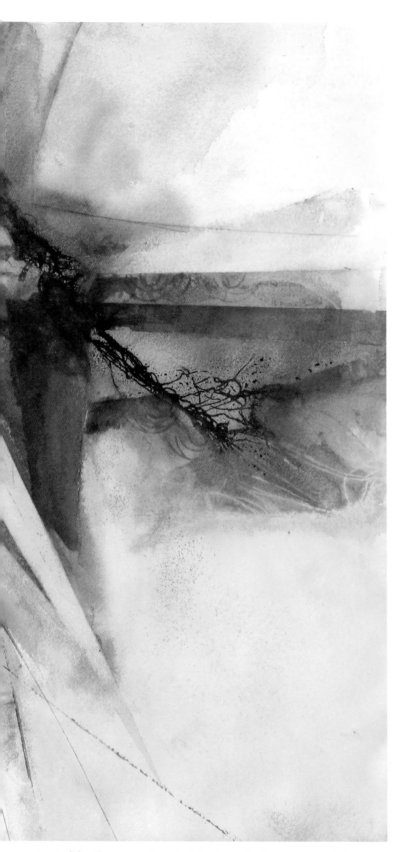

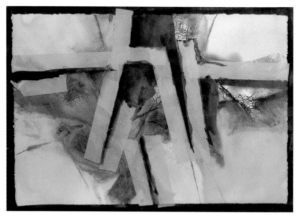

8 To finish the painting, I added more darks on dry paper to achieve crisp edges and enhance the cruciform composition. Masking tape was applied to the surface and burnished with the edge of a plastic card. This step ensures that the paint will not seep under the tape. When you add additional paint, the exposed areas will fill with color and the areas covered in metallic spray will resist.

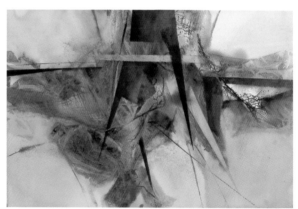

9 To regain some whites or lights of the paper is an easy task, accomplished by using a piece of transparency and a Mr. Clean® Magic Eraser®. Dampen the eraser with water and rub it along the edge of the transparency to lift the color back to the white of the paper. These magic erasers can lift even staining color. You can also use a stencil or masking tape to define the shapes you want to lift.

10 The final touch to finish the painting was to add more color in the upper left corner to give a more asymmetrical balance to the composition. The crisp darks were added with a credit card loaded with dark, fluid paint.

Combining realism with abstraction using a cruciform composition

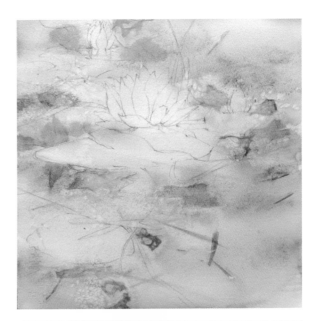

1 Water lilies are a perfect subject choice for illustrating how to approach semi-abstraction. First, draw the images on Arches® 140# cold press watercolor paper and then wet the entire surface. Use negative painting to frame the shapes, but do not paint the shapes themselves. Place pieces of 10-gram unryu oriental paper randomly onto this wet surface and sprinkle on some salt to create additional texture. Allow this underpainting to dry and then glue down the unryu papers with thinned Yes! Paste™ (page 55).

2 Once again, use negative painting choosing dark values to enhance the cruciform composition and more firmly establish the shapes of the flowers. If you choose to add linear shapes in the background, try to reverse the value of these lines by making them light against the darks and dark against the lights. Use harmonic colors to enrich the surface and add more depth.

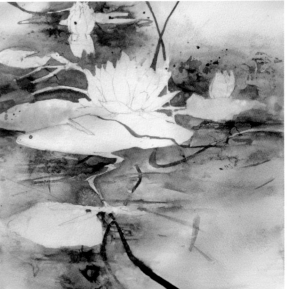

15"x15" Karlyn Holman

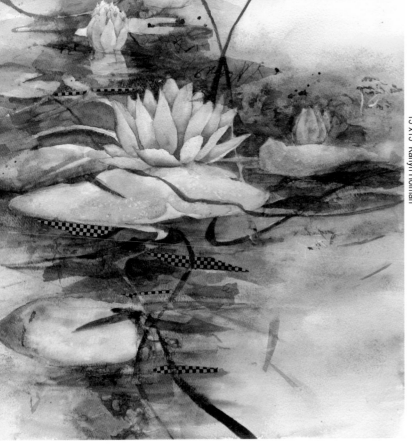

3 At this stage, you are now ready to paint the positive shapes. You may also glue down additional collage papers or experiment with other textural techniques. Remember to maintain a strong contrast in your values of light against dark and dark against light.

1 When attempting semi-abstraction, many people are baffled by the question of "what to paint." Something as simple as pieces of fruit can be an inspiration. To begin your cruciform composition, draw some simple shapes of fruit to form both vertical and horizontal patterns. Wet the paper and add washes of mid-tone colors, painting around the fruit and leaving the fruit itself the white of the paper. Pre-stained pieces of tissue paper may be introduced to accentuate the cruciform design. Salt may be tossed in for texture. When the paper dries, glue the collage papers in place with thinned Yes! Paste™.

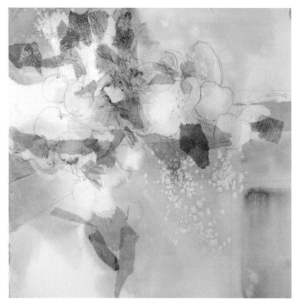

2 In this step, the darker shapes are now established behind the fruit. Every time you paint on the various collage papers, the paint reacts differently than it does on the watercolor paper alone. Once your dark pattern is established, you may then paint the positive subjects.

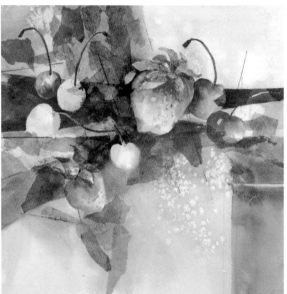

15"x15" Karlyn Holman

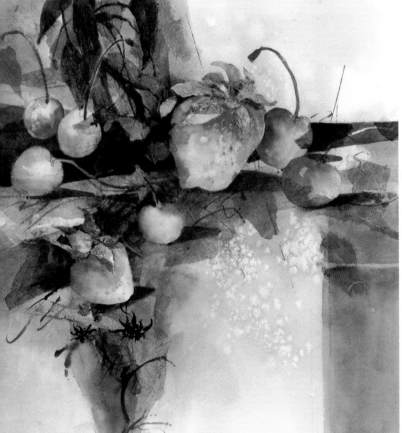

3 This step shows the final darks that are added to emphasize the cruciform design and create a sense of drama and movement. Try to design these shapes to lead the viewers to the focal area where the horizontal and vertical lines intersect.

Combining water lilies with shapes

1 Draw only the positive shapes of your subject on 140# Arches® watercolor cold press paper. Wet your paper on both sides and start with a triad of primary colors. I chose Winsor yellow, quinacridone coral and cobalt to create a "focus of light" on the wet surface. Do not paint any part of your actual drawing. Instead, concentrate on painting only the negative areas. Place ripped up pieces of unryu paper onto the wet surface for added texture. Stretch gauze onto the wet surface to create some random lines and add color sanding and salt if desired. After the underpainting dries, glue everything in place with thinned Yes! Paste™ (page 55).

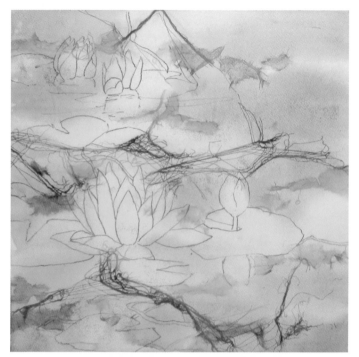

2 The next step is really fun. Collect various circular shapes that fit your paper size. I usually just raid my pantry. Place the largest circle over your intended focal area, as if you are framing the shape. Add more circles interlocking with the larger circle, again selecting the most interesting areas to accentuate. Make sure that some of the circle shapes connect with the edges of the paper. Begin creating a dark path of values through your composition using negative painting. Paint inside some circles and outside others, but do not paint any of the positive shapes. Let the colors in the under painting influence your subsequent color choices.

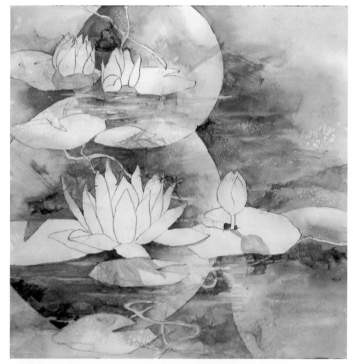

3 After the underpainting dries, you may finally paint the positive shapes, ideally starting with the lily pads. Try this idea: wet a lily pad and add light colors if it is next to a dark area and dark colors if it is next to a light area. While these colors are still wet, place plastic wrap over the paint. Fan the plastic into radiating folds, starting in the center of each lily pad and allow the paint to dry before removing the plastic. The shapes created by the pleated plastic will mimic the veins of the actual lily pads.

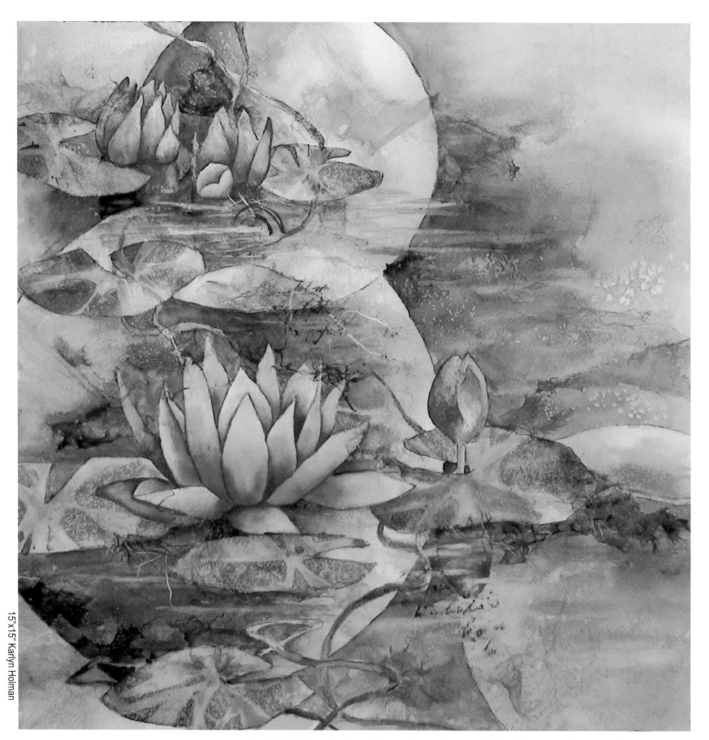

4 Finish by painting the positive shapes of the flowers. As you select areas to paint, be sure to place lights next to darks and darks next to lights. When painting the flowers, always start with the back petals and work towards the front shapes, thereby creating the greatest contrast in your painting.

15"x15" Karlyn Holman

This watercolor began as a cruciform, superimposed with various shapes of color. While the painting was wet, I used a plastic cup as a stamp to create some circular shapes. The circular shapes quickly defined the essence of the painting and lead to more stamping. I also threw margarita salt on the wet painting to enhance the texture.

After the underpainting dried, the circular shapes reminded me of cut fruit, so I used collage to add fruit images ripped from a napkin and reinforced this theme by painting additional fruit images to finish the composition.

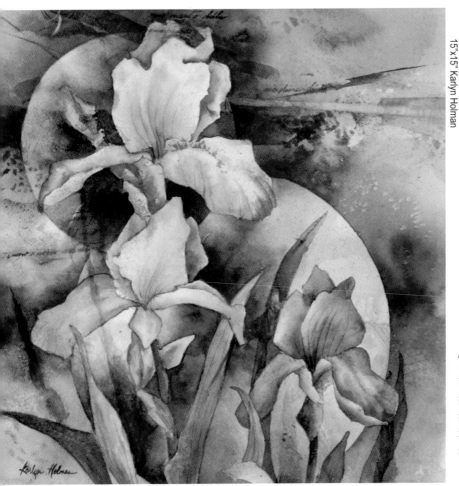

15"x15" Karlyn Holman

These irises were painted using a similar technique involving circles. Remember to always paint the underpainting first, let it dry and then design the abstract shapes. Again, reverse the lights against darks and darks against lights.

The use of checkerboard shapes in this painting of morning glories is one of my favorite examples of how to creatively design a contrasting background. Again, I did the underpainting first, then designed the linking dark shapes that "popped out" the flowers. I was careful to link the dark shapes to the edges of the paper and establish a range of values, as well as incorporate warm and cool colors. The checkerboards serve as effective transitional shapes.

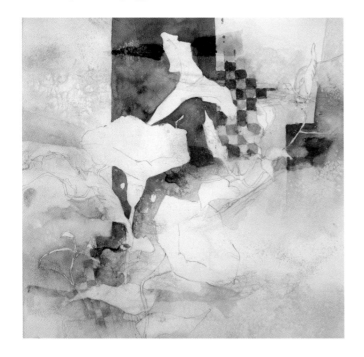

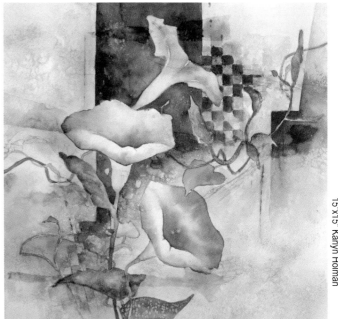

15"x15" Karlyn Holman

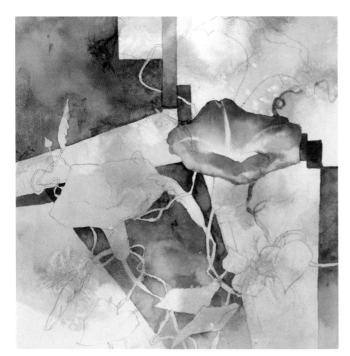

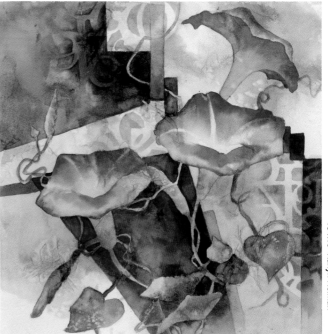

15"x15" Karlyn Holman

The shapes in this background are predominately triangular and echo the triangular shapes of the morning glories. The lettering that links throughout the painting was achieved by using a commercial stencil. The background colors I chose are variations of the colors of the morning glories.

This is a beautiful example of a cruciform composition, mixing realism with abstract design. The interlocking shapes and recurring circular shapes work effectively together to frame in the white flower. Karen Knutson is a master at enhancing her focal area by placing her darkest darks next to her lightest lights.

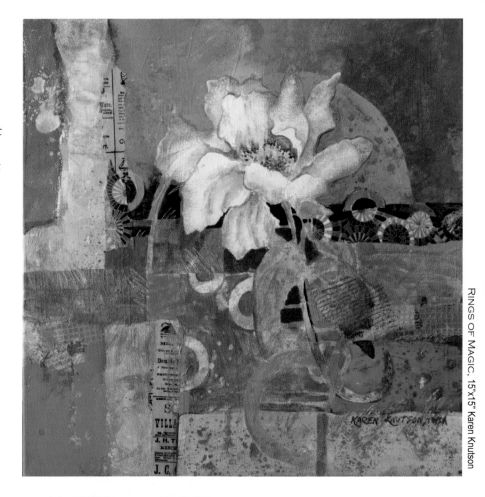

RINGS OF MAGIC, 15"x15" Karen Knutson

This painting shows how masterfully Karen can showcase a gentle flower like this delicate white iris and yet contrast it against the abstract hard lines of design in the background.

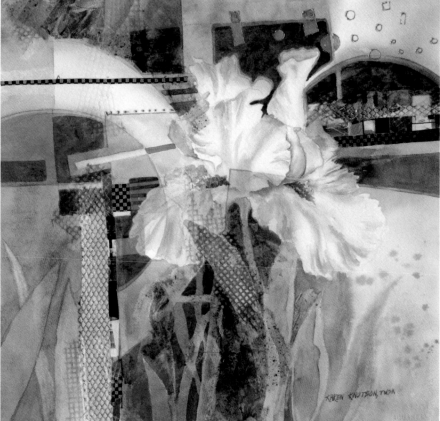

WHISPER OF NATURE, 15"x15" Karen Knutson

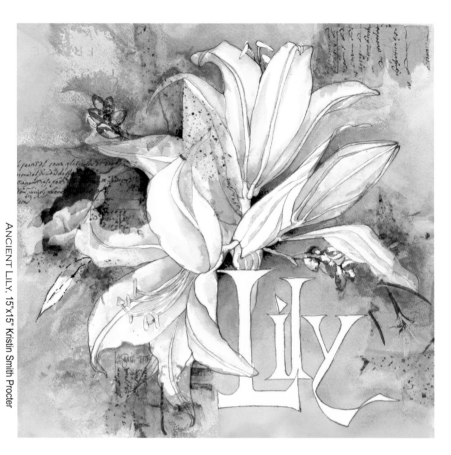

This painting by Kristin Smith Procter illustrates her ability to mix original lettering with a realistic subject.

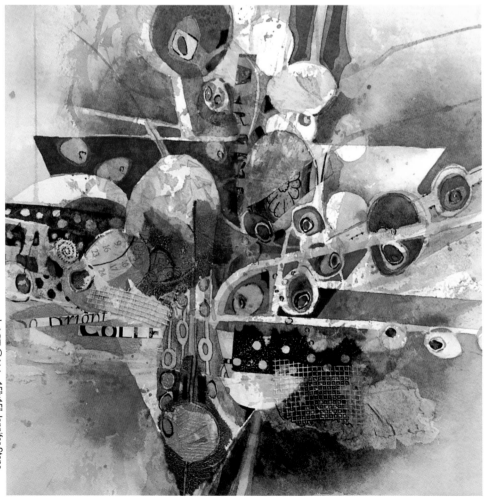

Jennifer Stone's painting of olives in a martini glass has an effervescence that spills right out of the glass into the rest of the composition. In this very entertaining mix of realism and abstract design, Jennifer may have limited her choice of colors, but she had no limitations whatsoever when she designed the vast range of values and shapes.

Exploring another approach to semi-abstraction

This painting was inspired by a photograph showing the natural light catching the cast shadows of a handful of mushrooms lying on my kitchen counter—another good reason why I always have my camera handy.

Karlyn Holman

1 Begin by wetting the paper on both sides. Draw into this wet surface with a watercolor crayon utilizing a cruciform composition.

2 Apply warm and cool colors randomly, leaving the drawn shapes unpainted. At this stage, just enjoy the freedom of applying fresh colors and watching surprises happen.

3 Stretch medical gauze in and through the mushroom shapes, thereby creating interesting and varied linear patterns. Place wax paper on the surface for added texture. While the paper is still wet, spray metallic spray paint into the gauze areas. Do not overspray because the sprayed areas will resist subsequent washes of watercolor. The areas of resist often become some of the most exciting parts of your finished painting. Leave everything in place on the paper and allow your composition to dry.

4 This shows how the painting looks once the wax paper and gauze have been removed.

5 At this stage, your painting may need more darks to pull it together. Create lines in the dark area by negatively painting around the shapes.

6 Next, print inkjet images of the mushrooms on tissue paper and glue them onto the surface (page 64-65). Stroke thinned Yes! Paste™ onto the surface of the painting and then place the images **inkjet side down**, applying additional glue on top of the images.

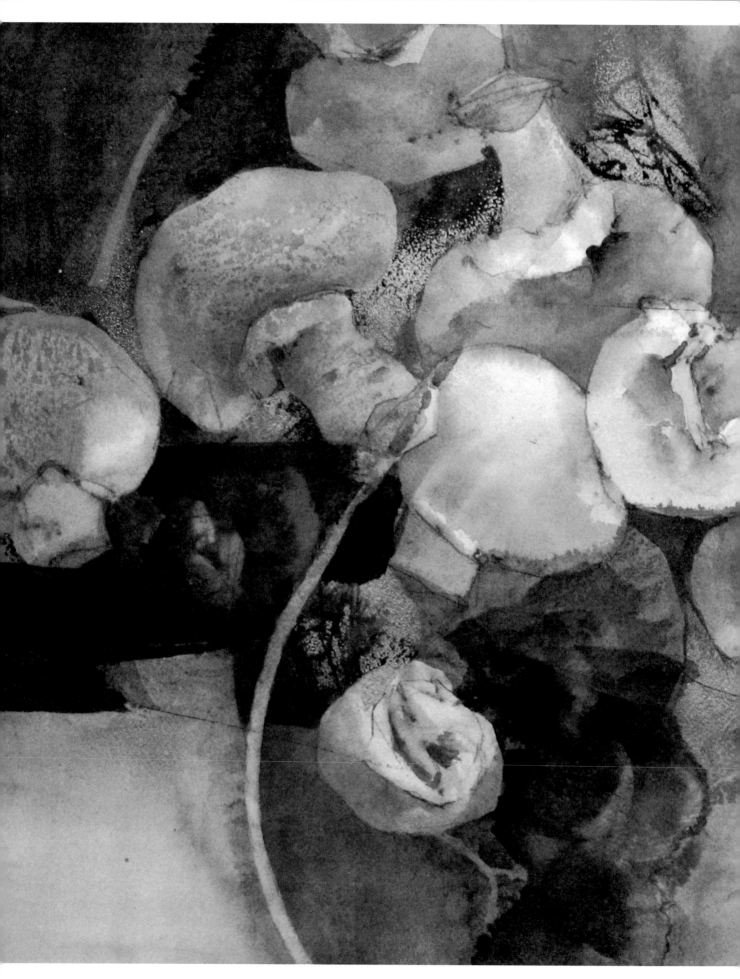

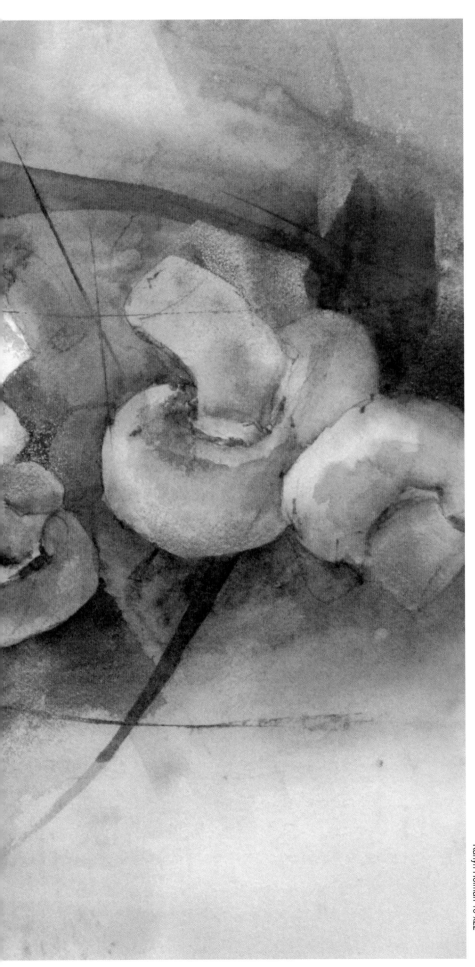

7 You may choose to add more dark color throughout the painting. You may also create lines of movement by using a credit card loaded with paint.

Karlyn Holman 15"x22"

Bridging the gap between drawing and painting by using water soluble crayons

You may want to consider using water soluble crayons in an abstract project to add lines and help create a painterly surface. I always have these water soluble crayons handy in my studio and I carry these crayons with me whenever I travel. Water soluble crayons are direct, very tactile tools that allow you to add fresh energy to your paintings anytime, anywhere. Just remember, these crayons are opaque and contain wax and will never take the place of transparent watercolor.

1 Layering, or adding color over color, is the best way to finish an abstract. This under painting was created by using plastic wrap, gauze, wax paper and gold metallic spray paint. The photo shows the dry underpainting after all the texture-making devices have been removed.

2 Next, energy and contrast were created by drawing on the dry surface with opaque Caran d'Ache® lines. Try to establish movement and link the colorful shapes to the edges of your paper. The waxy nature and high quality of these crayons provide excellent covering power. They mix well and allow you to layer color over color to build up luminosity.

3 At any time, you can add either lines or shapes of color. A white crayon may be used over the dry surface to simplify an area while other colors of these heavily pigmented drawing crayons may be used to add rich color and exciting contrast.

4 The watercolor crayons can be activated with a wet brush to create a "veil of opaque color." This easy technique adds a painterly feel to your abstract and allows you to play with and enrich the surface.

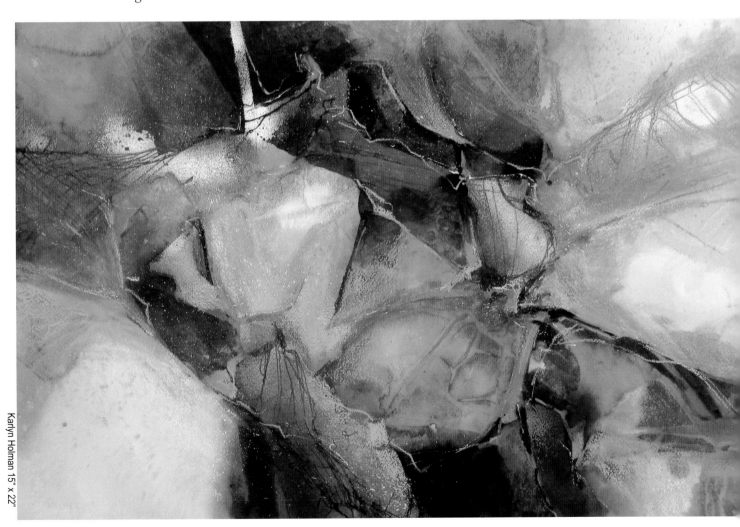

Karlyn Holman 15" x 22"

5 To finish this painting, connecting dark shapes were added, linking from one edge of the paper to another. Adding these exciting opaque colors is like adding jewels. As transparent watercolorists, we usually work from light colors to dark colors, so you may enjoy the challenge of changing a dark color into a light color. The final painting showcases the glitter of the metallic paint and the richness of the watercolor crayons.

Adding the mystery of a "veil of opaque color" to finish your paintings

Veiling is the technique of taking diluted opaque paint and selectively placing this mixture over your painting. Take acrylic paint or white gesso and dilute with matte medium rather than water. Water used as a dilutant can break down the polymer or binder too much. Paint with inadequate polymer can rub off. The technique of veiling is one of the best ways to salvage your "old dog" paintings. Glazing opaque paint over transparent paint can transform your piece.

Start your painting using transparent colors. This painting was glazed with variations of gray diluted opaque paint to pop out the somewhat abstract vase of flowers.

Karlyn Holman 22"x30"

This painting suggests a butterfly theme and was layered with many veils of opaque color. When you paint with this opaque "veil of color," a trace of the underpainting will show through in the finished piece, creating a sense of mystery.

Karlyn Holman 22"x30"

Rejuvenating "old dogs" as a departure point

When you have lost interest in a painting, you are definitely ready to take the challenge of an "I'll try anything" attitude. This is when new discoveries happen. I usually turn to collage to save a painting, but layering or mixing media or, perhaps, simply adding darks are all effective in adding a face lift to your "old dogs."

Never throw away a piece of artwork. Keep your paintings stored in a sacred pile and someday, you may find yourself wanting to recycle them into a new interpretation. Think of these creative starts as works in incubation. When you paint from the heart, you put so much of yourself into your work. Sometimes it helps to take a step back and give your ideas and work a chance to evolve. These creative starts may later form the basis for truly inspired paintings.

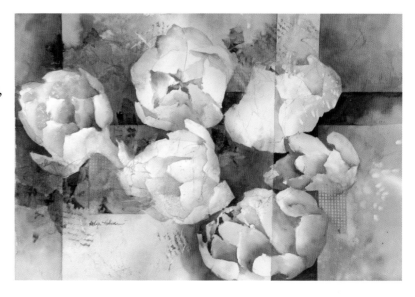

I rarely feel a painting is finished —
I think of it as a work in progress

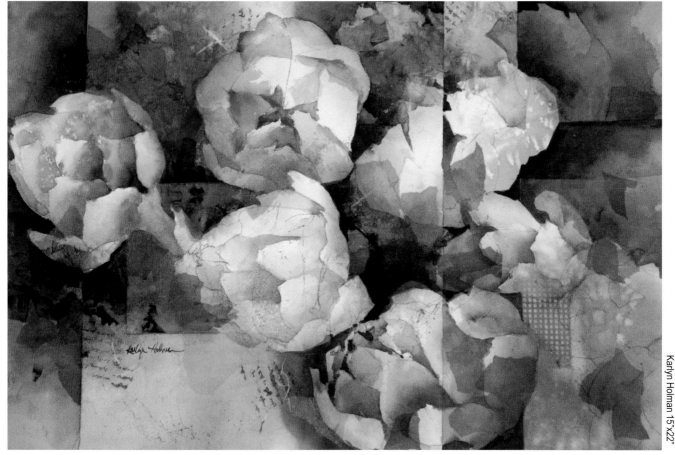

Karlyn Holman 15"x22"

This painting of artichokes needed something to make the piece feel resolved. The addition of the background shapes and more dark shapes, as well as tissue collage, pulled the piece into a finished painting.

129

Bailing or veiling?
The point when you just have to start over

Have you ever had a painting that had many good qualities but didn't meet your expectations? For Karen Knutson, this challenge inspired her to do a complete make-over. She started with toned acrylic veils of color and created an intriguing new interpretation.

Karen has an extraordinary instinct for composition and can transform any subject into a strong design. Karen's paintings are constantly changing. She sets goals each year so she will grow, and she teaches with endless energy.

Karen Knutson

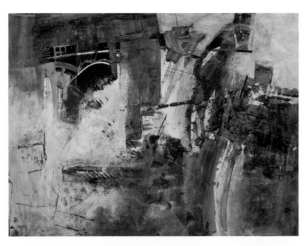

This painting was initially an experiment to try new techniques. Karen had no plan and just playfully painted and explored with her paints. Unfortunately, the end result reminded her of a tragic bridge collapse in Minneapolis. To erase this memory, Karen decided to redo the painting.

1 Karen chose very bright (neon) colors for her first layer. She mixed bright yellow paint with thinned-down gesso and matte medium. This thin glaze allowed some of the under painting to glow through.

2 She then added thinned-down teal to the lower corner, and just as this layer was losing its shine, she sprinkled in water and then wiped away the drops of water to expose a little of the bright yellow below. Karen continued to add the teal color in a cruciform fashion to reach all four sides of the paper. She was careful to keep each shape unique. While the top center area was still wet, she used her fingernail to create lines, exposing some the yellow below. Finally, she added a bright red, lacing it around the rings and through the middle section of the painting. An antique look on the corners was achieved by layering an orange color over the blue and then lifting part of it with a tissue.

3 In order to make the red color extend to the left side, Karen painted string shapes. She also wanted more contrast between the teal and the light section, so she glazed it with a white mixture, and softened the edges with a light yellow glaze. At this point, she decided that the mailbox shape on the left needed red surrounding it. The lower right area was glazed with an orange color and then sprinkled with rubbing alcohol right away to create the bubbled look.

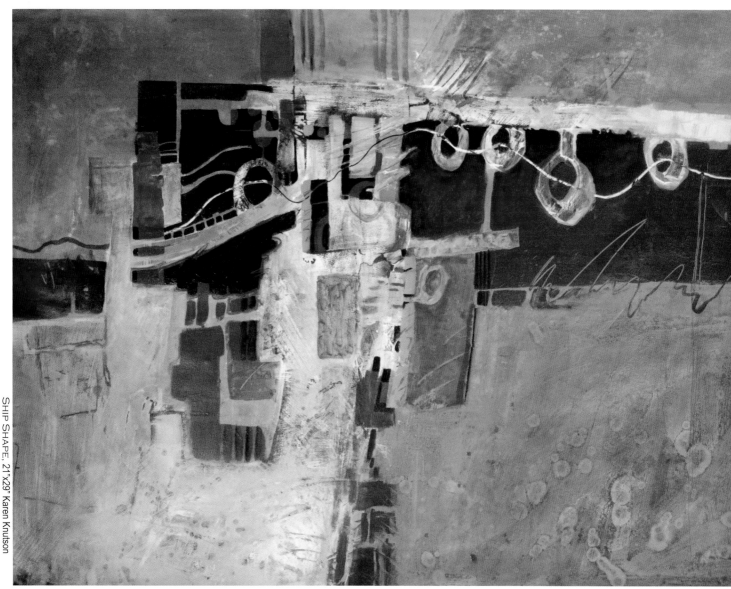

SHIP SHAPE, 21"x29" Karen Knutson

4 Using the underpainting as her guide, Karen negatively painted around the lines near the mailbox shape. She also repeated the circle shapes on the left part of the painting. The upper left section needed more development so Karen used black to draw more attention to that area. She also strengthened the connection to the bottom by making the red color brighter and weaving some interesting shapes that repeated other shapes in the painting. She used rubbing alcohol to lift out the white string lacing through the circle shapes. The finished painting resembled the side of a ship with floats hanging on it so she named the painting *Ship Shape*.

Using collage to move into semi-abstraction

A sunny day in a colorful European market really is an inspiring vision. Trying to capture the complexity of stall after stall of people and their wares and the brilliant colors of their tents can be challenging. Try an approach of capturing only the essence of the scene by combining representational elements with abstract elements. The challenge is to capture the color and excitement with not too much detail. Beginning your painting wet into wet and preparing the surface with collage papers provides surprises and a somewhat out of control start. When you use this approach, your painting often takes on a life of its own and may lead you in directions you cannot anticipate.

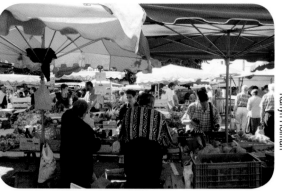
Karlyn Holman

1 Start your painting by attaching your paper to a board using masking tape. When you add collage papers into a wet surface, you may encounter uneven drying. The taped paper will help your paper remain somewhat flat when it dries. Wet the paper and begin layering paint and collage. Work spontaneously and let your creative energy guide you. As you add colors and place the 10-gram unryu and Ogura papers randomly onto the wet surface, you will begin to see magical results and the makings of a fun and free interpretation. Spray

with your fine mister until the papers have absorbed the color. Draw on this wet surface with a watercolor crayon to compose your subject. A watercolor pencil is too sharp and could incise the surface. I chose a light orange Caran d'Ache® crayon. After the papers and paint dry, glue down the unryu with thinned Yes! Paste™ (page 55). The colors will look vibrant when wet and will dry with less intensity. The Yes! Paste™ allows you to continue painting on this surface with no resist after it dries.

2 When the glue dries, paint in the negative darks and watch as textures magically appear. I applied additional pieces of pre-stained tissue paper to add more lively random color (page 99). Be sure to have enough glue in your thinned mixture to adhere the papers. If you do not have enough glue, you will not get crisp lines as you continue to paint over the papers.

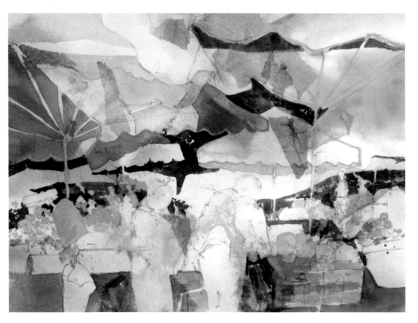

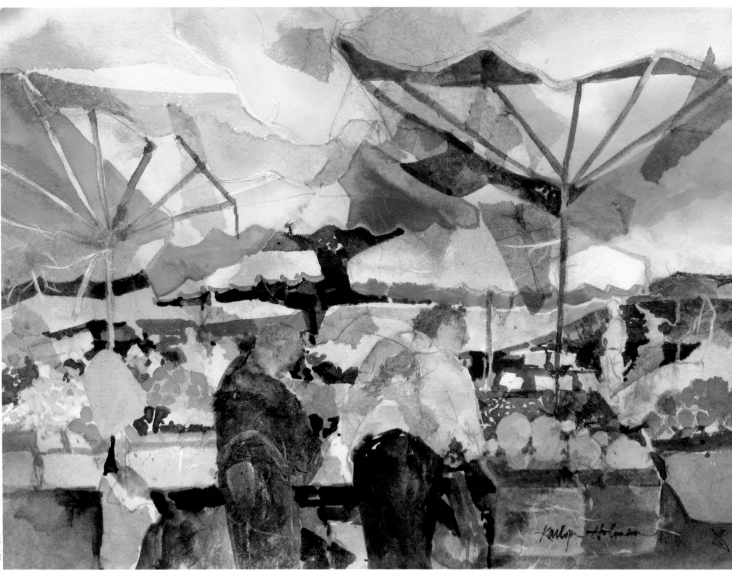

3 These techniques do not capture every detail and create an impression of a busy day at the market instead of a labor-intensive realistic viewpoint. This free "without boundaries" approach creates great textures and vibrancy of color, yet still portrays the bustling nature of a busy market without the clutter of too many details.

Starting with acrylic and ending with watercolor

Acrylic paint is a water-based medium that can be manipulated with water. Acrylic is very different from watercolor in that when the paint dries, it acts like a resist and is waterproof. Special precaution must be exercised to protect your brushes. You must keep your brushes wet or thoroughly wash them out after each use or they will be forever damaged. The viscous nature of acrylics makes it possible to drizzle the paint off a stick.

Starting this black and white design feels like stepping back into my days as a student in art school at the University of Wisconsin, Madison in the early sixties. Back then, art with a capital "A" was Abstract Expressionism. The bold darks linking through the composition feel connected and finished before any color is ever added. In fact, no matter what I paint, I view my paintings as abstract design; the subject is nothing more than shape, color, line, texture and movement.

Painting in acrylic requires some precaution in order to avoid getting this paint on your clothing. Acrylic is almost impossible to remove from your clothes, so using an apron or cover-up is a good idea. Acrylic paint on your hands is not as difficult to remove. For some reason, acrylics seem to jump everywhere. Using plastic gloves or a paint barrier like Gloves In A Bottle® will protect your hands. I find gloves impair the feel of the process and I do not mind getting paint on my hands. Another important precaution is to be careful not to allow acrylic paints to go down the drain. To help keep the environment clean, use paper towels to get rid of the excess paint on your brushes and sticks. Always do a final clean up of your brushes with soap and water.

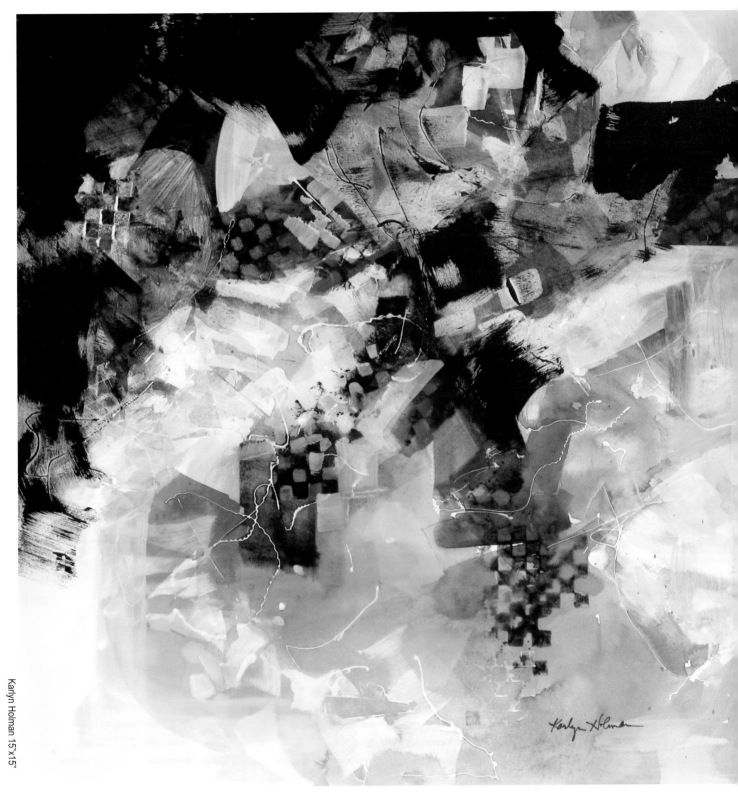

Karlyn Holman 15"x15"

The black design was painted with a foam brush using black gesso. The checkerboards were stamped with black gesso before the transparent watercolor paint was applied.

Hard edges, strong tonal transitions, lines and glowing color—a formula for success

This lesson is a foolproof way to paint a successful abstract painting. The elements of design unfold one at a time, allowing you to control the process. Painting a recognizable subject is not important; you simply want to work with the elements of design and portray an expressive interpretation of color, shape, value, texture, movement and line.

1 Start with black gesso or gloss acrylic and design a movement of black shapes. This dark color will establish a full range of values from one (white of the paper) to nine (black gesso). The path of dark should touch the edges of the paper as it passes through the composition. This strong tonal difference will add visual strength to your painting. Once you establish this basic beginning, you may add the subtle variations of color and texture that encourage your viewers to enjoy your painting up close.

This step is critical to the development of your design. You need to design in tonal transitional shapes to soften the disparity between black value nine and the white of the paper. Letting the foam brush run out of paint leaves a dry brush look that is perfect for these transitional effects. These shapes or textures must entertain the viewer and connect the dark shapes you have already established.

2 Adding the lines was a really fun step. The search for a paint that would drizzle was a long process. I observed that the Jack Richeson gesso would drizzle off my mixing stick so I playfully composed a drawing with this drizzled line and immediately fell in love with the results. I also found that Apple Barrel® Gloss™ acrylics will drizzle. Almost no other acrylics will drizzle. Some acrylic companies have designed additives you can add to their acrylic product that will result in a drizzled line. Using a pointed satay stick and simply dipping this stick into the paint and letting some of the paint run off will give you the control you need to add these expressive lines. The limited control you have when using this technique is the best part of this lesson. After mixing the paint thoroughly, drizzle a thick/thin varied line directly onto your watercolor paper and allow it to dry. You must move decisively in order to keep your images fresh and exciting. This expressive line reminds me of Jackson Pollack's style of working, only with more restraint.

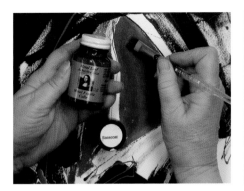

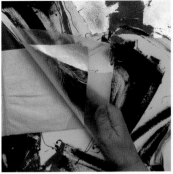

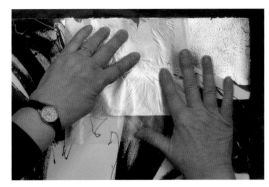

3 To begin the gold leaf process, the surface must be clean. Apply a thin coat of liquid gold leaf adhesive sizing to the paper surface. Let dry until tacky, about thirty to sixty minutes.

To apply the leaf, use waxed paper cut a bit larger than the leaf. Lay the wax paper over the leaf. Press your hand over the papers and the wax paper will pick up the leaf. Lay both on the adhesive surface.

Rub the leaf lightly to be sure it is well adhered.

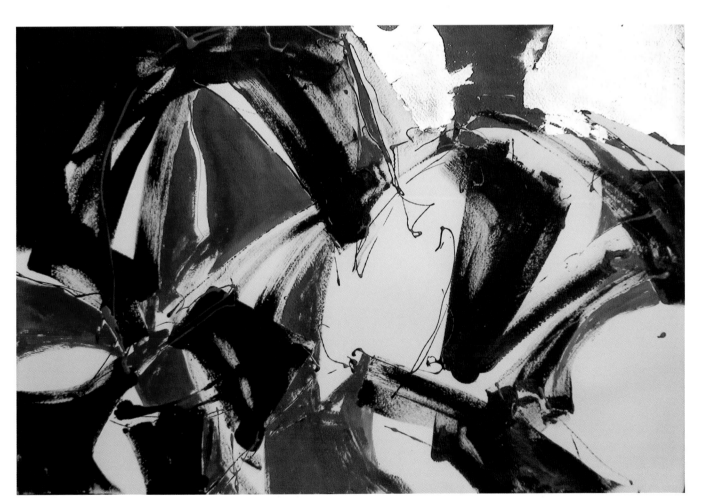

4 This stage shows the red clay tonal base coat and the start of the application of gold leaf. I personally like the look of the red clay color peeking through the gold leaf. The imitation gold leaf kit used in this demo is a Mona Lisa™ Product.

5 This shows the completion of the gold leafing.

Karlyn Holman 15"x22"

6 Metal leaf is available in many colors, even variegated combinations. The final painting needs to be coated with either a liquid or spray sealer to help prevent the metal from changing to an antique look. If painting abstracts is new for you, I recommend that you keep a strong focus of either warm or cool colors. Adding the final glowing color is the last step. Decide on a dominant warm or cool selection, keeping the color dynamic. In this painting I chose scarlet lake as the dominant warm color.

Starting with white acrylic shapes and lines

Karlyn Holman

The term *alla prima* means "all-at-once." An *alla prima* painting is very spontaneous, and this free, all-at-once way of working is a favorite with watercolor artists. Resist the temptation to return and add additional color on the paper later because doing so may diminish the wet into wet look that you are trying to achieve.

If you enjoy the drama of painting with black acrylic, try painting with white acrylic which can add a wonderful sparkle to your finished piece. After mixing the paint thoroughly with your satay stick, drizzle a thick/thin playful line of white acrylic directly onto your watercolor paper. You can also add the paint directly onto the paper with a palette knife or a credit card. Allow the acrylic to dry before proceeding.

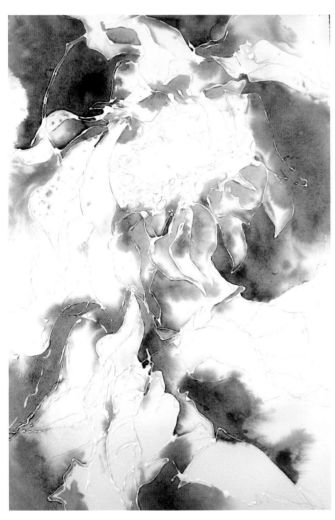

Karlyn Holman 15"x22"

1 To begin the *alla prima* technique, place your paper on a support board and wet both sides of it, tilting it at a slight angle. This combination of water and pigment on a slanted surface is classic watercolor. The painting happens quickly and with less control than on dry paper. Starting with your background, paint in dark colors to create a path of movement that zig zags throughout your composition. Then enrich your background by charging in additional harmonic colors.

2 When you begin the process of adding colors to your main subject, touch the colors at the top of each compositional shape. Tilt the paper slightly and allow gravity to pull the color into and throughout the shapes. This method will preserve some whites within your composition and lends a spontaneous look to the finished work. Continue to work on a wet surface, spraying your paper with a fine mister if necessary. As you get close to completion, use more pigment and less water to create the darks.

Westie—the "alla prima" dog

1 Draw your subject on 140# Arches® cold press paper. To really capture and reflect the personality of your subject, take time to draw and paint the eyes, nose and mouth before you begin painting your composition. I used alizarin crimson and phthalo green to make a dark black which I used to paint these features.

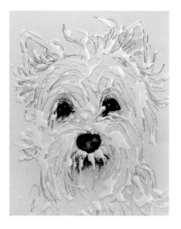

Draw the Westie with drizzled gloss white acrylic. This technique can be really fun because you have control over some of the lines, but many of the lines just do their own thing. In this painting, the drizzled paint really captures the textural richness of the Westie's coat.

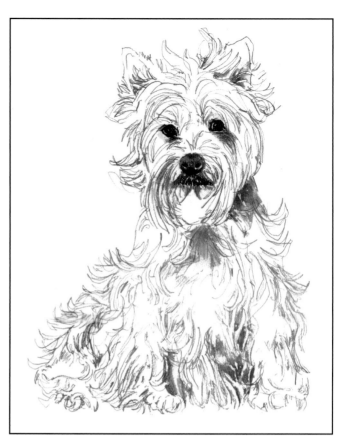

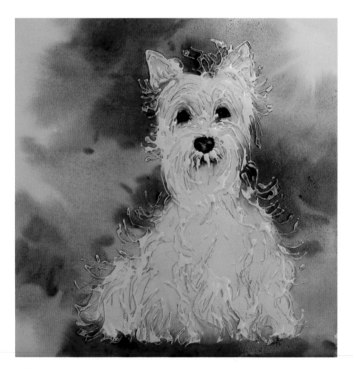

2 Wet both sides of the paper and paint only the background. I chose quinacridone burnt orange to establish a linking shape in the background.

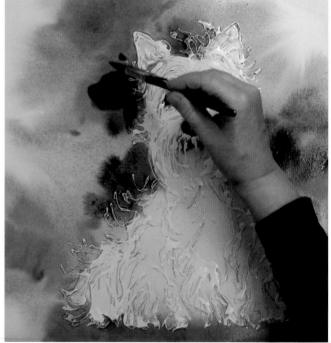

3 Now place cobalt blue directly into the orange background to form a neutralized gray. Maintain some nuance of the orange color and use a light touch when applying the complementary blue color. Remember to keep checking to be sure your painting remains wet, and if you notice the surface is drying, spray it with your fine mister.

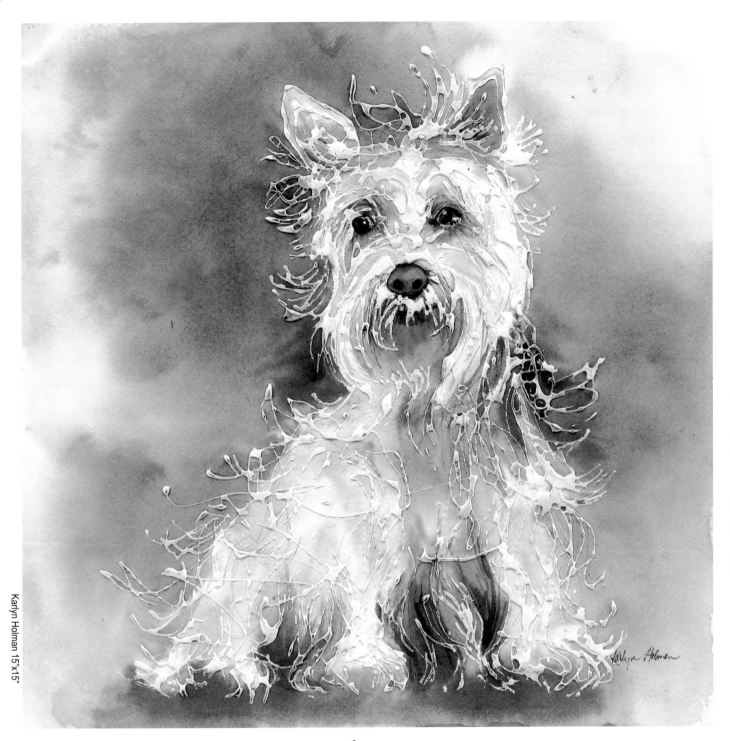

4 Now comes the fun part. Pull some of these grays into the Westie to form the shadows. Also add some pinks in his ears and on his body. Try to establish a range of values from the white of his coat to the dark shadows under his chin. The resulting thick and thin lines gave this fella a lot of character.

Drizzling acrylic lines only

The line that randomly drizzles off a stick has so much character. The line varies from thick to thin and from in control to out of control.

Your doodles could be the inspiration for a painting. Grab your old sketchbooks and look for some doodles that could serve as an idea reference. By concentrating on just line, you can create an exciting mixed media interpretation of just about any subject. Line is an element of art that can pack powerful emotion and strong design. Line can be passive or dynamic. As the artist, you are actually controlling the emotion you want your viewers to feel.

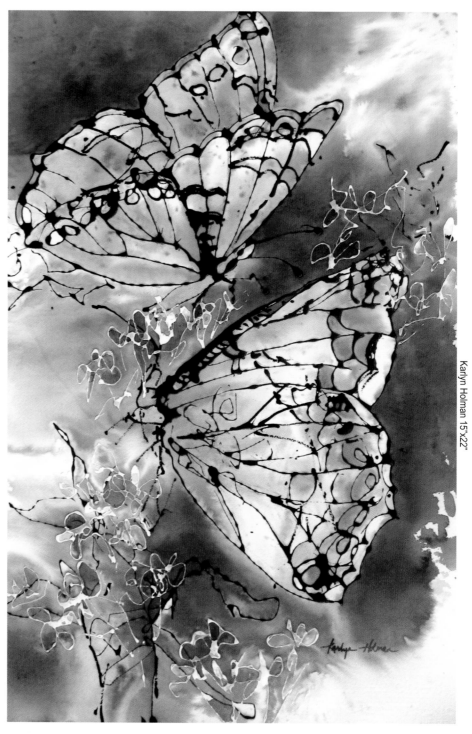

This butterfly was painted wet into wet on a tilted board. The *alla prima* approach always looks best when you save some whites in your background as well as in your subject.

Karlyn Holman 15"x22"

Applying acrylic with a gutta bottle

The blending of acrylic and watercolor is such a natural combination. As I continued my search for more ways to apply the acrylic, a silk artist named Nancy Murphy told me about the gutta bottle. This simple bottle with various sized tips is used for many purposes such as cake decorating, silk painting and dispensing glue. I fill the bottle with either my white gloss acrylic or white gesso* and squeeze the paint out into a fine line. The gloss acrylic will create a more raised, glossy line and the gesso leaves a flat look. This mixed media approach creates a rich, white outline that somewhat resists the added watercolors. When you mix media, it is important to evaluate the uniqueness that each medium has to offer and to take advantage of the best qualities of each technique or form. In this case, the white line provides a surface that embellishes your painting and provides a resist to the watercolor washes. This is another of those wonderful situations that offers the chance to experience spontaneous surprises while still exercising some control. Using this approach will keep your paintings fresh and exciting.

These multi-petal white flowers were a perfect choice to be outlined in white acrylic. The image was drawn on 140# Arches® cold press paper using an HB pencil. When I designed the white flowers, I tried to seal the top of the flowers with the white acrylic so the paint would not flow into the petals. The coneheads were designed to be spiky to allow the paint to flow out into the background. The stems and leaves were also outlined with acrylic.

It is important to paint the background first so some of the color can run into your flowers. The flowers are basically white and a little toning makes them stand out. The flowing color literally paints itself so you should watch the paint closely and manipulate the movement to your advantage. If color goes where you do not want it, lift it out with a thirsty brush and not a towel. By doing so, you keep the paper somewhat wet and the flowing action can continue.

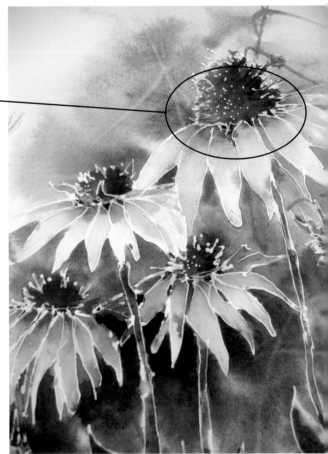

*White gesso is a painting ground or primer used by acrylic and oil painters to seal their canvas, wood or other surfaces. Gesso comes in many colors and is used often by mixed media artists.

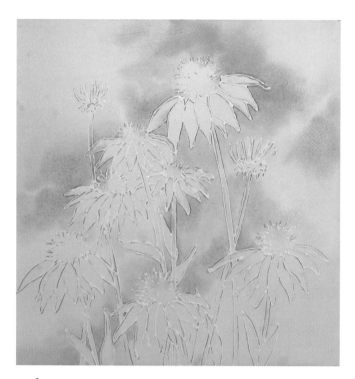

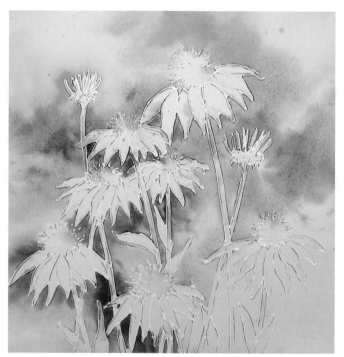

1 Place the dried underpainting of lines on a support board, wet both sides of the paper and tip the board at a slight angle so the paint will move over the textured surface. Choose colors that move slowly or very little (page 82). Do not rush; watch as the paint slowly moves around the white lines and practically paints itself. Start with a light value color. For this example, I chose manganese blue.

2 Continue adding pure colors, I chose permanent rose as the next color. Think about the movement you are creating as you layer in more colors. Try to save some lights in your background.

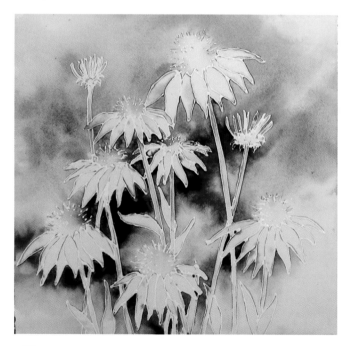

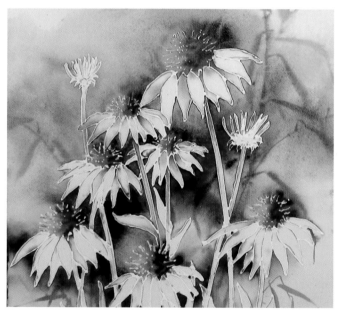

3 This layer shows the addition of permanent rose and French ultramarine blue. I tried to work in a horizontal, somewhat zigzag movement to counter the vertical flowers. I kept the painting wet by spraying occasionally with my fine mister.

4 To paint the coneheads, I used Winsor yellow, scarlet lake, and quinacridone burnt orange on the sun side of the coneheads and alizarin crimson and Antwerp blue on the shadow side of the coneheads. Most of these colors move in water and will begin to radiate as they move outside the lines. While the background is still wet, paint in some out of focus light grasses to add depth to your painting. I used Antwerp blue and quinacridone gold to create the grass colors.

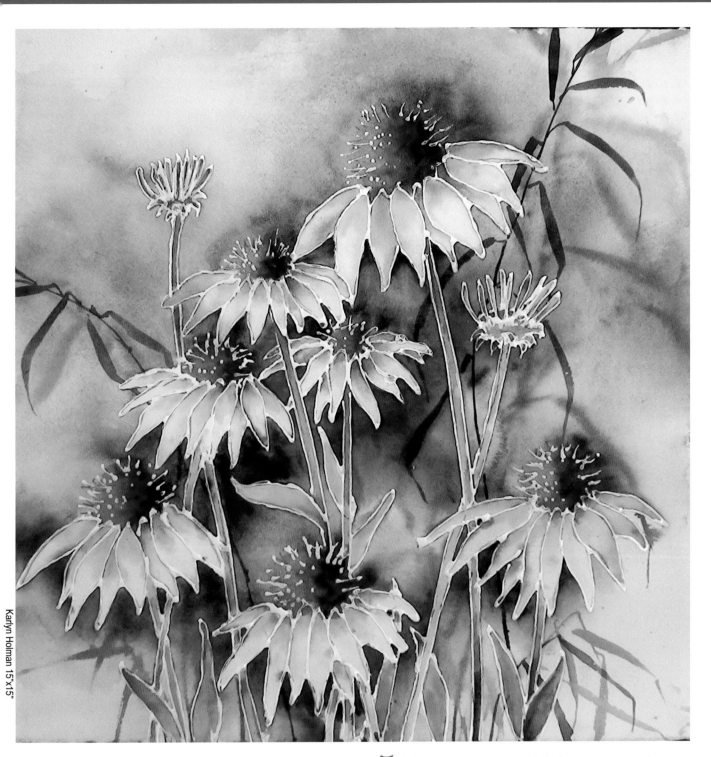

5 The last step was to add dark, crisp, grassy shapes over the out of focus grasses. The background of the flowers may need a little color applied on dry paper to crisp up some edges. To finish the flowers, wet each petal and let quinacridone gold and quinacridone burnt orange flow downward to provide a nice complementary color choice to the final painting.

Using the gutta bottle to create lost and found edges

This technique gives new meaning to losing an edge. The process is so simple; just squeeze a gutta bottle that is filled with acrylic paint and you will create a line. Then, with a very slight press of the trigger of a spray bottle, you may begin to soften the line. After a little experimentation, you will be an expert. I found that after playing with the drizzled lines, I felt a need for more control and for a thinner line that could be melted or softened a bit. The gutta bottle was the perfect tool for achieving this effect. The acrylic is measured out in continuous, small amounts allowing you to exercise more control.

Gutta bottles come in many sizes and with various tips. I like the .05 and .07 size tip. You simply fill the bottle with any acrylic paint or gesso, attach the tip and you are ready to start your new adventure. When you are finished with a session, simply refill your gutta bottle, place the tip back on and stick a silk pin in the tip. Then store the bottle on its side so the tip stays wet and the paint cannot dry out. This eliminates a lot of messy clean up and this way the bottles are always ready to use.

Amy Kalmon © 2008

Amy Kalmon © 2008

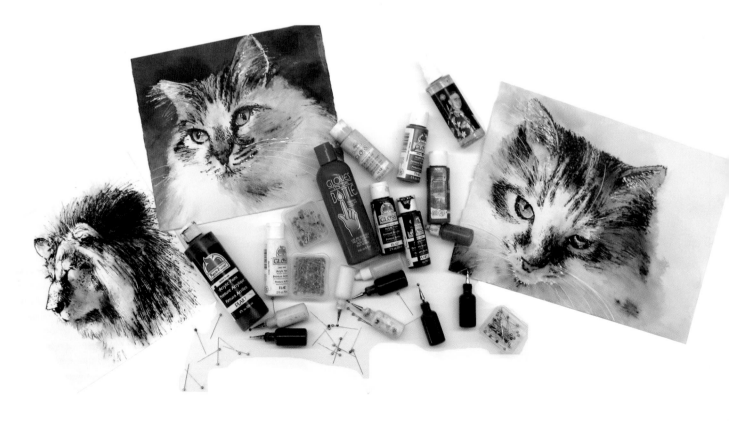

1 This demonstration was painted on 140# Arches® cold press watercolor paper. I filled the gutta bottle with gloss acrylic and slightly squeezed the gutta bottle to create lines on my paper. I drew one of the trees and then stopped and sprayed with my fine mister to create the soft shadows. This softening of the lines actually formed the mid-tone values in the tree. Do not depress the trigger full blast or you will lose your drawing. If you spray too lightly, spray again and wait until something happens. When the paper was wet with these droplets of water, I drew into the puddles with the tip of my gutta bottle and watched as the combination of water and paint dissolved into soft gray values. As you work on your painting, continue drawing and periodically pausing to spray. This underdrawing dries very quickly, so in order to create the soft edges, you must stop frequently and spray, otherwise the paint will be too dry to activate. Dry the acrylic thoroughly before painting.

If you are right handed, start in the upper left-hand side of your drawing so your hand will not be bumping into the wet paint. Reverse this method if you are left-handed.

There is something magical about painting on this full valued acrylic underpainting. Now you may begin to add color. It is not necessary to use any masking to protect the trees from flying color. The acrylic will provide some resist and any color that lands on the trees will just make them look more realistic.

2 To paint the background colors, I threw rich paint onto the dry surface to suggest the patterns of fall leaves. I used a small oriental, natural fibered brush. A synthetic brush will not release the paint. All the colors were applied *alla prima* and in their pure form and allowed to mix on the paper. Try to throw the paint for your foliage using a zigzag motion. The most frequent mistake is to design these shapes in a straight line. The yellow pattern was created using Winsor yellow and quinacridone gold.

3 If the thrown paint size is too small, simply throw in water to expand the colored areas. Next, I added scarlet lake, quinacridone burnt orange and alizarin crimson to create the warm reds and oranges.

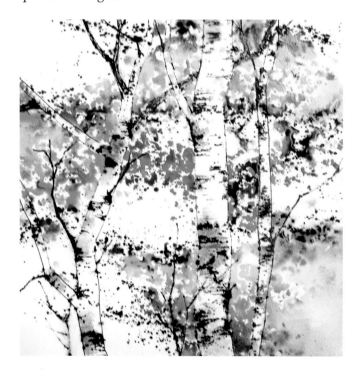

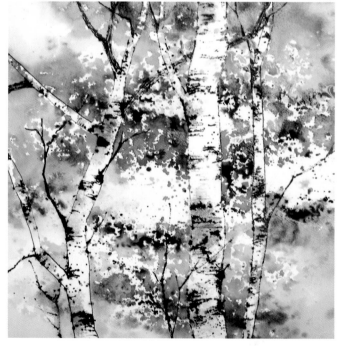

4 Antwerp blue formed the blues, greens and the darks depending on where it landed. If it landed in the yellow, the greens appeared. As the blue landed in the reds, the darks appeared. If the blue landed on white paper, the suggestion of blue sky occurred.

5 To make this style of painting more of a vignette, soften the edges. To accomplish this, simply spray into the wet paint with a fine mister or wet the paint with clean water on your brush.

6 Allow the paint to dry thoroughly. To paint the birch trees, wet the trees and add cobalt blue on the shadow sides. Tip your work to allow the paint to run into an uneven pattern of shadows. While the blue paint is still wet, add quinacridone burnt orange directly over the blue to create a birch tree gray. Once again, tip the paper so these grays can move together. Mixing the colors on the paper is the best way to mix gray. In this painting, you still see a little pure blue and a little pure quinacridone burnt orange shine through. Using your palette knife, scrape some of the paint back to the white of the paper to create the effect of peeling bark.

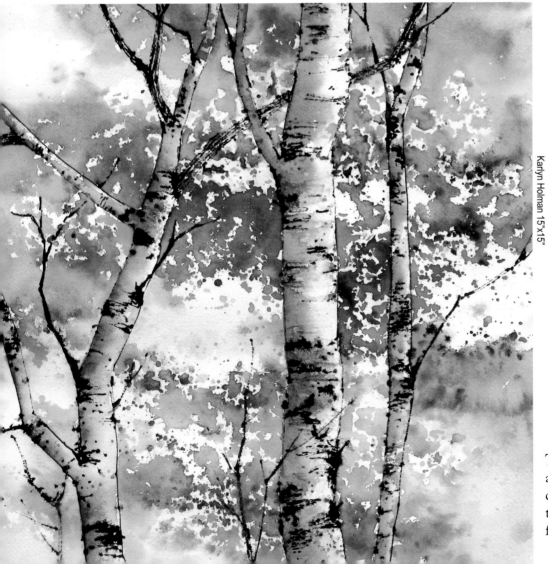

Karlyn Holman 15"x15"

Mixing the pure pigments on the wet surface creates the most beautiful birch tree grays

The stark black of the acrylic provides a great contrast to the vibrant, transparent colors of the fall foliage.

Remembering iconic images—an opportunity to honor these treasured paintings

Throughout the ages, this iconic compositional style has entertained and enlightened us. Remembering iconic images is an opportunity to honor the artists that created these treasures.

I went to a Catholic grade school and earned holy cards for my good deeds. When my piano lesson went well, I remember how special it was to receive a holy card of St. Cecilia, the patron saint of music. Once, I even received a holy card and a plastic virgin when I sold the most magazines. These holy cards were my first introduction to iconic composition.

This image of the gothic couple titled *American Gothic, 1930* by Grant Wood (1891 to 1942) greeted me each morning from the back of the cornflakes box. This subject shows how these iconic figures were laden with symbols like the pitchfork, the gothic window, the rickrack on the wife's apron and the broach on her neckline.

The *Mona Lisa* (1503-1506) by Leonardo da Vinci is probably one of the most romanticized and celebrated iconic paintings.

Art school introduced me to my favorite artist, Gustaf Klimt (1862 to 1918). This painting of *The Kiss* is an amazing example of the dazzling enrichment created by the suggestion of fabric using gold leaf and patterns.

The Scream, 1893, has become an international icon. This haunting image by Edvard Munch, illustrates emphatically how art can portray a deeply emotional feeling.

This simple iconic chair titled *Vincent's Chair with his Pipe*, 1888 by Vincent Van Gogh (1853 to 1890) will always remind us of his simple lifestyle and dedication to his art.

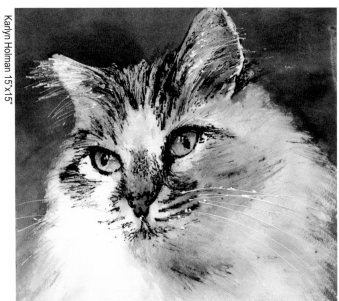

Try placing your subject in the middle of your composition and enjoy painting an iconic image.

An easy approach to an iconic portrait

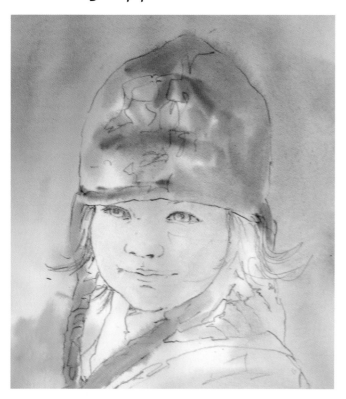

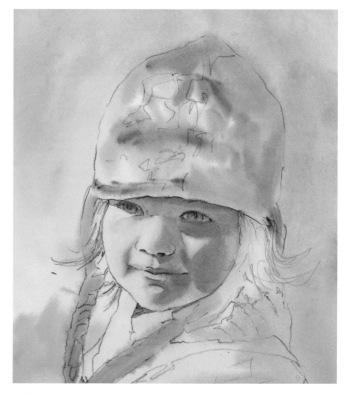

1 This drawing of Ki-Lin was drawn with contour lines. It is not necessary to draw in the shadows. Wet the front and back of your paper. Mix a skin tone using a yellow and a red. You could use either Winsor yellow, aureolin yellow or raw sienna for your yellow choice and select either quinacridone coral, quinacridone burnt orange or permanent rose for the red choice. Paint all the skin areas with this flesh-toned wash. Now add more yellow on the sun side and more red on the shadow side. While this mixture is still wet, lift away the white shapes with a thirsty brush. Although the color will continue to fill in, keep lifting until the color stabilizes. Next, paint in a loose background of warm colors on the sun side and cool colors on the cool side. Add a base of soft color on the clothing, being sure to save some whites on the sun side. Add some color in shadows areas of the clothing but remember to save some whites in this underpainting.

2 This step is done on dry paper and captures the cast shadows on the face. A mixture of alizarin crimson and quinacridone burnt orange was used to create these shadows. **Use a synthetic brush to soften the edges of these shadows.** This step is all about creating lost and found edges to define the shadow shapes.

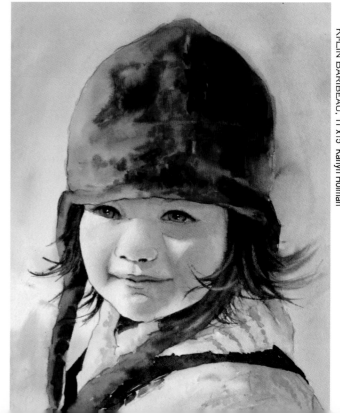

KI-LIN BARIBEAU, 11"x15" Karlyn Holman

3 The finishing layers were completed in control on dry paper. The final background was wet and additional color of a similar range was added to create greater intensity. The hair was painted wet into wet. The crevice darks around the mouth and eyes were painted using quinacridone burnt orange mixed with cobalt blue.

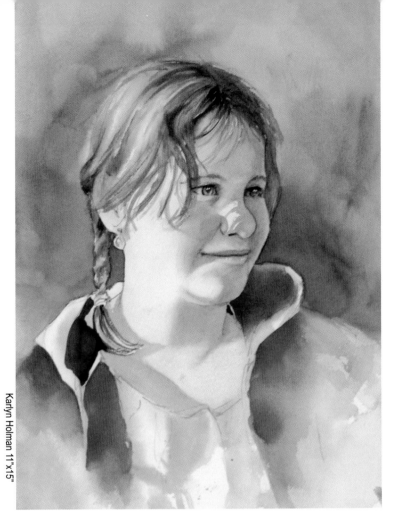

These portraits were all started wet into wet and finished on dry paper.

Rachael has been one of my favorite subjects for many years. I could fill a book with my paintings of her.

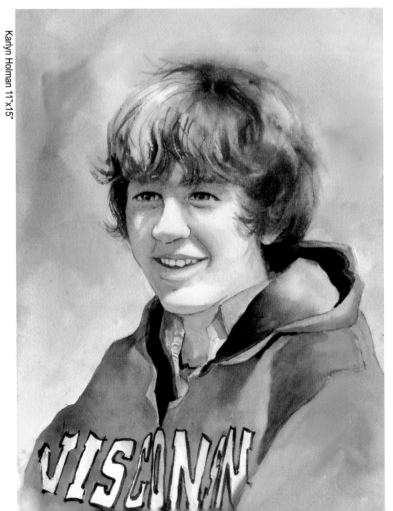

Hunter is a good sport about posing for his grandmother. It is very important to have a good photograph to work from when attempting portraiture. Try to get your light source from an angle, often referred to as "Rembrandt light."

153

An iconic giraffe using a combination of drizzled lines and the gutta bottle

1 Draw your subject with pencil in the middle of a piece of watercolor paper. Using a combination of drizzled lines and gutta bottle lines, follow your pencil lines and create the black lines. The drizzled line has more character and will produce both thick and thin lines, while the gutta bottle will provide the control you need when drawing delicate areas such as the eyes. After the acrylic dries, wet the paper on both sides. Paint manganese blue in the background for contrast. This color moves very little in water and will stay where you put it.

2 Begin this *alla prima* style painting using the pure colors of raw sienna, quinacridone gold and quinacridone burnt orange. Be sure to use enough burnt orange so when you add the cobalt blue, the colors will neutralize into grays and Mr. Giraffe will not turn green from too much yellow.

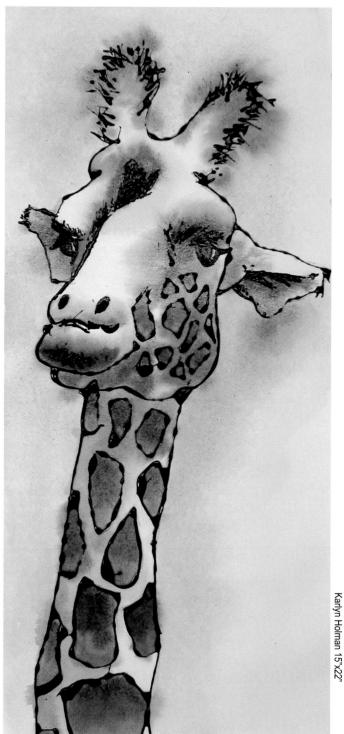

Karlyn Holman 15"x22"

3 Now add cobalt blue on areas that need a soft brown or darks. Watch the magic as these complementary colors neutralize into beautiful grays. Don't worry if the colors move out of the lines. Just step back and watch the spontaneous fun and free look emerge.

An iconic lion using only the gutta bottle

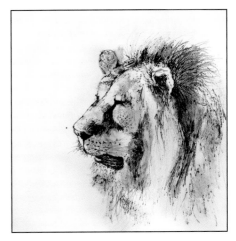

1 Fill your .05 gutta bottle with acrylic paint. Draw over your pencil drawing and enjoy the control you experience as the paint flows out smoothly onto your watercolor paper. Stop every so often and spray into your acrylic lines with a fine mister. These tiny spots of water will soften the acrylic paint and transform the lines into a soft gray. Only spray once or twice at the most. After a little practice, this process becomes very easy.

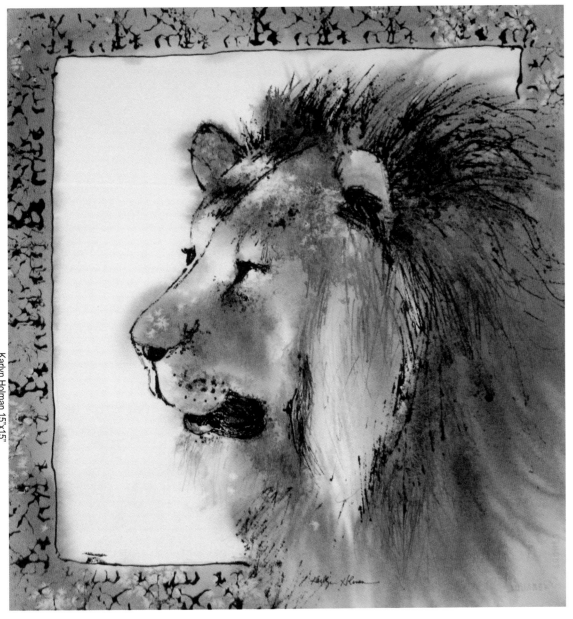

Karlyn Holman 15"x15"

2 The final painting was completed with watercolor. The use of a border added to the iconic approach.

Painting an iconic cat

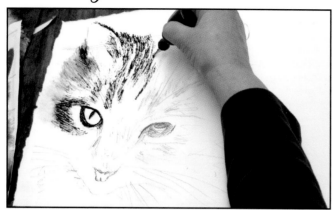

1 On dry 140# Arches® cold press paper, draw your image in pencil. Fill your gutta bottle with gesso or acrylic and, using a very light squeeze of the bottle, start drawing over your pencil lines. The viscous nature of the acrylic allows it to really hold the lines.

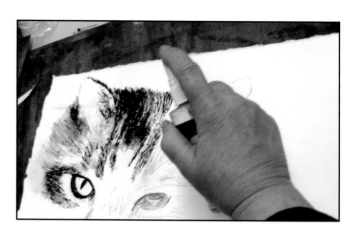

2 After a short time, stop and spray with your fine mister. Do not "point and shoot" the mister; use a sweeping motion so the spray is distributed evenly over the area you are drawing. Spray once and then wait to see what happens. Spray again if necessary. The paint will magically begin to soften and form lovely grays.

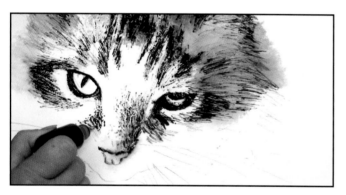

3 Continue by drawing on the "misty" surface and watch the edges continue to melt into beautiful grays. The accidental movement of the paint is always a surprise. Be mindful of spending some time just watching this phenomenon happen. Then move on to continue drawing your subject.

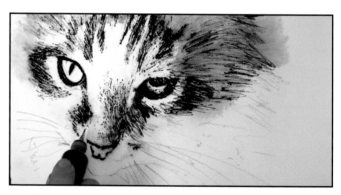

4 When your painting has dried, feel free to go back and draw over any areas that need corrections or additions.

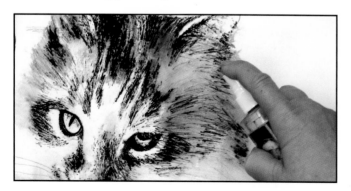

5 Again, stop and spray because the thin lines created by the gutta bottle dry very quickly. The coolest areas are created by drawing with the gutta bottle on the wet surface.

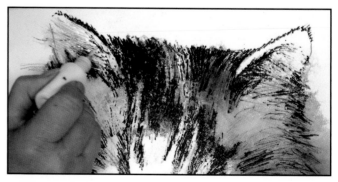

6 The white lines were added after the black paint dried and served to accentuate the white whiskers, the ear hairs and the highlights in the eyes.

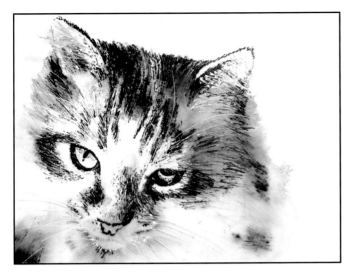

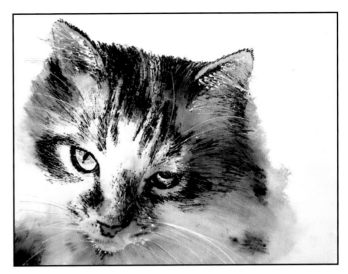

7 The serendipitous movement of the paint produced by using this technique makes preparing this underpainting or what is essentially a value study, a really fun experience. The final underpainting has a full range of values from the white of the paper (one) to the black of the acrylic (nine). The soft grays form an assortment of values somewhere between one and nine. The acrylic will provide resist as you begin to add colors.

8 To paint the cat, choose transparent colors to create the warm areas of your painting. I used quinacridone coral, quinacridone gold, raw sienna and quinacridone burnt orange.

9 The final layers added were transparent cool colors. I used cobalt and manganese blue.

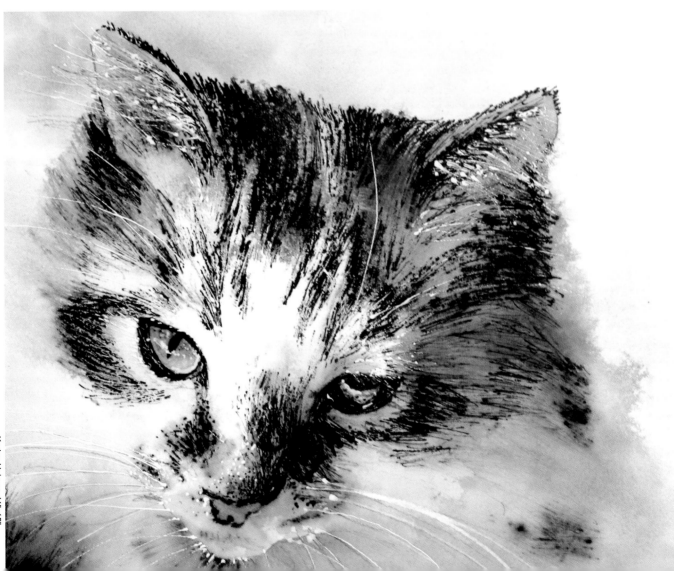

Karlyn Holman 11"x15"

Combining an iconic subject with collage and water soluble crayons

Caran d'Ache® crayons provide a bridge between drawing and painting. These high quality, richly-colored crayons allow you to be spontaneous and tactile at the same time. They have excellent covering power and lend opacity and a sense of immediacy to your work because, while they mimic the fluidity of applying paint to the surface, they retain the spontaneity of drawing. These opaque water soluble crayons can be used to add light over dark and bright over dull.

Barbara McFarland loves to work intuitively. These water soluble crayons combined with collage are a perfect medium for her tropical subjects.

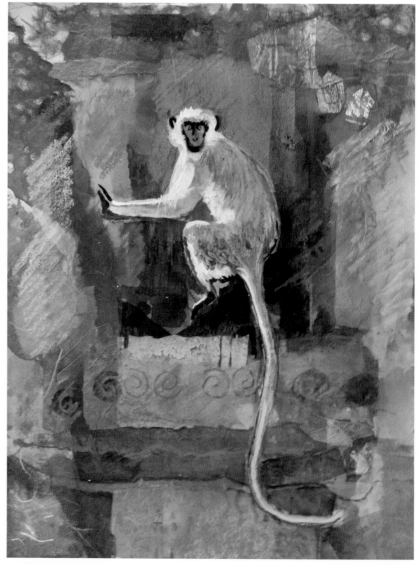

Barbara McFarland 11"x15"

Barbara used the hallowed iconic compositional style to create a series of paintings depicting the wild life on the island of Nevis. She prepared an underpainting of collage, stamping and water soluble crayons. After she set the stage with lovely color and texture, she added the monkeys. Carefully chosen patterns and symbols were used to finalize her interpretation.

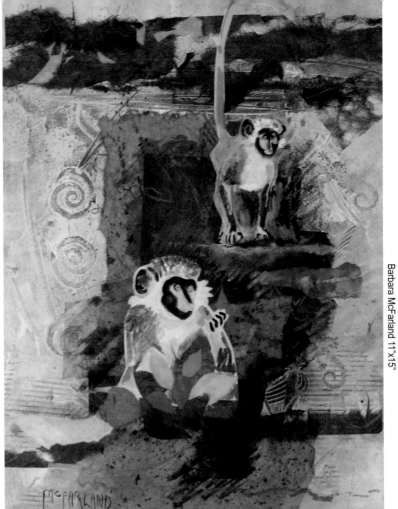

Barbara McFarland 11"x15"

The harmonic background colors of blue and green really come alive with the addition of the complementary orange used on both the monkeys and in the background. Barbara's thoughtful combination of great values, strong composition, color and texture resulted in a beautiful and dynamic painting.

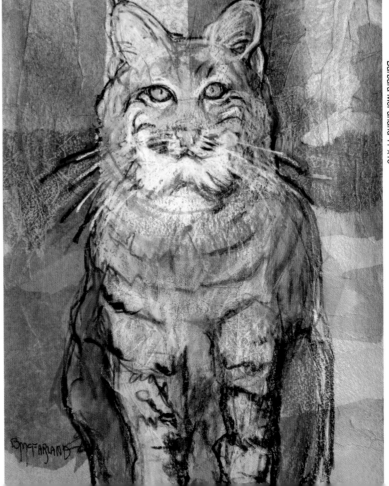

Barbara McFarland 11"x15"

Barbara employs the cruciform compositional style to back up her iconic subjects. This overlay of subtle color was a pleasant background for her cat painting. The freely drawn orange lines pick up the orange in the background.

Creating distinctive linear drawings

Line interprets a subject and also reveals the attitude of the artist using the line. The character of line is unique. A line usually starts as a gesture and can vary as to whether it is heavy or fine, thick or thin, sketchy or refined and broken or continuous.

I took life drawing all through art school and continually studied the tonal drawings of the Old Masters. For years I had been looking for a pen that could give me the ability to quickly capture people and landscapes at any time and any place. I finally found the Elegant Writer® pen. The lines drawn with this pen can be activated with a mere wet brushstroke or two and suddenly I have what feels like a finished painting. If you have a busy lifestyle, consider carrying these pens and a small sketch book with you and use your free time to capture the gestures and essence of interesting subjects. You can work from photos, real life or your imagination. Another great idea is to carry brushes that store water in the handle and you will be ready to spontaneously activate your drawing at any time.

Pauline Hailwood used a pipette and a pen to create this free-hand flowing look in her painting. Pauline enjoys highly contrasted images using India ink.

GARLIC, 7"x13" Pauline Hailwood

Karlyn Holman 11"x15"

Observing and drawing people are two of my passions. This is a portrait of my granddaughter, Rachael, in a meditative moment as we were travelling on a ferry boat.

Karlyn Holman 11"x15"

A subject as simple as these rocks can become an interesting composition with only a few strokes of a wet brush, a suggestion of color and some color sanding. Conserving areas of the white paper is crucial to the final impact of varied values.

Drawing with the Elegant Writer® pen is exhilarating. After you create the lines, you simply add water next to a line and in a matter of moments, the line bursts forth with warm and sometimes cool color in this serendipitous "leave it to whatever happens" method of creation. I remember with great fondness those coloring books that had little dots that would burst forth with color when you wet them. This pen transforms lines into light and dark values in moments. There is something magically spontaneous and undeniably wonderful about these quick interpretations that a more rendered and very detailed interpretation often misses. The best part is that you can then add color because the lines do not continue to reactivate.

To create a spontaneous drawing, start with your subject and do not be afraid to exaggerate, distort or invent as you draw. Adopt a more expressive and less photographic approach. Only a few strokes will tell the story. Instead of trying to copy exactly what you see, try to make more of a personal statement.

1 I began drawing this dog on dry Arches® 140# cold press paper.

2 Using a number 10 or 12 round brush, I began to wet the pen lines and tipped the paper to encourage the tonal washes to flow with gravity, making sure that I also saved some of the white of the paper.

3 You can always redraw over your wet painting to get even more darks. Continue to activate the ink until you are happy with your painting.

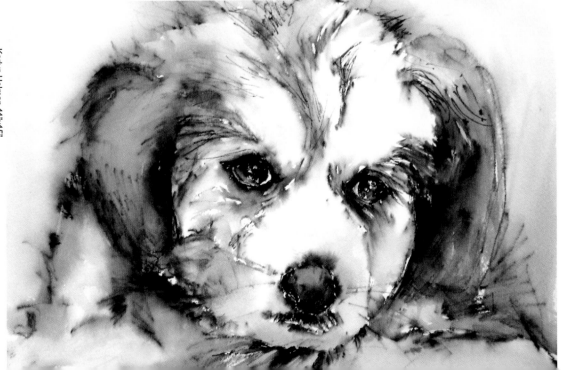

Karlyn Holman 11"x15"

The Elegant Writer® pen creates spontaneous on location paintings

This is the entrance to the Le Vieux Couvent in France with the light creating a dramatic path. The scene was perfect for the fine point Elegant Writer® pen. Drawing and activating the pen lines is a truly spontaneous experience and results in these beautiful value studies.

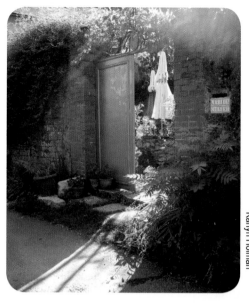

Karlyn Holman

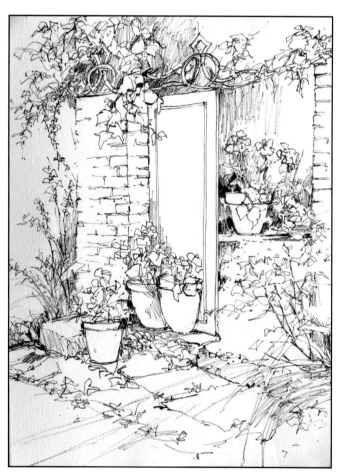

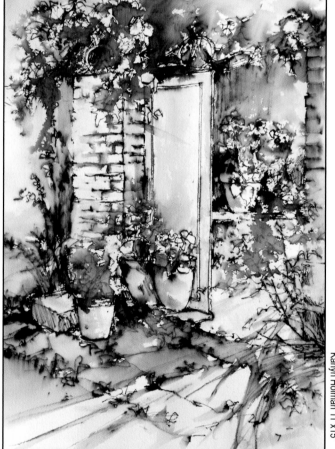

Karlyn Holman 11"x15"

1 The pen drawing shows the values created by shading with the pen. The more ink you have in an area, the darker your value study. I try to visualize the finished painting and this helps me place the shading where I want it.

2 This is the look after about five minutes of wetting the lines with only water and allowing the colors and values to flow into these lovely washes. You can tip the paper to encourage the pinks and blues to appear. You can tip the paper to encourage the pinks and blues to appear. After you activate the lines and the drawing dries, the lines do not reactivate. They become stable and allow you to add watercolor over the values you created. I decided to leave this image as a drawing.

This lovely scene in Umbria, Italy had endless textures and cast shadows. I wanted to quickly draw the scene because I only had a brief amount of time before our scheduled departure. The Elegant Writer® pen was the perfect choice for this "quick draw."

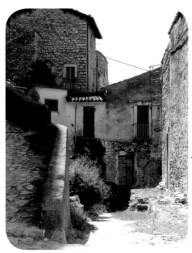

Karlyn Holman

1 Build up thick and thin lines to create as much character as possible. Add more lines in areas you want more darks and less lines in areas you want to keep as a rest area.

2 This is the exciting part. You can wet the lines with water or introduce some color with the water and watch the painting come alive in just minutes. Tip the paper to get more movement and graded washes in your composition. As the lines are activated, they stabilize and you can continue painting over the lines and they will not reactivate.

This painting shows the additional of watercolor.

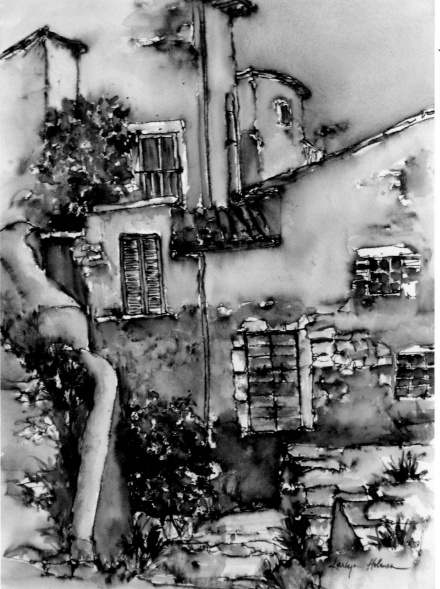

Karlyn Holman 11"x15"

Combining the Elegant Writer® pen with tissue paper collage and Caran d'Ache® crayons is a perfect match

Markets have the most intriguing collection of vegetables and fruits. For some reason, I never get tired of painting artichokes. As with any subject that you paint in a series, your interpretation usually becomes more and more abstract and more colorful.

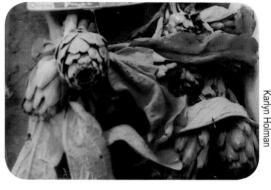

Karlyn Holman

1 Draw your subject with the Elegant Writer® fine tip pen. Try to create lines with character by pressing harder to make a darker line and lifting the pen to make a softer line. You can even shade in some areas to assure that you will have darker values when you activate the lines.

2 In this demo, I used color on my wet brush to activate the lines and not only created value, but exciting color as the pen lines combined with the watercolor. As these values started appearing, it was almost magical.

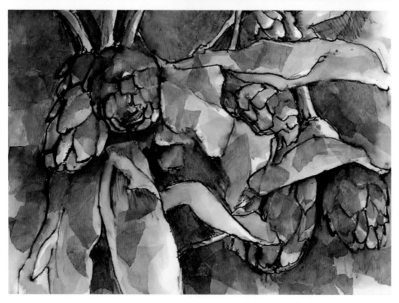

3 The next step is to prepare tissue paper with light washes of watercolor (page 99). When this dries, glue the tissue paper randomly over your image using thinned Yes! Paste™ (page 55).

4 The real fun comes when you add lines and opaque colors using the Caran d'Ache® watercolor crayons. You may draw directly on the surface or wet the crayon markings to create a veil of opaque color. Do not hold back. This is your chance to paint and draw with abandon as you add these colorful lines and shapes over your dark underpainting.

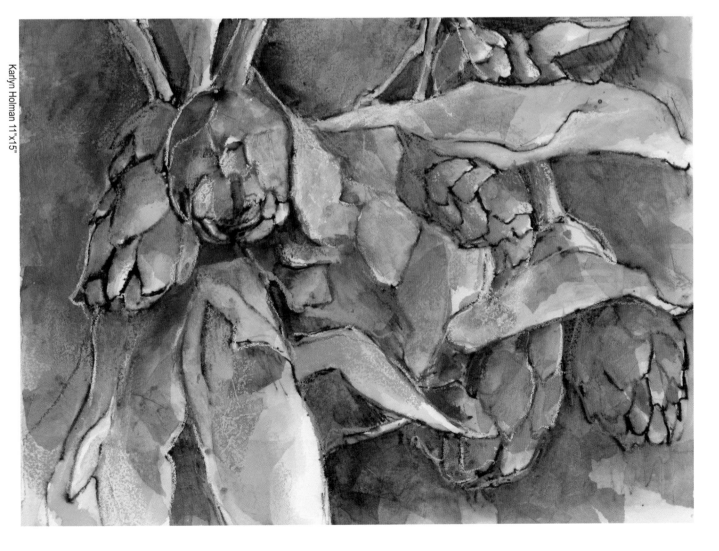

Karlyn Holman 11"x15"

Watercolor batik on rice paper

Batik means "wax written" and involves the use of liquid hot wax and successive dye baths. Kathie George adapted this art form by starting her image with hot wax and then applying watercolor washes over the wax on Oriental paper, resulting in a perfect marriage of media.

Kathie George has redefined the ancient art form of batik by combining it with watercolor to create a contemporary art form she refers to as "watercolor batik." The abstract textural qualities created by her watercolor batiks capture a mood and create an artistic interpretation rather than a literal interpretation. Kathie is a full-time artist and instructor.

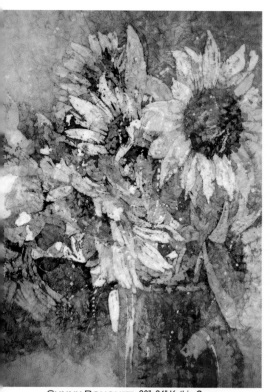

SUNNY BOUQUET, 20"x24" Kathie George

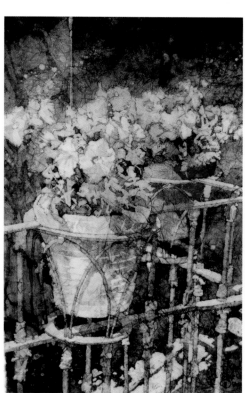

SUNBATHING, 17"x24" Kathie George

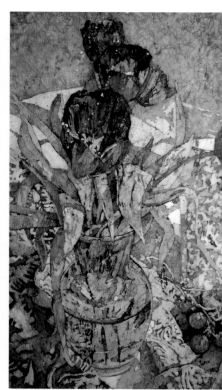

CAT'S EYE VIEW 1, 22"x26" Kathie George

These intriguing paintings are created by applying hot wax onto Ginwashi Oriental paper and then adding successive layers of watercolor pigments. Kathie's use of harmonically enriched color choices and her broad range of values have resulted in these stunning interpretations.

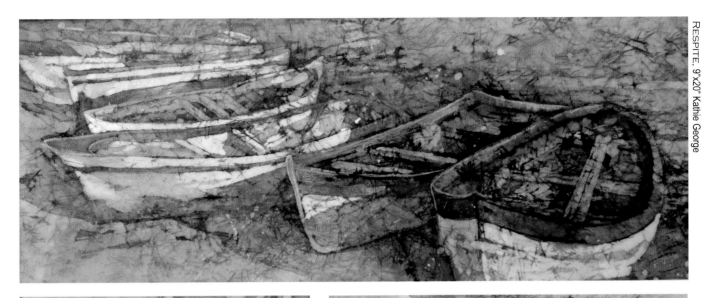

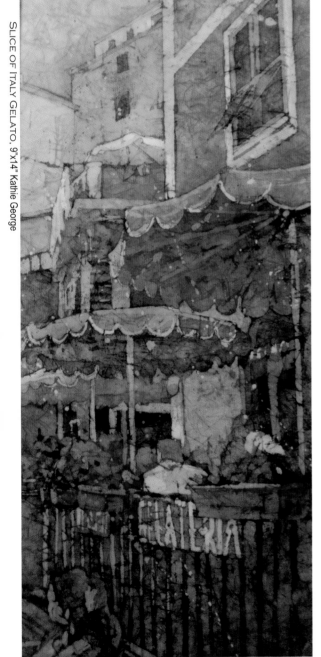

Kathie's work exhibits strong abstract design mixed in with the energy and beautiful textures found in batik. She draws in the viewer with her strong contrast in values and her colorful interpretations.

167

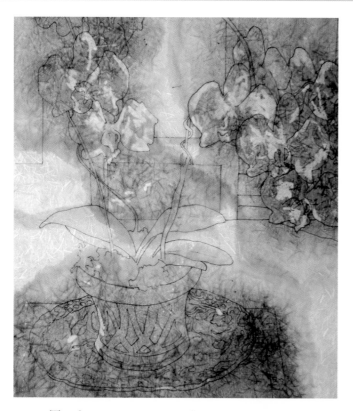

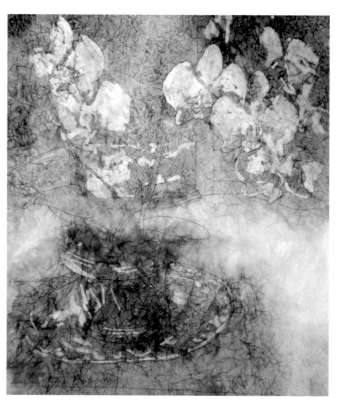

1 The first step in creating batik is to draw your image on Ginwashi Oriental paper using a .05 Micron® pen. Wax the areas you want to save as white or lights.

2 Continue to paint darker washes of color on the Ginwashi paper.

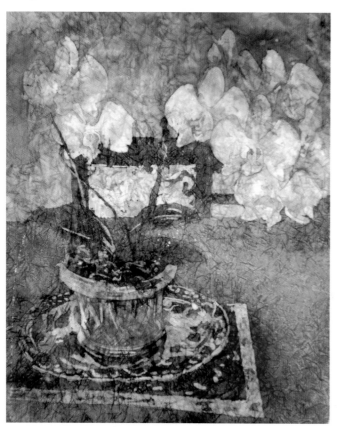

4 When the final darker colors are painted on, dried and waxed, crinkle the watercolor batik and add more darks in the crinkles.

3 As the colors dry, wax the areas you want to save. The waxed areas will resist any additional colors that are added.

5 When your work is completely dry, cover it with a piece of newspaper, take your iron and press out the wax. When you remove the newspaper, you will see your batik transformed with rich color. The ironing process often reveals elements of surprise. Who ever thought ironing could be so much fun?

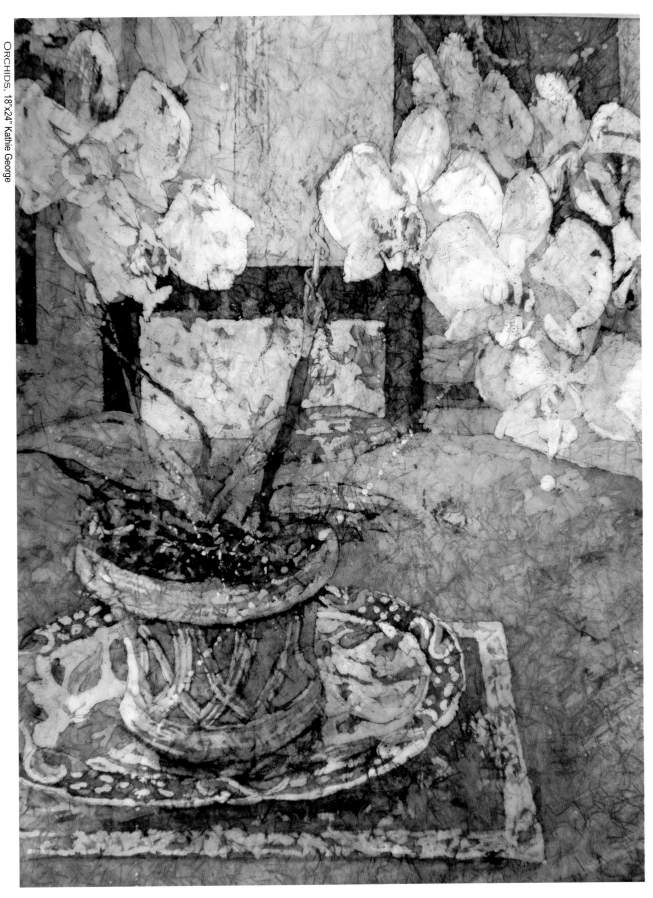

6 The finished batik reveals an elegant and artful blend of radiant color,
textures and, best of all, a special energy that only this process can produce.

Painting with food coloring instead of pigment

This lesson was shared by Cindy Markowski. Biking throughout the fall season, she was intrigued by the bright golds and yellows of early fall, then the vibrant reds, and finally the frost covered leaves on the ground. With those images as her inspiration, she began using real leaves with liquid watercolors but found her results somewhat disappointing once the watercolors dried. To capture the intense vibrancy of those beautiful leaves, she tried plain old liquid food coloring from the grocery store and came up with the perfect solution. Not only did the food coloring result in wonderfully bright colors, it was inexpensive. Her choice of materials makes the process affordable enough to use with school groups. When she taught this technique to a group of eighth graders, their enthusiasm was infectious. They loved the active process and were proud of their finished paintings.

Cindy Markowski

1 Gather leaves of varied sizes and arrange them vein side down on dry watercolor paper. Trace around the leaves with a watercolor pencil and then set the leaves aside. Wet the paper and then return the leaves to their outlined positions. These outlines will be helpful when you complete the painting.

2 Squirt full-strength yellow food coloring onto the wet paper. Dilute the red food coloring one part water to two parts coloring in a separate squirt bottle. Add drops of red to your paper, avoiding the yellow drops. Finally, dilute the blue food coloring, one part blue to two parts water. Squirt the blue drops around the edges of the painting.

3 Place a piece of Plexiglas® over the paper and stand on it. Place a weight on the Plexiglas® and leave it there until the next day.

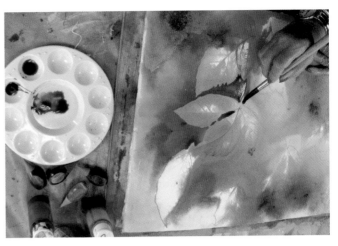

4 When your work is completely dry, remove the Plexiglas® and leaves. The colors and impressions of the leaves remain when the leaves are removed. The outlines of the leaves are still evident through the color.

5 Cindy painted the negative areas with diluted food coloring. Additional shapes were designed using skillful negative painting.

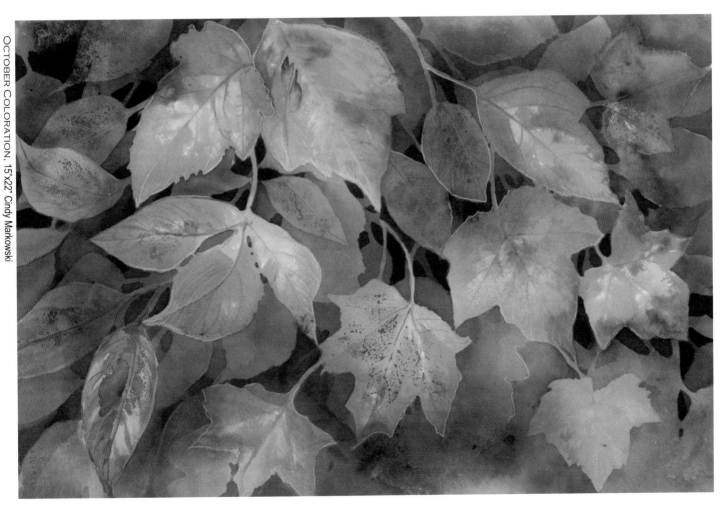

OCTOBER COLORATION, 15"x22" Cindy Markowski

6 Cindy added some lines of colored pencil to complete the painting. She has used this unusual technique for over twelve years and the colors are just as vibrant today as they were years ago.

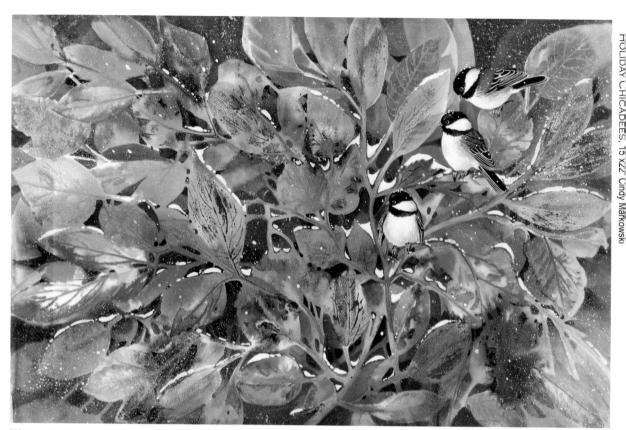

This painting started with peony leaves. Cindy added the chickadees and a touch of snow. The warm glowing underpainting complements the cool dominance to give the final painting a wintry feel. This painting was chosen for a Christmas card for the Courage Center in 2010.

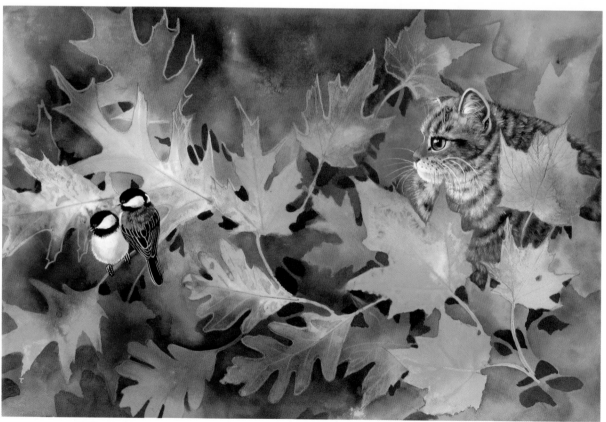

Cindy is a wildlife painter and added these realistic animals to provide more entertainment for the viewer. The combination of birds and a cat also reflects the tension often found in the world of nature.

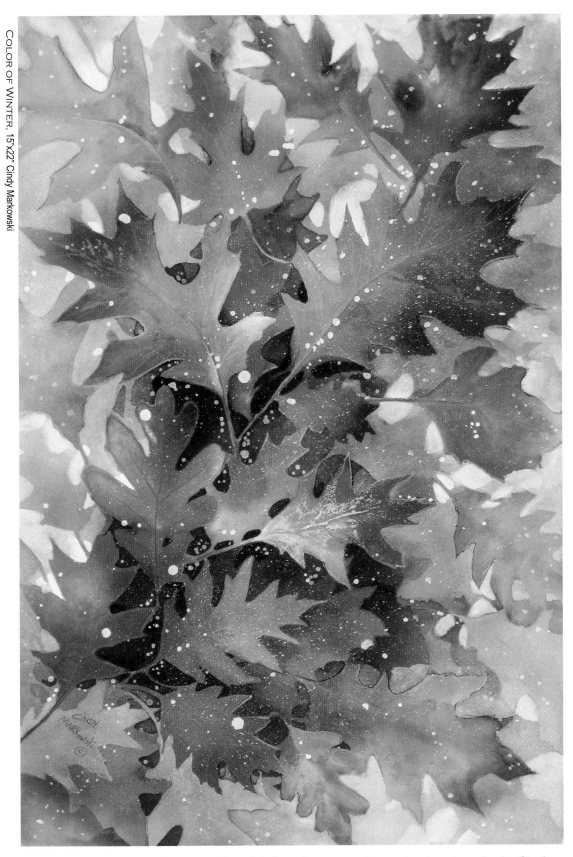

This painting has veils of opaque color added on the outer edges to lend a wintry look. Cindy also flicked a small amount of white acrylic on the painting to evoke the feeling of falling snow. The use of veiling allows the warm colors to flow through the opaque mixture and makes the color appear to come forward, adding depth and interest to the finished work.

Conclusion

Sometimes I wonder if I have a "personal" style of art expression because my paintings exhibit such a broad range of content, from realism to total abstraction. This range of wonder has always been present in my work—a need to experiment and try new things, while continuing to paint very traditional watercolor. Not only am I driven in life by my passion to teach and share my ideas, everyday is a new adventure in reading about, thinking about and creating art. While I admire artists who have a very strong personal style, I am ultimately driven to try new ideas, new tools and new directions.

If you are experiencing artist block or simply feel a need to try a new direction, I encourage you to open your heart, trust yourself and listen to your own voice. Have fun experimenting with the techniques and exercises presented in this book but realize that they are intended to serve merely as starting points from which you can begin to travel down the path of your own artistic journey.

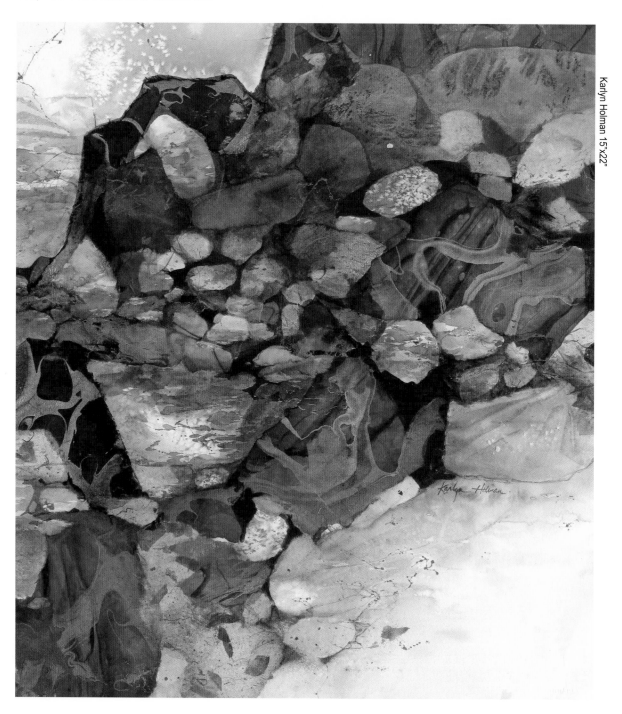

Karlyn Holman 15"x22"

Instructional materials by Karlyn Holman

Watercolor instruction books

DVD Companion

"Just Lines"

**"Just Lines" consist of Karlyn's line drawings on Arches®
cold press 140# watercolor paper.** These drawings are a
companion to the demonstrations in the book *Watercolor
Without Boundaries*. "Just Lines" is an inspiring start for
the beginner and advanced artist who wish to try Karlyn's
techniques and teachings with minimal preparation. Be
free and paint "without boundaries!"

DVDs

DVD Companion

"Lessons in a Bag"

**"Lessons in a Bag" consist of Karlyn's line drawings
on watercolor paper, full color lesson and reference
photo.** These are inspiring tools for the beginner and
advanced artist who wish to try Karlyn's techniques
and teachings with minimal preparation. All you do
is paint! Our customers find these "Lessons in a Bag"
easy to do. Many comment on how they feel more
relaxed and don't experience the difficulties of trying
something new because "it's just a lesson!" Karlyn
also allows you to sell your finished painting as your
own original—so what have you got to lose?

*These are
great tools for those
looking to teach
Karlyn's lessons*

Books, DVDs, "Just Lines" and "Lessons in a Bag" can be ordered from our website www.karlynholman.com
Karlyn's signature line of brushes and the art supplies that Karlyn uses can be purchased from our gallery store
by calling 715-373-2922 or you may go to our website to print off our order form and mail it in.

Index